PHILIP HENSHER is a columnist for the *Independent*, arts critic for the *Spectator* and a Granta Best of Young British novelist. He has written ten books, including *The Mulberry Empire*, *Scenes from Early Life*, *Kitchen Venom*, which won the Somerset Maugham Award, and *The Northern Clemency*, which was shortlisted for the Man Booker Prize. He lives in South London and Geneva, and is Professor of Creative Writing at Bath Spa University.

From the reviews for *The Missing Ink*:

'Delightful and spot-on. Hensher laments the decline of handwriting, not in a precious way, not because he wishes everyone were a quill-wielding aesthete, but because it's a human activity that could be forgotten, or ignored, or done badly, or done well, and why not do it well?'

PHILIP PULLMAN

'Reading this book reminds you of the aura a specimen of handwriting can have – all the more so as it becomes a rarer thing . . . its advocacy of one of the most humane and plea-surable forms of self-expression is pretty much irresistible'

JOHN MULLAN, *Guardian*

'A manifesto for the virtues of penmanship . . . written with passion and thoughtfulness' PHILIP WOMACK, *Telegraph*

'As fewer people write by hand, some of us who do venture to squeak a thin call of alarm, like mice behind the frescoes during the last days of Pompeii. Philip Hensher voices dismay more manfully in this eloquent account of what has been and will be lost by the ending of this ancient habit'

ERIC CHRISTIANSEN, *Spectator*

'With his novelist's gift for shimmering prose, Hensher may be just the man to inspire a public handwriting revival. If not, his work is a fitting tribute to a dying art that, with voice-recognition software now approaching human proficiency, may be poised to disappear for ever' *Booklist*

'For all its abundant wit, the spirit of this eloquent book is a deadly serious one: our handwritten words are the perfectly individuated marks we make, and leave, in the world' *Independent*

'What really makes *The Missing Ink* are Hensher's stories, jokes, mocking asides, and parenthetical grumbles . . . It is its portrait of the author, and his devotion to handwriting's palpable intimacy, that makes *The Missing Ink* so enjoyable'

DAMON YOUNG, *Sydney Morning Herald*

'Like a charming dinner guest, [Hensher] brims with fun facts, sharp insights and wry wit'

ABIGAIL MEISEL, *New York* Times Book Review

'An ode to a dying form . . . There remains something wonderful about receiving a letter that has been physically touched – actually crafted – by the hands of your correspondent' JULIA TURNER, *Slate*

'A highly readable, casually elegant look at a "modest, pleasurable, private skill" . . . Hensher finds virtue in the slowness of handwriting, and he cites evidence that if you improve a child's handwriting, you improve his literary skills' ANDREW MARTIN, *Financial Times*

Also by Philip Hensher

Other Lulus

Kitchen Venom

Pleasured

The Bedroom of the Mister's Wife

The Mulberry Empire

The Fit

The Northern Clemency

King of the Badgers

Scenes from Early Life

PHILIP HENSHER

The Missing Ink

How handwriting makes us who we are

PAN BOOKS

First published 2012 by Macmillan

First published in paperback 2013 by Pan Books
an imprint of Pan Macmillan, a division of Macmillan Publishers Limited
Pan Macmillan, 20 New Wharf Road, London N1 9RR
Basingstoke and Oxford
Associated companies throughout the world
www.panmacmillan.com

ISBN 978-1-4472-2169-2

1 3 5 7 9 8 6 4 2

A CIP catalogue record for this book is available from the British Library.

Printed and bound by CPI Group (UK) Ltd, Croydon CR0 4YY

Visit www.panmacmillan.com to read more about all our books
and to buy them. You will also find features, author interviews and
news of any author events, and you can sign up for e-newsletters
so that you're always first to hear about our new releases.

For Pa

Contents

The Missing Ink

1 ~ Witness

'No, I didn't learn handwriting. Well, in every lesson, with the letters, I suppose. Not handwriting as such. I'm seventy – I don't know how old I am. I can't remember. It's legible, my handwriting. Which is more than you can say for your father. It's not got a lot of style to it, my handwriting. It's most important that people can read your handwriting.

'My eldest sister is left-handed, so it always looks awkward, watching her write. I can't remember what my younger sister's handwriting was like. It's thirty years since she died. My father's writing was illegible. No form to the letters. My mother's was upright and round, a little bit like mine, I expect.

'I worked in an office in Wolverhampton, working in stock control, and you depended on people being able to read your handwriting, because they were sending orders out, so it was me who kept the records. Nothing was done on computers then. There were little coloured stickers – red meant re-order, and green, we've got plenty. I had a very nice boss in stock control. They couldn't have children, and they adopted a little girl, and I used to go and babysit for them, often.'

Interviewer: 'You'd have been what, seventeen?'

'Oh, I don't know – why does he want me to – it was the

year of the Suez crisis, when I learnt to drive. Because when the Suez crisis was on, you were allowed to drive without people sitting with you. And so if you got in a mess, you had to get yourself out of it. I remember my father standing at the window, watching me back out of the drive, and I drove straight into the stone gateposts. Bang.'

[Laughs.]

M.H., retired librarian, 75

2 ~ Introduction

About six months ago, I realized that I had no idea what the handwriting of a good friend of mine looked like. I had known him for over a decade, but somehow we had never communicated using handwritten notes. He had left messages for me, e-mailed me, sent text messages galore. But I don't think I had ever had a letter from him written by hand, a postcard from his holidays, a reminder of something pushed through my letterbox. I had no idea whether his handwriting was bold or crabbed, sloping or upright, italic or rounded, elegant or slapdash.

The odd thing is this. It had never struck me as strange before, and there was no particular reason why it had suddenly come to mind. We could have gone on like this forever, hardly noticing that we had no need of handwriting any more.

This book has been written at a moment when, it seems, handwriting is about to vanish from our lives altogether. Is anything going to be lost apart from the habit of writing with pen on paper? Will some part of our humanity, as we have always understood it, disappear as well? To answer these questions, I've gone back to look at some aspects of writing with a pen on paper. I'm going to talk about the pioneers who interested themselves in teaching handwriting,

and in particular styles: in the nineteenth century, the Americans Platt Rogers Spencer and A. N. Palmer, with their corporate copperplate, and the English inventor of efficient 'civil service' hand, Vere Foster. There are the revivers of the elegant italic style in the twentieth century, and the great proponent of child-centred art and writing, Marion Richardson, who transformed the study of handwriting in the 1930s. This book also talks about what handwriting has meant to us. And I'm going to talk about the sometimes-eccentric conclusions about personality, illness, psychosis and even suitability for employment which students of the pseudo-science of graphology have tried to draw from a close study of handwriting. We'll hear about writing implements, including both the nineteenth-century fountain pen, and that wonderful thing, the Bic Cristal ballpoint, and some varieties of ink. I wanted to convey a sense of how much handwriting can mean to any of us, and from time to time I set up a tape recorder in front of friends and family and asked them to talk about handwriting. Sometimes it gave a surprising insight into an individual life. And actually, writing this book has given me a surprising insight into my own life. I felt, after writing it, that some of my personal values had been clarified.

The book had better be written while it still makes some sense. At some point in recent years, handwriting has stopped being a necessary and inevitable intermediary between people – something by which individuals communicate with each other, putting a little bit of their personality into the form of their message as they press the ink-bearing point onto the paper. It has started to become an option, and often an unattractive, elaborate one. Before

handwriting goes altogether, we might look at what it has meant to us, and what we have put into it.

For each of us, the act of putting marks on paper with ink goes back as far as we can probably remember. At some point, somebody comes along and tells us that if you make a rounded shape and then join it to a straight vertical line, that means the letter 'a', just like the ones you see in the book. (But the ones in the book have a little umbrella over the top, don't they? Never mind that, for the moment: this is how we make them for ourselves.) If you make a different rounded shape, in the opposite direction, and a taller vertical line, then that means the letter 'b'. Do you see? And then a rounded shape, in the same direction as the first letter, but not joined to anything – that makes a c. And off you go.

Actually, I don't think I have any memory of this initial introduction to the art of writing letters on paper with a pen. It was just there, hovering before the limits of conscious memory, like the day on which the letters in the book swam out of incoherence and into sensible words. That day must have existed, and must have been momentous. I just don't remember it, and as far as I can tell from my memory, I've always been able to read and to write. When, as an adult, I went to Japan or to an Arabic-speaking country, and found myself functionally illiterate in the face of signs, it woke no deep memory in me of earliest childhood. It was just extremely strange.

But if I don't have any memory of that first instruction in writing, I have a clear memory of what followed: instructions in refinements, suggestions of how to purify the forms of your handwriting. There was the element of aspiration,

too. You longed to do 'joined-up writing', as we used to call the cursive hand when we were young. Instructed in print letters, I looked forward to the ability to join one letter to another as a mark of huge sophistication. Adult handwriting was unreadable, true, but perhaps that was its point. I saw the loops and impatient dashes of the adult hand as a secret and untrustworthy way of communicating that one day I would master. Unable to bear it any longer, I took a pen and covered a whole page of my school exercise book with grown-up writing, joined-up writing. There were no letters there to be read, still less words; just diagonal strokes linked each to the next in a bold series of gestures. That, I thought, was grown-up writing, if only it could be made to mean something, too.

There was, also, wanting to make your handwriting more like other people's. Often, this started with a single letter or figure. In the second year at school, our form teacher had a way of writing a 7 in the European way, with a cross-bar. A world of glamour and sophistication hung on that cross-bar; it might as well have had a beret on, be smoking Gitanes in the maths cupboard.* Later, there was rather a dubious fellow with queasy 'favourites' in the class: his face would shine as he drawled out the name of the class tart. He must have been removed from the teaching profession by the forces of law and order sometime in the 1980s; still, the uncial E's which have a knack of creep-

* Alternatively, he might have been a foreign spy. In the Alberto Cavalcanti film *Went The Day Well?*, the innocent English villagers first suspect that the platoon foisted on them may actually be German Nazis when they notice that their notes on a poker game cross the 7's.

ing in and out of my adult handwriting were spurred by what then seemed supreme elegance.*

Your hand is formed by aspiration to others – by the beautiful strokes of an italic hand of a friend which seems altogether wasted on a mere postcard, or a note on your door reading 'Dropped by – will come back later'. It's formed, too, by anti-aspiration, the desire not to be like fat Denise in the desk behind who reads with her mouth open and whose similarly obese writing, all bulging m's and looping p's, contains the atrocity of a little circle on top of every i. Or still more horrible, on occasion, (usually when she signs her name) a heart.†

These are the things we remember: the attempts to modify ourselves through our handwriting, and not what came first. Our handwriting, like ourselves, seems always to have been there.

The rituals and pleasurable pieces of small behaviour attached to writing with a pen are the next thing we remember. On a finger of my right hand, just on the joint, there is a callus which has been there for forty years, where my pen rests. For some reason, I used to call it 'my carbuncle' when I thought of it – I discovered that a carbuncle is something different and more unpleasant, and I don't know who

* Often these are termed 'Greek E's' – the ones with a crescent-shaped back – but uncial is a more accurate source. Uncial is the term for the rounded calligraphy characteristic of early mediaeval monasteries (see Chapter 7).

† There may be men in the world with a heart-shaped jot, as the dot over the i is called, but I have yet to meet one, or run a mile from them, rather.

taught me the lovely, but incorrect word. It has been there so long that I had it before I knew the difference between right and left, and used it to remind myself. 'Turn right' someone would say, and I would feel the hard little lump, like a leather pad, ink-stained, which showed what side that was on. And between words or sentences, to encourage thought, I might give it a small, comforting rub with my thumb.

In the same way, you could call up exactly the right word by pen chewing, an entertainment which every different pen contributed to in its own way. The clear-cased plastic ballpoint, the Bic Cristal, had a plug you could work free with your teeth and discard, or spit competitive distances. The casing was the perfect shape to turn into an Amazonian blowpipe for spitting wet paper at your enemies.* Or you would find that the plastic bit would quickly shatter with a light pressure of the pensive molars; first holding together, then splintering, leaving shards in the mouth and the ink-tube poking out in a foolish way. Pretty soon you would be attempting to write with only an inch of casing, stabbing painfully into the mound of your thumb. The green rollerballs and felt-tips, on the other hand, had a more resistant casing, and gratefully took the disgusting imprint of your teeth. They had a knack of leaking backwards, onto your tongue, to spectacular effect at break-time in the playground. I could write a whole book about ink-staining; the way, at the end of the morning, you

* You remove the plug and ink reservoir, then apply the mouth to the writing end with the spit ball at the plug end, but you know that already.

went to the bathroom and, with that gritty coal-tar soap with the school-smell – you never saw it anywhere else – scrubbed the residue of the morning's labours from the entire outer ridge on the little finger of your right hand. Bliss.

There were other rituals. If you were allowed a fountain pen, the private joy of slotting in the ink reservoir: the small resistance, and then as the plastic broke, the reservoir settling into its secure place with a silent plop. The ink never flowed immediately, and there was the gesture of flicking downwards in the air above the desk or floor to pull it towards the nib. Somehow, it never occurred to you to cover the nib with a tissue or handkerchief; somehow, there was always a reason to go on flicking downwards even after the first sign of the appearance of ink, just to flick that satisfying spattering Jackson Pollock line of ink. And when the ink ran out or wouldn't flow, whether from ballpoint or nib, the series of solutions you attempted: the movement of the pen over the paper in loops and hooks, first patiently then with a frenzied scribble, like a mid-period Twombly. When it failed again, you might daringly take the pen in your mouth and suck – it worked better with a fountain pen than with a biro, but both were just as liable to stain your tongue black, and bring forward the sage observation from the boy sitting next to you that 'My aunty died of ink poisoning, it's deadly if you take enough of it inside you.'

Technologies are either warm or cold, either attached to us with their own personalities, or simple, dead, replaceable tools to be picked up and discarded. The pen has been with us for so many millennia that it seems not just warm

but almost alive, like another finger. These rituals are signs of the intimacy of that relationship. They seem like gestures of grooming or of small-scale playing rather than the mending or maintenance of a tool. Sometimes, the pen has actually been referred to as a 'finger', and everyone knows what is meant: 'The moving finger writes, and having writ, moves on,' Omar Khayyam writes in Edward Fitzgerald's translation. It has sometimes been considered improper, indecent, unhygienic to lend a pen. There is a nineteenth-century bon mot, which you will sometimes hear even now, that there are three things that a gentleman never lends, a wife, a pipe and a pen, rather like a lady never lending her hairbrush. Among other occupations, I teach creative writing at a university in the West of England, and my students know, to their cost, that the prejudice has its point. If I borrow a ballpoint from one of them, within half an hour it is apt to creep towards my mouth, and by the end of a two-hour seminar it is often not in a returnable condition.

When the machines first came into our lives, they probably seemed as warm and humane as any other way of writing. I can only explain this by reference to my own history of engagement with writing with machines. When I was a boy, people occasionally asked me 'What do you want to do, when you grow up?' I always took this question seriously. Like other remarks adults made to children – what year are you in at school? I've been hearing a lot about your new digital watch – this seemed to me a real remark which looked for a real answer.

My family had a great friend called Tony Peagam, who was the editor at various times of different magazines. One was the AA magazine – the Automobile Association, not

the twelve-step recovering pisshead one – and once he put my dad on the cover. It was in relation to a story about car insurance. It seemed extraordinary to me that our family name might appear in print on a bright-red cover. Afterwards, for years, when people asked me what I wanted to do when I grew up, I would say 'I want to be a freelance journalist'. (Where I got 'freelance' from, I don't know. But it was so.)

After hearing this for a few years, my mother said that, if I wanted to become a journalist, I should learn shorthand and learn to type. The shorthand could probably wait,* but for my thirteenth birthday, I had a typewriter: an orange portable Olivetti, with its own tightly fitting case, closing with a satisfying click. I sat and conscientiously learnt to type. At first, the knowledge of the alphabet and the arrangement of the keyboard meshed in an ugly way.† My fingers hovered over it as I searched for a letter – Q, so oddly positioned at the start of everything. But I persevered, and soon I knew where everything was, mastering those interestingly dull exercises – glad had fad sad had shall gad hall. There were, I know now, people advocating at the time that children should be taught to type in school, but it certainly never got as far as Tapton School in Sheffield. We had two blind children in our class whose Braille-printing machines made an unholy racket, so what

* It's still waiting.

† The familiar QWERTY arrangement of the keyboard was chosen, not for its efficiency, but the opposite. The first users of the typewriter needed an arrangement which would slow users down, in order that the levers would not jam.

twenty-five typewriters of the early 1980s would have done to the nerves of the poor teacher can perhaps explain why typewriting lessons in schools never took off. For me, certainly, learning to type was a home-time endeavour. I never quite learnt to touch-type, but I could soon type, after a fashion, with alacrity. Even now, the odd person will remark on what a fast typist I am. Perhaps less so, nowadays.

In the 1970s, the ability to type was a special skill, to be acquired for a particular purpose. But now everyone can type.

Think of the last thing you wrote. The odds are that you sent an SMS text on your mobile phone with your thumbs working like fury.* Or perhaps you sent an e-mail, or just typed something on your laptop. Now, there are computers activated by voice recognition, and subsequently a television you can shout at to change channels, thus saving you the massive labour of pressing a button on a remote control.†
Soon, we may not need the keyboard, or, perhaps, our hands at all. But for the moment, it is the way we write. It is much less likely that, instead of SMS-ing, or e-mailing, or typing, you took a pen and wrote something on paper, with ink. The quick movement of thumbs over a miniature keypad, or of fingertips over a QWERTY keyboard, is the

* Marx, who saw and foresaw most things, outdoes himself by remarking that the history of civilization is entirely down to human beings possessing opposable thumbs. It was impressive to guess that sooner or later men would invent a way of writing that required only the movement of the thumbs.

† But how will it know whether you're shouting at it or at your annoying little brother?

way that writing almost always begins now. This is quite a recent change. Until the year 1978, I never wrote anything other than with a pen and paper. For another ten years, I never wrote anything that counted in any other way. I can identify the exact moment of transition, when I submitted the first chapter of my PhD to my supervisor in Cambridge, in 1987. I had handwritten it, not affectedly, but just because that was how I had always written essays. He marked it, sighed, handed it back and said 'In future, could you just type your work?' I did so, with no real sense of how things were to be from then on.

The rituals and sensory engagement with the pen bind us to it. The other ways in which we write nowadays, however, don't bind us in the same way. Like everyone else, I write a lot on a computer, and have done for over twenty years. In all that time, I've evolved exactly two pieces of ancillary, grooming-type behaviour towards the thing. Every so often, I take one of those cloths that you clean your glasses with, and wipe the screen clean of dust. (Sometimes I spray the screen first with glass-cleaning fluid). And there's the quite enjoyable ritual of taking a sharp object and poking in the gaps between the keys, chasing the little balls of dust and crud and dropped crumbs of sandwiches eaten with one hand while typing with the other, out from where they have unhygienically lurked for weeks.*

That, really, is the extent of any auxiliary play-type behaviour induced by a computer, and it's no wonder if we

* I've just bought a new laptop, and this one has keys virtually flush with the casing, with nowhere for anything to fall. So that reduces the list to one computer-based ritual.

haven't yet evolved many warm sensations towards the object, being unable to suck it, enjoy the sensory quality of its minor operations, or regard it as a direct extension of our being. Those other writing apparatuses, mobile telephones, occupy a little bit more of the same psychological space as the pen. Ten years ago, people kept their mobile phone in their pockets. Now, they hold them permanently in their hand like a small angry animal, gazing crossly into our faces, in apparent need of constant placation. Clearly, people do regard their mobile phones as, in some degree, an extension of themselves. There is, for instance, an unwillingness to lend a mobile phone, a sense that a request to borrow one in other than the direst emergency is in some degree overstepping the mark; a sense that is not to do with the fear that the lender may take the opportunity to telephone his aunt in Peru. And yet we have not evolved any of those small, pleasurable pieces of behaviour towards it that seem so ordinary in the case of our pens. We text, and let it rest again in the palm of the hand, and don't quite know what to do with it: an extension of our being, but inert, meaningless, in no particular need of our ongoing attention. It doesn't need to be cleaned, or cared for, and if you saw someone sucking one while they thought of the next phrase to text, you would think them dangerously insane.

Probably at some point in the future, we will start thinking of our communication devices as warm, in the way that we think, or used to think, of our pens. But in the meantime, we have surrendered our handwriting for something more mechanical, less distinctively human, less telling about ourselves and less present in our moments of

the highest happiness and the deepest emotion. Ink runs in our veins, and shows the world what we are like.

This is a book about the disappearance of handwriting. We don't quite know what will take its place – the transmission of thought via a keyboard into words; the rendering of voice commands into action; the understanding by a piece of technology of a gesture or, conceivably, a thought. The shaping of thought and written language by a pen, moved by a hand to register marks of ink on paper has for centuries, millennia, been regarded as key to our existence as human beings. In the past, handwriting has been regarded as almost the most powerful sign of our individuality. In 1847, in an American case, a witness testified without hesitation that a signature was genuine, though he had not seen an example of the handwriting for sixty-three years: the court accepted his testimony.[1] Handwriting is what registers our individuality, and the mark which our culture has made on us. It has been regarded as the path to riches, merit, honour; it has been seen as the unknowing key to our souls and our innermost nature. It has been regarded as a sign of our health as a society, of our intelligence, and as an object of simplicity, grace, fantasy and beauty in its own right. At some point, the ordinary pleasures and dignity of handwriting are going to be replaced permanently. What is going to replace them is a man in a well-connected electric room, waving frantically at a screen and saying, to nobody in particular, 'Why won't this effing thing work?' Before that happens, perhaps we should take a look at what we're so rapidly doing away with.

3 ~ There's Nothing Wrong with my Handwriting, They just Need to Pay Someone who Can Read it

In 2012, a gentleman at Lancaster University decided to sue the institution after markers criticized the legibility of his handwriting. Comments on his exam scripts included 'I cannot read this' to simply 'cannot read'. The *Times Higher Education Supplement*, reporting on the case, observed with horror that 'One marker even commented: "Can you do anything about your handwriting?"' as if it were an obviously absurd or prejudicial thing to ask. Fatally, the institution sent an e-mail, in which somebody wrote: 'His handwriting is not particularly good, but it is no worse than some others who do not suffer from a disability.' The university had to apologize for ever criticizing the student's handwriting, despite the fact that nobody could read it. The student, who was dyslexic, said that he understood that his exam papers would be transcribed because of concerns about his handwriting. The university countered that after concerns about his handwriting were voiced, his papers were re-marked with no change to the final marks. At the time of writing, the student is suing the university for the return of all his fees.[1]

Our attitude to our own handwriting is a peculiar mixture of shame and defiance: ashamed that it's so bad and untutored, but defiant in our belief that it's not our fault. What shame and defiance have in common, of course, is the determination to leave the cause of the shame or defiance unaltered. The blithe assumption that bad handwriting doesn't matter, and shouldn't be improved by its perpetrator, may be on the increase inside and outside education. The view expressed as long ago as 1987 by the Regional Examinations Board, that there were competent candidates whose work was 'degraded by the technical accuracy'[2] is falling away. Instead, the view of the 1970s radical head teacher from Islington who told an inquiry into his teaching practice that he didn't teach the kids to read and write because 'it's all typewriting nowadays'[3] is, apparently, on the rise.

The question is: should we even care? Should we accept that handwriting is a skill whose time has now passed, or does it carry with it a value that can never truly be superseded by the typed word?

Sometimes, however, it does matter in the most brutal economic or human sense. This has been true even before the invention of the Internet transformed everything. American Demographics claimed that bad handwriting skills were costing American business $200m in 1994. Thirty-eight million unreadable letters couldn't be delivered. Kodak said that 400,000 rolls of films couldn't be returned because names and addresses were unreadable.[4]* Does it still matter now

* Kodak would probably still be going if Americans learnt to write legibly, I dare say.

that there is no film industry any more and not so many hand-addressed envelopes to misread? Well, in 2000, a US court awarded $450,000 to the family of a Texas man who died after a pharmacist misread the doctor's handwritten prescription.[5] In a 2005 Scottish case, the handwriting of a staff nurse called Fiona Thomson in Airdrie, Lanarkshire was so appalling that a colleague misread an instruction to give 4 units of insulin for 40. The patient, Moira Pullar, died, and the nurses and hospital were savagely criticized by the judge at the inquest, Sheriff Dickson.[6]

Repeated anecdotal evidence suggests, however, that few people now believe that handwriting is something that ought to be improved in the interests of communication. What does it matter if your aunt's birthday card gets lost in the post? All these cases are arguments for the printed prescription, ordering everything over the Internet with typed details, never setting pen to paper. They don't seem to be arguments for improving competence in handwriting. But in a hurry, would a nurse making a note to a colleague always find a computer terminal? A lecturer called Tim Birkhead tells of an encounter with an undergraduate. 'While the essay was excellent, the handwriting was appalling, so I said that a bit more care with the handwriting wouldn't go amiss, particularly under exam conditions. Most undergraduates take such advice with a grateful smile. But not this one. After a moment's pause, he looked me straight in the eye and coolly said: "If you cannot read my handwriting, then the university ought to be employing someone who can." Then he left.'[7] Did not that undergraduate exhibit some failings that went beyond a mere inability to write well? Nor is this a purely British

phenomenon: we hear from an Australian academic* that 'Marking the final exam, it emerged that few could write neatly: from bold childlike printing to spidery scribblings in upper case, it is obvious that handwriting is a dying art.'[8] Some other elements of civilized life may die with this art, or skill, or habit.

If we want to understand why so many people now have very little command over their handwriting, and see no reason why they should ever make an effort in that direction, we ought to look at what their education has prepared them for. This is what is demanded of schoolchildren in the UK with regard to handwriting. At the earliest stage of the National Curriculum, which in the UK controls what is learnt and what may be taught from infant school onwards, the following is prescribed:

Handwriting and presentation

5. In order to develop a legible style, pupils should be taught:

Handwriting

a. how to hold a pencil/pen
b. to write from left to right and top to bottom of a page
c. to start and finish letters correctly
d. to form letters of regular size and shape
e. to put regular spaces between letters and words
f. how to form lower- and upper-case letters
g. how to join letters.

* Who, I warn you, might say she regards handwriting and grammar as a lost art, but evidently knows eff-all about the dangling participle.

But that's only the beginning of a child's engagement with handwriting. Naturally, the government has decided that the child must progress. In the consolidated set of 'level descriptions' by which schoolchildren work their way through the education system, a series of demands with respect to handwriting is smuggled in. It goes like this:

> Level 1: Letters are usually clearly shaped and correctly orientated. Level 2: In handwriting, letters are accurately formed and consistent in size. Level 3: Handwriting is joined and legible. Level 4: Handwriting style is fluent, joined and legible. Level 5: Handwriting is joined, clear and fluent and, where appropriate, is adapted to a range of tasks. Level 6: Handwriting is neat and legible. Level 7: Work is legible and attractively presented.[9]

There are further stages, but by that point the teacher and the administrator have both grown bored with saying that handwriting should be legible and clear, and no further demands are made on the student. Clearly, nobody at any point has followed handwriting through the syllabus as a developing skill, or they would have noticed that 'legibility' is something to be attained newly at every age from eight to twelve. At the earliest stage, teachers are supposed to set children some very complex tasks, joining up letters and showing how to enter and leave letters correctly. After that, it looks as if they're on their own. A student who has attained the level required at Level 3, and certainly at Level 4, shouldn't really need much more instruction. How many students really do come up to the mark of writing fluent, joined, legible writing at Level 4 is another matter. What

happens if they don't? The teacher rolls his eyes and makes a small but devastating tutting noise, I expect.

In fact, a study in 2006, carried out by London University's Institute of Education, discovered that fewer than half of British primary schools set time aside in a week to teach handwriting. Despite widespread support for the value of handwriting – more than half of the teachers surveyed supported the idea of a nationally prescribed handwriting school – only a fifth of the teachers taught pupils how to write more quickly.[10] Familiarity is said to breed contempt, but in this corner of contemporary culture, what attracts contempt is what individuals cannot do, or have not been taught to do. The other half of teachers, or perhaps four-fifths, may be represented by the teacher who said 'In business, rarely, if ever, do you have anything handwritten. Nothing ever comes across my desk handwritten. Children do need to have a little more pride in their penmanship, but if you look down the road, will it make any difference when everything is typed?'[11] The Islington head teacher I earlier referred to as justifying the failure to teach the children to read or write was, in the 1970s, struck off. In the twenty-first century, a Scottish headmaster says 'The importance of perfect handwriting is overplayed [sic] . . . I am much more interested in what a child writes about than the quality of their [sic] handwriting. So much time can be spent in primary schools on the correct formation of letters that it impacts [sic] on the learning of other, perhaps more important, literacy skills [sic].'[12]*

* Oh, crap. Seriously, what crap. When have handwriting lessons prevented children from learning to read and write, or 'literacy skills',

Of course, people have been complaining about bad handwriting in education for centuries. Lord Chesterfield in the eighteenth century was writing to his bastard that 'Your hand-writing is a very bad one, and would make a scurvy figure in an office-book of letters, or even in a lady's pocket-book. But that fault is easily cured by care, since every man who has the use of his eyes and of his right hand can write whatever hand he pleases.'[13] Lord Chesterfield's son, like many people of social standing before and since, had a hand which was 'neither a hand of business, nor of a gentleman; but the hand of a school-boy writing his exercise, which he hopes will never be read.' If he was alive today, he would probably feel free to tick off his father for being unable to read it, and probably sue him for being so insulting about something which wasn't his fault, too. What seems to be new is the attitude that bad handwriting is nothing to do with the writer's merits or application, and that people who can't read illegible and ill-formed handwriting ought to get over themselves, or pay somebody to read it instead. And if a student says 'It's not my fault', shouldn't we look at the methods through which handwriting is taught nowadays, and consider whether they might not have a point here?

What is driving the decline of handwriting? Why has it become, in some people's eyes, totally unnecessary? The

in this moron's horrible jargon? How the effing eff could they? What likelihood is there that you're going to be allowed to introduce handwriting lessons to the extent of 'impacting' on anything at all in a twenty-first-century Scottish school? Is he seriously suggesting that children were less literate in an age when handwriting lessons lasted half an hour? Jesus, sometimes you really want to give up.

simple answer is the dominance of the keyboard. Many institutions are just giving up, in the face of an apparently hopeless situation. In April 2011, the Indiana Department of Education instructed its schools that only proficiency with a keyboard would be expected. 'They can continue to teach handwriting if they want'. The new common core standards in education, which at that point had been adopted by forty-two states, no longer require schools to teach a cursive hand. The *Daily Telegraph*, reporting on this story, interviewed a psychologist called Dr Scott Hamilton who said it made sense to only teach children how to sign their names in joined-up writing. "The time allocated for cursive instruction could then be devoted to learning keyboarding and typing skills. From an intuitive standpoint, this may make sense, based on the increasingly digital world into which this generation of children is growing up."[14] God save us all from Dr Hamilton's intuitions, and from a brave new world in which the people of Indiana are unable to write anything but their own names.*

In this world, we understand that people will write exclusively on keyboards. When such people are forced, by rare circumstance, to write a letter by hand, do we forgive

* Here's a thing. You're driving down an Indiana track when out of nowhere comes a tractor into the side of your Subaru. How do you exchange details? Neither of you have ever been able to write anything but your own names. The farmhand don't be holding with them thar smart phones nor with that new-fangled Internet. (Or he does, but the battery on your smartphone has died a death – take your pick of disastrous scenarios). So there the two of you stand, helpless, in an Indiana field, trying to work out which way up to hold a pen and cursing the idiotic name of Dr Scott Hamilton who landed you in this mess.

the ugly confusion on paper made by those who have taken the decision, or had the decision forced on them, not to write by hand any more? Some recent public episodes suggest that this isn't yet the case. We seem to believe both that handwriting doesn't matter, since everyone types, and that when people do write a handwritten letter, it ought to be elegant, graceful, and well practised. In 2009, the war in Afghanistan was coming towards its eighth year. Like all wars in Afghanistan, it was proving much less easy than anyone had originally thought.* The Western public was getting restless, and a general belief was taking hold that the leaders of the willing actually didn't much care about the dead soldiers coming back from Afghanistan. To counter this impression, political leaders took to writing personal letters, by hand, to the families of the bereaved.

A grenadier guardsman, Jamie Janes, was killed in Afghanistan by a bomb on 5 October 2009. In the days following his death, the then Prime Minister, Gordon Brown, wrote to Jamie's mother. When Mrs Janes received the letter, she, horrified, took it straight to the newspapers. Brown had written the letter in his usual felt-tip pen. It was filled with spelling mistakes which gave the impression that it was dashed off in haste, without much care – 'Dear Mrs James, It is with the greatst of sadness that I write to offer you and you family my personal condolencs on the death of your son, Jamie. I hear from colleagus . . .' Perhaps still more frightening was Brown's handwriting, which not many people, probably, had seen. It leant backwards; it was

* I wrote a book on the subject, *The Mulberry Empire*.

10 DOWNING STREET
LONDON SW1A 2AA

THE PRIME MINISTER

Dear Mrs James

 It is with the greatest of sadness that I write to offer you and your family my personal condolences on the death of your son, Jamie. I know from colleagues that Jamie was a brave, selfless and wholly professional soldier who was held in the highest esteem and regard by all who worked with him. I know that words can offer little comfort at a time of grief

Gordon Brown's handwriting.

printed and joined randomly; there were no real upstrokes or downstrokes. It was not, people said, the handwriting of an educated man.

This was deeply unfair. Brown, as was only half-known at the time and rarely alluded to, was not far from partially sighted. He clearly knew how 'condolence' and 'colleague' were spelled. This was the letter of someone who had great difficulty in writing by hand for good medical reasons. The poor man was obliged to phone the indignant mother, and turn the whole episode into a discussion of his near-blindness.

Nevertheless, the Brown episode shows that, sometimes, we expect people to write well. In certain circumstances, we deplore bad writing: the bad, ugly, illiterate, ill-formed writing of someone who has never practised writing, never considered that it might be a duty to write in ways which people can read and take some pleasure from. If we expect good writing on elevated occasions, is it not reasonable to expect people to write reasonably well all the time? It is not reasonable to think that people can write terribly, illegibly badly almost all the time and then elevate their handwriting for special purposes. Sometimes, it clearly matters a good deal.

There are, perhaps, some signs that handwriting is being maintained in education by a handful of believers. The fightback in parts of education continues. One American schoolteacher boldly said in 2001 that 'about 50 per cent of kids have illegible handwriting'.[15] A UK 2010 survey by the pen manufacturers Berol found what they wanted to hear: 82 per cent of teachers said they had noticed a deterioration in recent years. The Confederation

of British Industry Scotland said that 'legibility of hand-
writing matters. There is a wide range of forms to be
completed by hand in most organizations and in certain
circumstances. Some of these are documents that may
potentially be called in evidence in legal proceedings.'[16]

From 1984, a revival in handwriting tuition in schools
started to be noticed. Often, a print hand was maintained
alongside the old-fashioned cursive deriving from the
nineteenth-century handwriting guru, A.N. Palmer.[17] (It's
noticeable that many very well-educated Americans of
forty and under do habitually write in a firm print hand,
without any cursive joins at all.) Handwriting is still taught
in pockets in the United States, despite resistance. 'We just
had this discussion,' a Chicago teacher says, explaining how
he came to teach handwriting again. 'They have to know
this because they'll still need it. Not everyone has a com-
puter. And for state testing, they have to physically print or
do cursive.'[18] One perceived problem is that the national
unity of style in America seems to be disappearing. This
seems to be one area where diversity is perceived by Ameri-
cans not as exciting, but as confusing and unnecessary.
The *New York Times* observed in the 1990s that 'ethnic
diversity has brought new lettering: Greek E's, for example,
which look like backward 3's, and European 7's, which are
written with a line across the staff.'[19] Is this a bad thing?
Perhaps, to generations accustomed to imposing ways of
outlining letters on sighing children, the excitement of
seeing that you could choose, if you wished, to make your
letters in another way seems intimidating.

In third grade in American schools – seven to eight-
ish – now as it has been for decades, a cursive hand is

introduced. In 1984, the *New York Times* reported a recommendation by an emeritus professor of education from Buffalo, New York, that schools should 'devote about five to ten minutes to teaching handwriting two or three times a week in elementary school.'* They also managed to find that Houston did spend twenty minutes a day in teacher-directed handwriting instruction from first to sixth grade – this was in the early 1980s. In recent years, a programme called Handwriting Without Tears has encouraged teachers to devote ten to fifteen minutes a day on handwriting.[20] Other twenty-first-century initiatives included teaching American schoolchildren cursive from the start.[21] There seems no doubt that, here and there, there are many individual schoolteachers in America sufficiently convinced of the importance of handwriting lessons in their own education not only to reintroduce such lessons, but actually extend them downwards and upwards.

In England, on the other hand, in 1982, we are told that 'only 5 per cent of schools taught handwriting. By 1987, this had suddenly increased to about 60 per cent'.[22] The National Curriculum now stresses handwriting. 'The four criteria of the Sats level two handwriting test are legibility, consistent size and spacing of letters, flow and movement, and a confident personal style.'[23] But does anyone follow this? From time to time, you hear of an individual school

* 'What does emeritus mean, Rupert?' Frank Giles asked Rupert Murdoch after being turned into Editor Emeritus of *The Times* after one egregious catastrophe under his editorial stewardship. 'It's Latin, Frank,' the proprietor said. 'The e- means you're out. The meritus means you deserve it.'

that decides to push it up the agenda – a school called Otford County Primary devised a unique strategy with the support of the great handwriting scholar Rosemary Sassoon (a bit like getting Richard Dawkins to plan your Year-2 Nature Studies, one might think). A primary school called Stonesfield introduced a proper cursive policy.[24] Walthamstow School for Girls, spectacularly, insisted that all work had to be done by pupils with fountain pens rather than ballpoints – the rule, of course, had to be imposed on staff, too. Lunchtime handwriting surgeries were introduced.[25]

This all sounds wonderful. Now for the bad news. After reading about these handwriting strategies in individual schools from fifteen years ago, I wrote to the headteachers of the schools asking what had happened since, and how they had developed these interesting policies. I am sorry to say that, when this book went to print, none of them had responded to me. When I telephoned the PA of one head-teacher to ask if they had any intention of doing so, and if, for instance, they still taught handwriting, since they might be too busy to write a letter to me, she had no idea what I was talking about. Some schools may have hand-writing policies, for all I know. They may spend their whole days doing nothing else. On the other hand, if they do maintain any interest in handwriting, they're in no great hurry to tell anyone about it. I suspect those who were briefly excited a decade or two ago are now about as much interested in handwriting these days as anyone else.

4 ~ A History Of Handwriting, from String Onwards

1. Early Neolithic folk take to tying knots in string to remind them of things. Not really handwriting.

2. 412,000 BC. A community of Homo Erectus living at Bilzingsleben in modern Germany leave notches on bone. Not really handwriting.

3. 8000 BC. The Azilian culture in southern France take to painting squiggles, stripes and spots on pebbles. Nobody knows what they meant, if anything, if not a slightly tragic wish by a prehistoric Terence Conran to brighten up the cave. Not really handwriting.

4. 5300 BC. The Vinca culture in the Balkans incise symbols on clay. Two hundred and ten symbols are recorded. They appear to be related to the possession of objects. Not really handwriting.

5. Depressing realization sets in. Writing was invented not by human beings but by accountants. Most of the early writing systems are records of how much crap people own, how much money they have, how much money they owe, and other lowering/boastful facts of human life.

6. The accountants invent writing systems in Yangshao in China around 4000 BC, and various middle Eastern sites between 8000 and 1500 BC.

7. Sumerians around 3700 BC start to stick one-syllable symbols together to form words, first by joining pictorial symbols together so that 'eye plus water meant *weeping*.'[1] Still not handwriting.

8. Egyptians invent hieroglyphs. System now includes 26 one-consonant signs. The principle of the consonant alphabet widely accepted by 2000 BC. Not much like handwriting.

9. Over the next 4,000 years, Egyptians develop four scripts: hieroglyphic, hieratic, demotic and Coptic. Hieratic is developed by accountants, written on papyrus and other surfaces, taking on links between letters and other simplifications. Suddenly, it looks a lot like handwriting. All of a sudden, people start writing proper literature in it. Response of accountants to this not recorded. Possibly start going round handing round clay-tablet business cards to newly affluent poets.

10. In Mesopotamia, wedge-shaped tools applied to clay produce a form of writing called cuneiform. Scribes are trained at special schools, performing exercises in writing over and over. Very much like handwriting lessons.

11. The development of alphabets results in a Phoenician alphabet with twenty-two consonants around 1000 BC. Other writing systems quickly follow, including Greek,

Hebrew, Arabic, and others which have not survived. All of these demonstrate the personal ability to write letters, as well as incised or engraved forms. From this point on, it's all handwriting.

5 ~ *What's my Handwriting Like?*

Many previous books about handwriting have been written by people with beautiful handwriting, to which the readers might want to aspire. This is not one of those books. What people usually say about my handwriting is that it looks 'incisive', 'quite grown-up' and, most often, 'What's that word there?' It looks like this:

Joaquin phoenix was gazed at, by MTV, for luck.

It came about in the following way.

1. Taught a print hand at Malden Manor Infant School, 1969. Upright letters, not joined-up. Good for stories about spaceships and ones about magical princesses, sometimes at the same time.

2. Longed to start on joined-up handwriting. Invented own script, bearing no relation to letters or words. Developed

inexplicable urge to write under the pseudonym of Edwin Harrington, possibly connected to the first ambition.

3. Observed difference between Mummy's handwriting, nice, cosy and round, though as she admits, utterly unable to spell the word 'carrot',* and Daddy's, elaborate, graceful, reaching upwards boldly and with a signature like a knife into a wound, not much like his name at all. Insight grasped: people don't write all the same, and the way they write is a little bit like them.

4. Was taught joined-up writing at Malden Manor Junior School, 1971. Slowly mastered the rounded letterforms recommended by Marion Richardson in the 1930s. Took particular pleasure in her z's, like this $-\mathcal{Z}-$ and struggled with her r's, with the hook and hammock. Found faint disappointment in the no-nonsense f's, and felt there must be more to life than that. First signs of rebelliousness: replaced the back-to-back brackets of the Richardson x with two crossing diagonal lines. Felt much better about not being allowed to write in a forward-sloping hand.

5. Glimpsed the signature of Elizabeth I. Love at first sight. For some time wrote title pages of unwritten novels by Edwin Harrington, my chosen pen-name, with absurd arabesques under the signature. Now eight years old. The novels of Edwin Harrington went unwritten.[†]

* Still can't (2011). My weakness, never surmounted, is 'Peloponnese', a place I've been to half a dozen times, have written articles about, and still had to go and look up just now and copy out letter by letter.

[†] So far.

Elizabeth I's signature.

6. In the handwriting hour, Mrs Clark instructs us to copy out a poem from the anthology and decorate it. There will be a prize. I copy out a poem about ducks and attempt to draw some portraits of ducks among the reeds. Find I am unable to draw a duck. Moreover, Mrs Clark, deep in her Welsh soul, with her passionate devotion to Marion Richardson's letterforms, disapproves of the adaptation of the f and the t in my handwriting. The t should join from the bottom, she says, not from the crossbar. She calls out one name after another as winner of the class competition, as I hover over her desk. All the names she calls have buggered off to torture a frog in the school pond, or something. Finally, after having gone through fourteen names, she has no alternative left. I am declared the handwriting champion of 2Cl. There is no prize but Mrs Clark's unwillingly bestowed acclamation. Am overjoyed.

7. Teenage dissatisfaction with own handwriting, but not so much as with the horror of teenage girls' near circular hand with a heart over the i. Buy a first fountain pen. Mr Buckley of English remarks that I press so hard on the paper when I write that he could read it on the other side with his fingertips, like Braille. It's true that the nibs of the fountain pens have a tendency to bend upwards like Arabian Nights' slippers and to divide in two under the pressure. Mortified, for a time I try to pass my pen over the paper with a featherlike touch. All too much. Handwriting becomes entirely illegible for a time.

8. At university, become entranced with the stabbing stunted verticals of my tutor E.G.W. Mackenzie's hand-

writing. Meet a boy from a very posh school with a strange posh name who is forever leaving distinguished-looking notes on my door. He explains to me about italic handwriting, which was apparently taught at his Catholic boarding school. Combination of the influence of Miss Mackenzie's violent verticals and Paul im Thurn's public-school italics produce a handwriting entirely consisting of violent downward verticals, enlivened with the occasional equilateral triangle. Fortunately modify this in time for finals, which I manage to pass.

9. Beginning PhD thesis, hand in first chapter written in ink on paper. As I was saying earlier, my supervisor, Norman Bryson, tells me to write everything on a computer in future because my first chapter makes his eyes hurt and it's not fair. The beginning of the end of handwriting.

10. 2008. A creative-writing student tells me that she is unable to carry a notebook around with her to make notes in with a pen (for overheard dialogue on buses, characteristic small pieces of behaviour among strangers) because she can't write with a pen on paper. Can't? 'It really hurts.' And, by the way, the student finds my handwriting really difficult to read, so could I give all feedback in typing? Including marginal comments? Yes, that too.

6 ~ *Witness*

'The thing about handwriting at prep school – there were really two main currents, both of them emulating one of the masters. There was the headmaster, who was a dapper, sarcastic, chain-smoking, favouritizing sort. He had extremely neat print-like writing, in which all personality seemed to be suppressed. A lot of us were rather frightened of the headmaster, and we felt this must be a good way to write, utterly neat and legible – neatness was something of a fetish. But then we had another master – F. X. Sempill – who had very beautiful . . . I suppose it was essentially italic writing, but his capitals had marvellous rococo flourishes and tails. He was a mysterious though clearly rather repressed character, and perhaps in his case the repressions were released into these curlicues. I was rather more drawn to him. You asked about the Greek E, because I wrote about it in a novel, in a passage very much based on my own prep-school experience. It's never come naturally to me, because it's difficult to incorporate into anything at all cursive, isn't it?

'There was a sense of liberation in getting away from mimicking the headmaster's boring hand. I can remember spending a lot of time writing, almost like self-imposed "lines" – just writing things out, trying out different let-

ters. There were other boys who were into doing that as well. We got quite self-conscious about handwriting. I think we had formal handwriting lessons when we first arrived at the school. I was reading very fluently at that age – I was seven and a half – though I remember there were one or two boys who could barely read. We used Marion Richardson's copybooks, which was a sort of copperplate, wasn't it? No, it wasn't. I remember there were Marion Richardson books around which we were encouraged to use. I don't think I used them myself. I said copperplate, but as you see I can't actually remember.

'The pens were quite a thing. We all had fountain pens, always cartridge pens, and the cartridges were put to all sorts of uses afterwards. One played with them, turned them into missiles of different kinds. I had a Parker at that time; some other boys had Osmiroids. We had crazes for different-coloured inks; and those biros with four different coloured inks that you could select – I gave one of those to my favourite master. He shared my birthday, so he would give me a bit of illicit tuck, and I gave him a four-colour biro to do his marking with. Mr Sempill kept different-coloured pencils behind his breast-pocket handkerchief – all very sharp, green, red and blue, to do his curlicues with.

'How did I write essays and things? I can't quite remember. It was one's own signature, of course, that one spent quite a lot of time on, and wrote on everything one owned that didn't already have a name tag on it. I loved the Elizabethan signature; I remember spending hours doing Elizabeth I, with those scrolling lines underneath. And I carried on, trying out new styles, new letters, all through big school and Oxford. I sometimes come across an old

Bodleian yellow slip in a book, you know, and I'd laboriously been writing the title of a book over and over on it, trying out different styles. By then I had friends with very cultivated, usually italic hands, so handwriting was still part of the atmosphere. And as an English graduate, of course, you had to study historic handwriting, though I don't think that affected my own.

'Some boys at school wrote revoltingly badly. I can see I was rather pleased with my own handwriting. It seemed beautiful to me, though of course when I come across it now it looks gauche and pretentious. It has simplified over the years. It's got faster. The truth is that I write by hand less and less. I always wrote all my books fully in longhand up until the last one. I wrote the first three with the same silver Sheaffer, a beautiful pen, though now all the silver's been rubbed off the barrel of it by my thumb. For the last two books I used a very good Parker I won in a *Listener* crossword competition. In fact with the latest I found myself beginning a chapter in longhand, then moving quite quickly on to the computer – something I never thought I would do. I had to send a handwritten letter to someone yesterday, and I started off quite elegantly, but after a few lines it was getting awkward and odd. I was missing out letters. Perhaps we're losing the art of writing by hand.

'I suspect I do still sometimes come to conclusions about people on the basis of their handwriting. At prep school someone had a book on, what's it called? Graphology – we came to damning conclusions about those boys who had, say, very backward-leaning handwriting. It was supposed to show they were emotionally stunted – or something – and I retain a trace of that still. There are cer-

tainly things I'm snobbish about, like circles for dots over i's, an abomination.

'The thing that I've written more than anything this year is my own name. I've signed something like four thousand copies of my new book, and during those marathon sessions one just watches one's signature disintegrate in front of one's eyes, missing out more and more letters. If I feel I've really short-changed them on the letters, I try to make up for it on the underlining.'

[Collapse of interviewer and subject].

'From my teens I've always underlined my signature – perhaps it's a tiny vestige of Elizabeth I. A graphologist would probably have an explanation for it too.

'You can know someone for years these days, and have no idea what their handwriting is like. None at all. An American boyfriend of mine sent me some photographs after I'd known him for about a year, and he added a note saying 'It struck me that you'd never seen my writing'. It was quite true, I hadn't. It must be different nowadays even in a newspaper office, I think. I was very aware of people's handwriting when I joined the *TLS*, because we were all subbing things on the page, with varying degrees of legibility. One colleague always used a very soft and usually very blunt pencil. Another had absolutely minute and obsessively neat handwriting – which took me back to childhood too, seeing how much you could get on to a piece of paper. Our sense of each other's personality in the office probably was bound up with our sense of each other's handwriting.'

Interviewer: 'What's the letter that gives you most pleasure to write?'

'Over the years, I've taken a lot of pleasure in a capital B where the top stroke sweeps back, through the ascender, and curls down behind and even under the letter. On the other hand, I'm a bit embarrassed about lower-case y's, especially at the end of the word. I never used to put a loop in the descender. But then I started doing it. I don't know why. It didn't seem really to fit in with the rest of my writing. I suppose your writing does keep evolving, and after a while degenerating, in little ways. And now I want to talk to you about secretary hand.'

A.J.H., novelist, 57

7 ~ Out of the Billiard Halls, Courtesy of Copperplate

At some point in the mid 1860s, a young man is getting off a train in the American Midwest. The miracle of the railways has made many things possible, and changed the world in unexpected ways. In Britain, only the fact of the railways has required the whole country to adopt a unified, commonly agreed time.* In America, one of the effects is that someone with a good idea can take it round the whole country, gathering disciples by the thousands. One of these good ideas is a particular model of handwriting, and, as time goes on, this one model of handwriting is being taken from place to place, gathering adherents and proponents. This is how to write, if you want to get on. The name of the man who started this wonderful movement is Platt Rogers Spencer; the gentleman who is getting off the train at a station that didn't exist three years ago must remain anonymous, one of dozens taking the Spencer gospel to new towns, hungry for modernity. I like to think of him as a young man in a sharp Chicago suit, a brown bowler, and

* Isambard Kingdom Brunel realized that there could hardly be a timetable of trains between London and Bristol if Bristol were ten minutes behind – or ahead, I forget which.

a heart full of optimism. He could just about burst into song right now. He's come to explain to the religious old sharpshooters who have just built a school here just how important it is to make the children write a proper, neat, commercial hand according to the principles of Mr P. R. Spencer; how it's going to form the clerks, lawyers, school-teachers and clergymen of the future, and bring aspiration to the fine, upstanding young men and women of the new high school at Dead Man's Gulch. The apostrophe on the sign is younger than the town: perhaps only the same age as the railway station. Tonight, after explaining the Spencerian principles, he'll dine off pork and beans in the three-bedroom boarding house, wash his smalls in the shaving bowl on the dresser in his lodgings. Tomorrow, feeling slightly damp about the nethers, he'll board the train for the next new settlement.

The copperplate hand survived an extraordinary length of time, considering its many disadvantages to writer and reader. Its fundamental problem is that it takes a style of engraving, not of writing, as its model. Its origin is the engraved lettering which printing could deliver – hence copperplate, engraved on a metal plate. Though it reached its zenith with the evangelical proposals of the nineteenth-century writing masters, it was still going strong in individual hands in the second half of the twentieth century. Even now, it possesses some residual force. Copperplate, or roundhand, emerges triumphant in the eighteenth century. It married two things that the century was rather keen on. In the first place, it was relatively legible, and its flowing movement meant it could (in theory) be written swiftly. Just discernible in the bills of

A bill of lading from 1805.

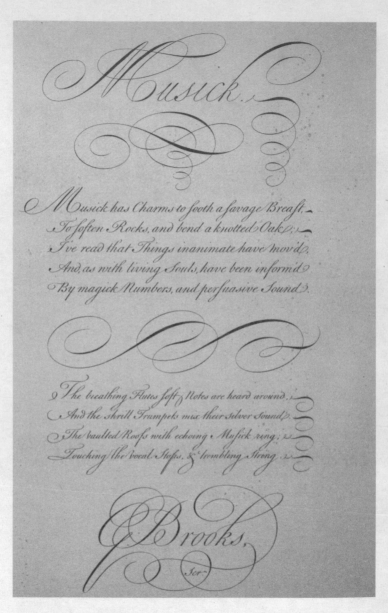

An example of copperplate from George Bickham's
The Universal Penman, 1743.

lading that survive from the period is some sort of commercial imperative, to get things done neatly, get them done quickly, and get things done correctly.

But, at the same time, there is the aesthetic appeal of copperplate, which is of course much more obvious to us. The instructors in penmanship who arose with copperplate, such as George Bickham's *The Universal Penman* of 1743, are interested in producing a functional, legible hand, but just as much in teaching pupils how to produce highly elaborate exercises in display. Most obviously, Bickham's examples pullulate with ornamental borders, as the pen spirals off onto the edges to create a bouquet of flowers or abstract patterns.

The letterforms enabled this easily. Horizontal bars sprouted loops and arabesques; the crossbars of t's and f's look like miniature ski-slopes; ornamental turns of the pen which hardly ever seem the same twice, and which combine, entwine and then shoot off again for no very good reason.

The aspirational difference between the practical handwriting we see in private letters of the period and the 'display' handwriting with which Bickham sets down some doggerel quatrain, surrounding it with fat-faced putti with pothooks for hair, is not a unique phenomenon. Yesterday, I was watching a perspiring television chef in a competition produce a dish consisting of roasted seabass, strips of cucumber cooked *sous vide*, elderflower baignets and a lemon foam which looked rather like cuckoo spit, among other untempting components and garnishes. At the same time I was going in and out of the kitchen to give a very basic spag bol a stir or two. That enjoyment of unattainable

aspiration while practising a basic version of the art form is not a deplorable thing – I mean, it was a Wednesday night, I'd had a hard day, and at least I was cooking, so it's not like I was being a total slut or anything. The first readers of Bickham must have been something like that, enjoying the borderline absurdity of Bickham's ornamental flourishes ('studiously composed to adorn the Piece', he sternly instructs us, ticking off more worthlessly extravagant idlers in the penman trade). They probably didn't make a habit of putting a kiss-curl on every single point of a capital letter F when they wrote a letter to Aunt Margery in the country, any more than they wasted time drawing arabesque doves in the margins. Still, it was probably nice to read books like Bickham's, do it exactly once, and then conclude it would be nice to do it again some time and improve your life beyond measure, in exactly the same way that I think that one of these days I'm going to *sous-vide* a cucumber and emerge afterwards a greatly improved and more impressive human being.

Moral improvement is not exactly the first thing one thinks about when looking at pre-twentieth-century copperplate – when it is neat, it makes one think of Becky Sharp trying to get off with the Marquis of Steyne, and when rapidly executed, it has a definite Sir Mulberry Hawk unhand-me-sir air about it. But moral improvement was exactly what the systematic teachers of copperplate were after as it moved into the nineteenth century. Those who wrote books of instruction in handwriting often have what seems to us an extravagant idea of what better handwriting can achieve on its own. One writer says that he is addressing 'the young man who is accustomed to spend his evening

on the streets or in debauch in the bar-room.' Instruction in handwriting, and the establishment of 'artistic penmanship' in his life can lead to a moral transformation, too. 'Very soon' – for the student of handwriting – 'vulgar stories, bar-room scandals and billiard halls begin to lose their attractiveness.'[1] The moral was hammered home by the sententious comments the students were required to copy. One 1846 English copybook contains the smug sentence 'Poverty is commonly occasioned by misconduct.'[2] So how is this unconvincing change from drunken billiard-monger to solid citizen to be effected? Why, by looking constantly at beautiful objects such as a nice rounded o. A Paul Pastner insists that people who study handwriting, however gross, stupid or unwashed to begin with, soon 'attain such a love for beautiful forms and such a facility in producing them as to really elevate and ennoble their thoughts and lives'. A sentiment which, if I were a Victorian urchin, would persuade me to stay in the gin shop for the rest of my life, making rude marks on the billiard board with a crayon clutched in my fist.

But the nineteenth-century penmasters had examples of such moral transformations before them. In particular, the man whose work is synonymous with the spread of Moral Copperplate – upright morally, though rightward-sloping graphically – spread the word with stories of his personal redemption through handwriting. Platt Rogers Spencer, born in 1800 in America, devoted his life to spreading copperplate through schools of instruction, countrywide. His mission spread in distinctively redemptive terms. His youth seemed to be directing him towards a religious vocation, but – he never hesitated to explain – his

vocation was interrupted by a brief period of alcoholism. He gave up the sauce in his early thirties, and from time to time afterwards would emit a poem giving dire warnings of the effects of drinking on home, prospects, and, no doubt, handwriting. If I can do it, Spencer's autobiographical legend says, so can you, and he encouraged his followers not just to improve their characters through writing, but to turn their expertise into morally improving schools of their own, run something like a franchise operation.

There is a certain irony in the fact that Spencerian hand-writing, given to the multiplication of curlicues around letters for ornamental purposes, has a far from sober effect on the reader. Some American Spencerians, still operating in a clandestine-sounding manner out of Suite 5 in an office block in Mission, Kansas, declare that 'America's Golden Age of Penmanship (1850-1925) produced the most graceful forms of handwriting ever developed by Western civiliza-tion.' (Which is not true, but they'd probably have to give up and move to Mexico if they ever stopped believing it.) Unfortunately, they undermine their commitment with their logo, which renders 'Spencerian Script' with so many flourishes about the upper-case S's that you seem, like Spencer in his pre-teetotal days, to be seeing two S's where there is only one.[3] The same is true of Spencer's gigantic, hideous, hilarious tombstone ('in Evergreen Cemetery in Geneva, Ohio, nine miles from Ashtabula' an indefatigable tracker of all things Spencer tells us).[4]* It's really quite hard

* Kitty Burns Florey, *Script and Scribble*, p.71. There's a photograph of the seven-foot monolith there, if you can face it.

to tell what Spencer's initials, P.R.S. might be – they are curlicued into doubleness, and you look at these elaborate exercises, trying to focus, muttering that you really must lay off the dry sherry.

Spencer's moral crusade was conducted on two fronts. The first was a sort of mad transcendental approach to writing. He wasn't the first nineteenth-century business-man to make a profitable business out of preaching a reliance on nature and simplicity, nor would he be the last. Spencer's philosophy of the letterforms, expounded in one of those heartwarming nineteenth-century autobiographies to which people unaccountably go on preferring a Dirty Martini and a night in with a DVD box set, was that they all derived ultimately from natural objects. A necessary part of improving letterforms, therefore, was the contem-plation of Nature and God's Bounty. Now, oddly enough, obviously loony as this sounds, it's not entirely untrue. The Phoenicians, who were the first to produce an alphabet that corresponded to sounds, took an Egyptian sign for water, which does look like an emblematic rendering of waves, and called it 'mem', meaning water, and it ultimately became the M of the Roman alphabet.[5]

So, yes, there is a demonstrable link between some nat-ural forms and the letters of the alphabet, if you care to go back three thousand years or so. Spencer's ideas, however, were a good deal less historically minded than this, and a great deal more pedagogical. He would have insisted that the budding penman go to contemplate the waves crashing on the shore before writing the letter M, if it weren't so obviously inconvenient in many parts of the American Mid-west where his business expanded so successfully. Never

mind. In 'the study of Nature . . . the elements of all the letters, in ways without number, enter into the composition of countless objects fitted to delight the eyes of the beholder.' Where? Oh, well, the Spencerians insisted, you can see the straight line in sunbeams. And there are curves in clouds. And ovals in 'leaf, bud and flower, in the wave-washed pebble, and in shells that lie scattered upon the shore.'[6]

This is a charming picture of Victorians wandering the woods and the shoreline, contemplating the wondrous forms of God-shaped nature before thinking of effecting their moral improvement by writing the word 'at' (a rounded pebble, a sunbeam crossing a cloud). It makes them sound like mystic Japanese calligraphers. I don't suppose there was ever much importance attached to this part of the exercise, however. More to the point was the second aspect of Spencer's success. Spencer had a network of schools and disciples, propagating the practice of copperplate in brutally effective ways, through drills, routines, handwriting exercises of an almost military precision, and making enough money to pay for a seven-foot hand-carved tombstone with a hideous bas-relief of a signature over a quill at the end of your life, apparently. Before Spencer, penmanship was a leisured, expensive, luxurious accomplishment, like covering screens in Jane Austen, which you would undertake with a hot penmaster if you had the spare time and the money and a general sort of willingness to elope at the back of your mind. After Spencer, writing rigorously and carefully was attainable by many more people. It's unfortunate that the end result goes on being perfectly hideous, but there you are.

SPENCERS' NEW STANDARD WRITING.

ITS PRINCIPLES, PROPORTIONS, CLASSIFICATION AND ANALYSIS.

PRINCIPLES.

Main Slant, 52° 90° Connective Slant

Correct Slant for letters

Spaces, 1, 1½, 1, 2, 1

Distance between letters in words.

1 — 2 — 3 — 4 — 5 — 6 — 7

STRAIGHT LINE | RIGHT CURVE | LEFT CURVE | LOOP | DIRECT OVAL | REVERSED OVAL | CAPITAL STEM

SHORT LETTERS.

LOOP OR EXTENDED LETTERS.

SEMI-EXTENDED LETTERS.

ABBREVIATED LETTERS: USED IN BEGINNING AND ENDING WORDS. TAUGHT IN COPY-BOOK No.4 AND SUCCEEDING NUMBERS

SUGGESTION. In using these model copies, practice with a *fine* pen may be followed by practice with a smooth-pointed *coarse* pen, with profit to those who aim to learn a business style of writing.

WRITTEN BY SPENCER BROTHERS. COPYRIGHT, 1884 AND 1885, BY I.-B. T., & CO.

A Spencerian handwriting chart.

Spencer worked hard to get his material into schools across America, both business schools and teacher-training schools. He succeeded, to the extent that Spencerian copperplate became, de facto, a national style of writing. Usefully, one of his principal associates became the superintendent of public instruction for New York State. During his life and after his death, his institutions and client institutions expanded constantly, thanks to a highly energetic circle of 'Spencerian authors' constantly travelling around hawking series of textbooks. We are told that, at one point, there were no fewer than thirty-eight relations and associates busy on Spencer's behalf.[7]

The appeal of Spencer's approach was that it was unprecedentedly systematic, analysing letterforms as the combination of various Principles and Elements, demanding an exact understanding of proportion of the lengths of letters above and below The Line. It was embedded in students by means of handwriting 'drills', the whole class repeating single Elements together, advancing to the mind-numbing repetition of individual letters, and on to whole words, sentences, and even poems. These poems, as I suggested, were often used to drive home a moral lesson as well as one about the extension of the g below the baseline, or the angle of the t-bar. The surviving student workbooks of the period are filled with daunting sentences about writing well, improving your lot in life, and maintaining a proper fear of death and judgement.

These drills sound nightmarish, and enthusiasts for the Spencerian method don't make it sound any more fun by their keen comparisons with military drills. One manual, by one of Spencer's relations, says that through the

Spencerian methods, 'entire classes may soon be trained to work in concert, all the pupils beginning to write at the same moment, and executing the same letter, and portion of a letter simultaneously.'[8] What the point of such simultaneity might be, we are not told, or whether anyone afterwards could tell the difference between two handwritten copies of a sentence written with each 'portion of a letter simultaneously', and one written subsequently. It seems unlikely. The main motivation for this craze for simultaneous, drill-like endeavours must have been the same one that encouraged authorities to face the front under a single surveilling eye, to sit upright in exactly the same way, to wear exactly the same clothes, and other grim exercises in control and punitive discipline. The idea was to give the pupil an automatic muscular movement whenever a pen was held and the words 'A quick brown fox' had to be written. But the addiction to the idea of simultaneous platoons of sighing juveniles working their loops gives the game away. The real aim was control.

If you want to see how extreme the desire for control could be, there are some truly terrifying images which survive of patent devices to bind the hand into correct pen-hold. They were termed things like 'Carstairs' System' and tend to be promoted in books called things like *L'Arsenal de la Chirurgie*.[9] The idea that there was a single correct way to hold a pen doesn't sound encouraging. The nineteenth century was obsessed with such questions of correct physical bearing, from knife-holding at table onwards. ('Well, ay don't think they were ducal folk,' a lady observes somewhere in Jilly Cooper. 'Because they were holdin' their knives like pencils.') It also invented any number of patent

CARSTAIRS' SYSTEM.

devices to promote correctness and constrain the young into the required position.*

The suggestion that there is only one correct way to hold a pen, walk, cut your meat, or play the piano is a peculiarly persistent one. Personally, I break the rule by resting my pen on the joint of my fourth finger rather than, as penmasters require, on the third or (the ghastly Carstairs' requirement) just sort of running alongside the index finger without resting on anything. But then again I know precious few pianists who fulfil the parallel requirement to be

* These restrictions went on much longer than you might think. My sister, born in 1962, was subjected to deportment classes at a Kingston-upon-Thames grammar school in 1973-4 which required her to walk around a room with a book on her head – she won a prize for it, indeed.

able to play while resting a book on the flat back of the hand, and the best pianist I know plays by sort of flopping his fingers onto the keyboard in a way which would appal Fanny Waterman. The patent devices invented to constrain and control the body in different ways must have ruined many more hands and other things than it guided to perfection. The best-known victim of such devices was the composer Robert Schumann, whose early promise as a concert pianist was brought to an end by his investment in a quack's hand-restricting device. But there must have been many more whose ability to write was actually damaged by such horrible devices as the Edwardian 'Write-True' Finger Guide and Pen-Rest and Carstairs' System, just as endless Edwardian women found their internal organs mashed into each other by the stays and corsets of the period. The aim, as I say, was control and restriction.

The spread of writing schools happened because copperplate was no longer a leisured, artistic activity, but a crucial way in which people should learn to communicate for practical, business purposes. One nineteenth-century handwriting textbook insists on its importance, indeed, to the less-leisured classes, saying 'To persons in the lower and middle ranks of life a good and rapid style is of special importance as legible writing quickly executed is in constant requisition in all trades and businesses.'[10] Here, we see an important principle of handwriting emerging for the first time – legible writing quickly executed. Almost every writer on handwriting since the late-nineteenth century has puzzled over the balance between speed of execution, and legibility of the result. On the whole, teachers will tell you, there is a trade-off. The faster the handwriting,

the less legible the result; the more care that is taken over legibility, the slower the execution.

Once this idea had taken root, copperplate in its Spencerian form was doomed. Spencer's principles of discipline, practical application, speed and fluency were good enough in the abstract. They had succeeded, at least, in doing away with an idea of handwriting which was going to find it necessary to scribble a pair of doves in the margin.* But those principles ought, as well, to have done away with the idea of a capital T with a camp little curl to the left, like a teapot. Whichever way you looked at it, those ornamental loops and curlicues were not a very good idea. They slowed down the execution, but without improving legibility; indeed, they made the handwriting less legible, but without allowing the writer to speed up. Something had to be done, and something soon would be.

We have to deduce most of the process of imbuing students with copperplate from surviving workbooks of students and from copybooks from which students could work on their own. One rare practical work on the teaching of handwriting from the copperplate age in England survives, and has been examined by the handwriting expert Rosemary Sassoon. Henry Gordon's *Handwriting and How To Teach It* has less of a Bismarckian spirit than Spencer's major-generals, stalking round the Midwest press-ganging the young into joyless drills. He was strongly against simultaneous writing of exercises in a set

* Now I think of it, Mrs Clark of 2Cl might have been a closet Bickhamite, though my marginal ducks were never going to satisfy her, artistically.

The Cat.

Here is a nice old cat
She has a kit in her
mouth She will not
hurt it. Oh no, but
she will take it to
a safe place and
hide it. If puss were
to see a mouse she
would catch it and
eat it very quickly

An example from Henry Gordon's *Handwriting and How To Teach It.*

time, which would bore the practised students and do nothing for the slapdash ones; he was shocked at the idea of speaking to a pupil who had made a mistake 'in a fault-finding tone'; he said that handwriting exercises should never be used as a punishment; and if he supports the idea of 'constant supervision', the sense of his work is less of a single terrifying Spencerian eye at the front of the class than of a kindly fellow going round and helpfully pointing out where things could be individually improved. 'What an excellent teacher Gordon must have been,' Sassoon remarks, accurately.[11]

But you only have to look at Gordon's models to see that improvement in both legibility and ease of writing could not be far away. He provides two entire lower-case alphabets, one 'looped' and the other 'unlooped'.* His capital H, I am sorry to say, is a demonstration of sheer madness, the four corners of the letter having four completely different terminations – from top left clockwise, a hammocky squiggle, a little rightward loop, a rising link and a fat leftward loop like a cushion. I mean, I'm all for baroque in its place,† but it does no good to pretend that the eventual mastery of these intricate flourishes does anything for legibility, efficiency, grace or attractiveness of the final result.

* Definition: a 'looped' alphabet would return along a different path in the upper portions, or ascenders, of the lower-case letters b, d, h, k, l, t, and the lower portions, or descenders, of the letters g, j, p, q, y, and both ascenders and descenders of the letter f, thus forming an enclosed loop. An unlooped letter will either return along the same path, forming a line, or will just go one way.

† Dresden.

Nevertheless, copperplate survived for an extraordinarily long time, and still remains present in our minds, I suspect, when the word 'handwriting' is pronounced in approving tones. In 1958, a Survey of Handwriting was published by Reginald Piggott, an adherent of the italic writing style. Many attempts were made to spread italic beyond a small and largely public-school coterie, so that the whole population would, sooner or later, write in this beautiful style. The approach of Piggott, however, was different. He placed advertisements in the press, and solicited examples of handwriting of every type, from all sections of society. His attempt may have been to draw attention to the corruption of handwriting, and to suggest a universal cure in the sloping nib and elegant alternation of thick and thin in italic. Certainly, the last pages of his book are an arid confection of instructions and aestheticism, which anyone, even at the time, could have seen would never come to anything much.

But the fascination of the Survey is in the body of the book. Piggott collected hundreds of examples of handwriting, and categorized them confidently. His categories are not quite ours. He doesn't find a place for two of the most common and useful handwriting styles of his time: A.N. Palmer's commercial hand, which was the most widely taught technique in America at that time, and Marion Richardson's sensible, rather round letterforms – we will come to these two shortly.

Most of the people who supplied Piggott with examples were people who had good reason to be proud of their handwriting. It seems likely that he seriously overestimated the incidence of italic writing in the population at the time, and many quite exhausting pages are filled with boys writing in

from public schools to show off the beauty of their italic style. There is, too, a high incidence of people with what, in the 1950s, would have been very old-fashioned copperplate, or its derivative, 'Civil Service Hand', as Piggott calls it. Victorian styles survived in all sorts of ways much longer than any of us think. It is tempting to envisage the 1950s as a decade in which everyone from the Queen downwards wore a beehive and giant jazz-coloured skirts or teddy-boy outfits and duck's-arse haircuts, according to gender.* Not everyone had festival-of-Britain printed curtains. Quite a lot of people went on wearing exactly what they had always worn, among the furniture which their parents had bequeathed them. You only have to think of people like Dame Ivy Compton-Burnett, living on into the very end of the 1960s with an unmodified Edwardian wardrobe, amid bleak Georgian furniture, to see that life for many people did not change greatly with the turn of each decade.

To look at some of Piggott's copperplate examples is to imagine them being written by Mrs Lopsided in *The Lady-killers*, who sees off all the bank-robbers who are trying to do her in. Actually, that image of survival isn't so inappropriate. Though they may look like the handwriting of some dear old lady preserving the handwriting of a Victorian childhood, in fact some of Piggott's copperplate examples were written by busy commercial men in their thirties. Why did this antique hand survive so long and with such appeal? Why is it copperplate that we tend to think of when we think of 'fine handwriting'?

* Sometimes. The DA was quite big among the bolder sort of lesbian in Notting Hill clubs, I'm reliably informed.

Copperplate still surrounds us at various moments, unlike many historical styles. It is pretty unlikely that you are going to come across an example of an uncial hand today – the style which introduced lower-case letters to the Roman world, which has a faint scent of incense about it, and looks like this:

Uncial hand

Similarly, the only way in which you are going to come across a black-letter script is in print rather than handwriting. There are probably two calligraphers in Munich who are still capable of writing black-letter. But for the rest of it, it would only surface if a harassed copywriter at an advertising agency was presented with a monk-brewed beer, and couldn't really think of anything better to do with it than reach for the drop-down menu to write:

Buy Our Monk-Flavoured Beer With Bits In It. It's Delicious (ish).

(Interestingly, this sort of thing is referred to by computer programmes as 'Old English', like a dog, rather than 'Gothic', which has been long taken up for a completely different and non-Gothic font, or black-letter, which they have clearly never heard of, confirming our impression that computer programmes just don't know what they're talking about.) But copperplate is the hand we reach for at elevated moments of our lives, whether printed in a simulacrum of a hand –

Mr and Mrs Edward Boffin
Unwillingly invite you to the wedding of
Their Pregnant Daughter
Ethel
To the Worthless Wretch Who Did the Deed

Or, of course, if we're extremely rich and show-offish, we may even stretch to paying a professional calligrapher to write wedding invitations to every one of our 250 Beverley Hills friends, in, of course, professional copperplate. (You are not going to shell out to see a calligrapher indulge his admiration of Marion Richardson's school-room hand).

It has an odd knack of surfacing in the most peculiar places. I am reminded by Kitty Burns Florey, in her enjoyable book on the rise and fall of handwriting,[12] that one of the most commonly seen uses of copperplate these days is in the Coca-Cola logo.

Looking at that logo as a surviving example of copperplate, something rather odd emerges. It contains two uppercase C's, but if you look at each of them, they are not just different in the way they are extended – the first one at the bottom, the second at the top – but in the way they are formed. The first upper-case C is made by moving downwards from the top of the letter; the second from the bottom upwards, and then along the top of the word 'Cola' and through the loop of the l.

No doubt the complexity of the writing evolved, in this case, in order to make it more difficult for imitators and fraudsters to copy. But isn't there something strange about a style of writing where a single letter, in the same position, preceding the same letter, can be written in two completely different ways? Even if it's done with deliberate perversity, for commercial reasons, isn't there something strange about a hand which can encompass such random variations in the ways the letters are formed? In the end, the practical eye is going to conclude that copperplate is unnecessarily elaborate, and, moreover, really quite ugly. A style which seems to allow you to alter the way the form is made from one word to the next according to idle whim, as in the Coca-Cola logo, offends against taste, habit, good manners and good looks. Someone was going to have a better idea.

7 ~ *Vere Foster and A.N. Palmer*

One of the most successful of these better ideas in the UK was inspired by Lord Palmerston, the great Foreign Secretary and Prime Minister.* Palmerston, in the course of a busy life, found time to concern himself with handwriting, and said once very strongly that 'Children should be taught to write a large hand and to form each letter well, instead of using fine upstrokes and firm downstrokes that looked like an area railing, a little lying on one side.'† The object of Palmerston's theory was a friend called Vere Foster, who took the instruction seriously. He produced a series of copybooks which were put into immediate circulation, and survived in British schools for the best part of a century.

Vere Foster firmly believed that traditional copperplate, as specified by penmasters like George Bickham, was pur-

* Queen Victoria detested him, partly because he once burst into the bedroom of one of her ladies-in-waiting in the unfulfilled hope of seducing the poor girl.

† Palmerston must be classed with Churchill as the only two prime ministers with any gift at all for metaphor – Churchill, who once described the meeting of minds on the appointment of a particularly saturnine individual to the Treasury as Chancellor of the Exchequer as resembling the joyous reunion of two long-separated kindred lizards.

A page of exercises from a Vere Foster copybook.

suing an impossible aim. Foster preferred to take 'real free writing' as his model. His copybooks look very artificial to us now, but there was a strong, idealistic, simplifying spirit behind them, which took public service as its goal, and the furthering of the *carrière ouverte aux talents* as a good beyond questioning.

The age that produced Vere Foster also produced the Northcote Trevelyan reform of the Civil Service. In 1857, Dickens had published a novel, *Little Dorrit*, which contained a savage satire on the conduct of public life – the Circumlocution Office, staffed, it appears, solely by offshoots of the Tite Barnacle family. Unexpectedly, *Little*

Dorrit was the best-selling of all Dickens's novels in his lifetime: there was clearly something in the air.

Vere Foster's copybooks are a minor, but very interesting, contribution to the vast reform and opening up of public service, and the slow movement towards universal education, from where a boy from the humblest background could (ideally) become a responsible public servant. Northcote Trevelyan utterly transformed the British civil service, away from the values of patronage and idleness which *Little Dorrit* so powerfully portrays. The system that would serve the values of competitive examinations and the reward of merit, regardless of connections, was slower to emerge. But one of the key components of this was a system that would teach children how to write legibly and competently. Vere Foster was ideally placed to deliver this. By 1870, written tests for copy boys and clerks were introduced into the civil service. Before long, the requirements of Vere Foster were being identified as 'civil service hands', a term which seems, as late as Reginald Piggott's Survey of 1958, to need no explanation.

In America, the next stage of handwriting to emerge came from a very similar place to Spencer's chain of franchised disciples. In some ways, the appearance of the results is similar. But the originators of the style of writing thought of themselves as modernistic, simplifying, clarifiers. They regarded the copperplate style as ornate and outdated. Away with it!

Unlike Vere Foster, whose aim became identified as the public service, his American counterparts focussed on the practice of business, commerce, and independent-minded moneymaking. From the 1890s onwards, the American pen-

You go up, and I go down. Take care, and hold fast while you are up in the air. See-saw! Up and down. Arthur Leslie Lockwood. November 18th 1893

Civil Service hand, by a writer aged six.

man A.N. Palmer worked through the well-established methods of business colleges, lectures, and correspondence courses. It was the golden age of salesmanship, of aspiration, of getting by and getting on, and one thinks of Herbie in the Jule Styne musical *Gypsy*, going from town to town with a pocket full of badges attesting membership of various business societies, declaring himself an Elk or an Oddfellow, as opportunity presented itself.

Between the 1890s, when Palmer published his first manual, *Palmer's Guide to Business Writing** and the 1910s,

* Had people heard of him already by then? Or was Palmer just the sort of man who would always include his name in the title of his first book? My dad used to play the French horn in a wind band called the

Palmer's simplified and rapid methods took over American handwriting schooling, and produced a completely new style. In some respects, the style remains in place to this day, despite the last Palmer school having gone bankrupt in the 1980s. If the Spencer style remains the admired ancestor of American handwriting, the Palmer manner and its direct offshoots remain a living presence as an idea of good handwriting for many Americans. When we English think of an American handwriting, with the loops and efficient forward dynamism – like the example shown opposite – it's Palmer we're thinking of.

Palmer's aim, like Spencer's, was efficiency in a business world. The demands of business had increased enormously since Spencer's day, which now seemed the product of a more leisured age. It is the story of handwriting since the dawn of time. Florentine scribes in the Medici counting houses in the sixteenth century had no time to be writing uncial hands, and took to what we call italic; copperplate was a more efficient way of writing than before; and we don't have time to be writing in taught hands, so we've given up altogether. In Palmer's case, he assured his readers that an elaborate copperplate hand takes time to produce, and cannot be speeded up. Whatever its legibility for the reader, it does not enable the writer to work with rapidity. The new writing style would be plain and legible, and also rapid. Its proponents liked the idea of 'real, live, usable,

Lucas Wind Ensemble, named after the conductor, a man named Lucas, who was well-known for having named his own wind ensemble after himself, a man, as I say, called Lucas.

Store Phone - (CR. 56035)
M. Cohen 8512 St. Monica
 " 515 Marino Dr -
Jack Gordon 811 N. Van Ness
James Titley 1516 Murry Circle
 7278 Holey Blvd
Cad Sed 658-804 - 4/5A-405
Valey Gardens Inc.
Al. Perlson 325 W 8th St. Ma. 7801
Lawrence M. Rummons 325 W 8th St.
Shirley Cowan 4171 Elmer St.
Oxnard & Keller 1485 Oxnard
South west cor.
Anthony Amatuzio, 14578 Dickens
Sherman oaks
Barney Rubins 5600 Van Nuys -
Frank Sinatta.
Al K Shapario
Charles McDonald
Brownies Bookshop
2307 Brooklyn Ave
Phone An - 0212

The 1950s notebook of LAPD Sergeant Con Keeler.
The names and addresses of notorious gangsters –
including Mickey Cohen – can be seen.

legible and salable penmanship' which would be 'no more beautiful than is consistent with utility.'[1]

The new style aimed to get it down quickly. It was a handwriting for the Gilded Age, when elevators were enabling the construction of buildings in Kansas City fifteen storeys high* and the full potential of speed was being realized in all sorts of ways. As Palmer's potential for speed was being realized, the first automobiles would be seen on the roads; during the rise of the style, 'Jacky' Fisher, the British First Sea Lord, would be commissioning and building a whole new fleet of warships of incredible velocity and ferocity; before Palmer's principles triumphed, men would take to the skies.† Efficiency, speed, ugly clarity and consistency: that was the future of writing.

With the same clarity of application that he expected

* *Oklahoma!* I don't know whether the Spencerian society can see these skyscrapers from their suite, or indeed whether the buildings that so impressed the visiting Curly still stand.

† In rather a different area, the aging Henry James gave up handwriting altogether, and took to dictating his novels – a shift in efficiency which enabled him to write his last three novels, *The Ambassadors*, *The Wings of the Dove* and *The Golden Bowl*, in successive years, 1902, 1903, 1904. We don't think of Henry James as an epitome of speed, rather as H.G. Wells's caricature in *Boon*, an elephant struggling to pick up a pea with his forelegs, but the feat of writing the three most involved novels in the language so rapidly surely stands with the internal combustion engine and the Wright Brothers' invention as a sign of the period's devotion to efficient speed. James scholars disagree about the moment when he took to dictation, but most people think it was at some point during *What Maisie Knew* – the madder sort of Jamesian will identify the exact chapter for you on stylistic grounds.

from his pupils, Palmer produced some pseudo-scientific truths and some truly gruelling exercises to enable the student to enter into his prescribed style. Far more than any previous handwriting entrepreneur, he examined the movements necessary to writing. He concluded that handwriting was an athletic activity, which involved much more than the hand.

It became an item of faith with Palmer that good handwriting was produced with movements of the whole arm. The use of the whole arm would avoid writers' cramp, and enable us all to go on working late into the evening tirelessly. Palmer talked in terms of blood and muscle, rather than pebbles and petals and waves, seeming to think of a physical movement – from the brain, down the neck, across the muscles of the shoulder, down the muscles of the arm, and then through the hand (basically unmoving) and fingers, and down the pen, as if the ink reservoir were just a continuation of the body's arteries. He spoke of handwriting, not emerging from the nib, but 'operating along the muscles of the arm.'[2]

Posture was dictated in extraordinary detail by Palmer and his successors. As late as 2000, we hear of an elementary school teacher in Detroit saying, 'Where do your feet go when we do D'Nealian?* Flat on the floor, that's right.'[3] Probably you write as I do, with the movements of the body not extending much further up the arm than the wrist. Palmer was certainly correct, that the small movements of the hand are tiring, and, much repeated, might

* A derivative of Palmer's methods.

even be damaging. Such grim effects as carpal tunnel syndrome hit inefficient handwriters, pianists and those who write on laptops, with the characteristic tiny movements of the hand – old-fashioned typewriters are much better for you, demanding much larger hand movements.* I've written the last three pages by hand, and I can feel an ominous tightening and ache on the inside of the wrist, and at the bottom joint of my little finger where it curls under and makes a cushion for the biro.

Try Palmer's whole arm movement, and it does feel refreshing to write from the shoulder, even without trying to imitate his letterforms. It has some curious effects on your writing, however. I immediately find that my handwriting gets bigger, for instance. I press much less hard on the paper, and the tip of the pen glides across the page. Interestingly, it becomes much less natural to lift the pen in the middle of words, or even between them. If I write the word 'unimportantly' in my usual handwriting, it comes out like this – *U ni mpor tant ly* – four breaks in one word:

If I try to write it from the shoulder, my whole arm moving, it comes out very readily in one movement, every

* I developed it after writing a 300,000 word novel by hand, with inefficient and un-Palmerian movements, and then rewriting it from beginning to end, twice, on a laptop, between 2003 and 2007.

letter joined together. Weirdly, without attempting to imitate Palmer's letterforms at all, my handwriting has, in an independent-minded way, developed some of the same characteristics. There is suddenly a bold loop under the p, where it normally just drops and stops. The y at the end, amazingly, just seems to find it perfectly natural to loop and close, in rather an extravagant way. Those loops and joins in Palmer's style of writing which seem so anti-functional to us, so at odds with Palmer's message of pared-down efficiency, are in fact serving an efficient end. The name of that end is whole-arm movement.

unimportantly

Palmer's teaching methods seem decidedly strange to us, but hundreds of schools stuck with it for decades. There was the devotion to pre-writing shape-making – students were meant to sit for hours making repeated ovals, looping and looping, and to devote as much energy as they could spare to what Palmer called 'push-pull' exercises, confronting the fundamental problem of handwriting, that sometimes the writer has to pull the pen across the page, and sometimes laboriously push it. The idea was that after you had done this for long enough, your arm would possess a sort of memory of its own. It would be basically impossible to make anything but the correct shape when you wrote, and impossible to grow tired while writing. We have the word of a large number of Palmer students, however,

that as soon as the teacher turned his back, it was much more natural to produce a sort of stab at the Palmer letter shapes without moving anything higher than the wrist. Once Palmer's methods had started to decline in popularity, the faults of the system started to become obvious. One 1940s graphologist, who perhaps had his own professional reasons for disliking a system which suppressed personality and imposed a military-style correctness on handwriting, wrote that 'Adults still remember [Palmer's] penmanship lessons as a source of acute discomfort and frustration. Even with such drills, Palmer's remains a tiring and slow method of writing. It is tiring and slow because it does not permit the writing hand to relax its muscles . . . And this slowness is furthered through an abundance of superfluous and left-tending strokes, of sudden changes in direction, of counterstrokes, and of elaborate, though useless and time-consuming finals.'[4]*

From our perspective, there is one thing extremely odd about every one of these proposals to shape the hand-writing. They start from the very first day, insisting that children should learn to write by joining up the letters and writing whole words. Cursive handwriting is not only the goal for Palmer, Vere Foster, Bickham and Spencer: it is the only way anyone could ever be permitted to begin to write. Change was brewing.

* By 'finals' the author means those elaborate flourishes which, even in Palmer, conclude a word with a little kick in the air, to no very obvious purpose. It's striking that many efficient writers in Palmer cursive have a decided tendency to link one word to the next, encouraged by these elaborate finals.

9 ~ *Dickens*

If you look at a page of Dickens's writing, the overpower-
ing impression is one of energy and fury – it is one of the
great unreadable nineteenth-century handwritings. But his
early training as a parliamentary reporter ought to have
given him a solid hand. Instead, what it gave him was a
consistent interest in the possibilities of handwriting – the
human dimension – which crops up in marginal, significant
ways all through the novels.

It's surprising how often the act of writing, of forming
letters, acts as an impetus for the plot in the great Dickens
novels. The action of *Bleak House* kicks off when Lady
Dedlock, bored, notices an unusual hand in an official
document. It is the unusual hand, it ultimately transpires,
of her lover, Captain Hawdon. The villainous solicitor,
Tulkinghorn, notices her interest, and makes it his business
to track down the scribe who wrote it. '"There was one
of them,' says Mr Tulkinghorn, carelessly feeling – tight,
unopenable oyster of the old school! – in the wrong coat-
pocket, 'the handwriting of which is peculiar, and I rather
like.'" It is a variety of the legal hand known as Chancery,
which survived for hundreds of years in specialized prac-
tice after it dropped out of ordinary use in the early
seventeenth century. We know, through another narrator,

that the style is 'law-hand, like the papers I had seen in Kenge and Carboy's office and the letters I had so long received from the firm. Among them was one, in the same writing, having nothing to do with the business of the shop, but announcing that a respectable man aged forty-five wanted engrossing or copying to execute with neatness and dispatch: Address to Nemo, care of Mr Krook, within.'

Law-hand, which is what Captain Hawdon writes, and which draws him to the attention of Lady Dedlock, was an exotic intrusion into ordinary reality in Dickens's time. It had more or less disappeared from ordinary writing by the seventeenth century, surviving only for special legal purposes. Already, in *The Pickwick Papers*, we have the barrister's clerk who justifies the bizarre style by saying 'The best of it is, that as nobody alive except myself can read the serjeant's writing, they [the plaintiffs] are obliged to wait for his opinions, when he has given them, till I have copied 'em, ha-ha-ha!' Much later, in *David Copperfield*, Traddles's adorable wife surprises David by learning law-hand to help him in his practice.

> 'What do you say to that writing, Copperfield?'
> 'It's extraordinarily legal and formal,' said I. 'I don't think I ever saw such a stiff hand.'
> 'Not like a lady's hand, is it?' said Traddles.
> 'A lady's!' I said. 'Bricks and mortar are more like a lady's hand!'

Dickens, like many people, believed firmly in the difference between male and female hands. Guppy asks Jobling in *Bleak House* whether a piece of writing by Lady Dedlock 'was a man's writing or a woman's?': 'A woman's. Fifty to

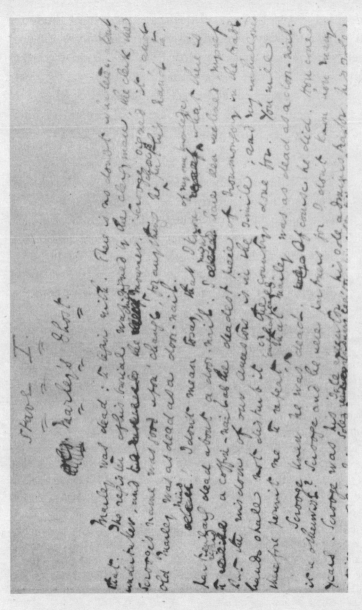

A handwritten page from *A Christmas Carol*.

one a lady's – slopes a good deal, and the end of the letter "n" long and hasty.' An old observation, but a specific one: there's no reason to think that Dickens would have disagreed with Jobling's professional analysis.*

There are professional writers at the one end, who write in a way peculiar to a sort of priestly caste, and at the other, ordinary people, who cannot write, or who struggle with the task.

> Sam Weller sat himself down in a box near the stove, and pulled out the sheet of gilt-edged letter-paper, and the hard-nibbed pen. Then looking carefully at the pen to see that there were no hairs in it, and dusting down the table, so that there might be no crumbs of bread under the paper, Sam tucked up the cuffs of his coat, squared his elbows, and composed himself to write.†
>
> To ladies and gentlemen who are not in the habit of devoting themselves practically to the science of penmanship, writing a letter is no very easy task; it being

* At least as old as Swift's amusing but rather offensive comment in *Gulliver's Travels* about the writing of the Lilliputians: 'Their manner of writing is very peculiar, being neither from the left to the right, like the *Europeans*; nor from the right to the left like the *Arabians*; nor from up to down, like the *Chinese*; nor from down to up, like the *Cascagians*; but aslant from one Corner of the Paper to the other, like Ladies in *England*.' (*Gulliver's Travels*, Book 1, Chapter 6.)

† I love Dickens's exactness of physical observation. This motion of a nervous writer is as beautifully seen as the moment in *David Copperfield*, praised by Claire Tomalin, when David, trying to gain the attention of the woman he knows is his aunt, Betsey Trotwood, lays a timid finger on her forearm.

always considered necessary in such cases for the writer to recline his head on his left arm, so as to place his eyes as nearly as possible on a level with the paper, and, while glancing sideways at the letters he is constructing, to form with his tongue imaginary characters to correspond. These motions, although unquestionably of the greatest assistance to original composition, retard in some degree the progress of the writer . . .*

The gap between absurd expertise on the part of some characters, and the struggle to write anything at all on others, comes up repeatedly. In *Nicholas Nickleby* Nicholas brings 'no greater amount of previous knowledge to the subject [of penmanship] than certain dim recollections of two or three very long sums entered into a ciphering book at school, and relieved for parental inspection by the effigy of a fat swan tastefully flourished by the writing-master's own hand . . .'† Just how ineffectual a style this is, in Dickens's view, is shown by a slightly poisonous comparison with the way Old Dorrit talks – 'he surrounded the subject with flourishes, as writing-masters embellish copy-books and ciphering-books; where the titles of the elementary rules of arithmetic diverge into swans, eagles,

* Again, the exactness of observation. I had a student in a class – not a very brilliant one – only last week who, taking notes, rested the side of her head on the table, the better to push her pen across the page.

† That was probably what happened to the style propagated by Bickham in the end – elaborate pen fantasies, indulged to impress credulous parents by terrible schools.

griffins and other calligraphic recreations, and where the capital letters go out of their minds and bodies into ecstasies of pen and ink.' In *Nicholas Nickleby*, another writing master 'touched up' Kate Nickleby's letters from school 'with a magnifying glass and a silver pen; at least I think they wrote them, though Kate was never quite certain about that, because she didn't know the handwriting of hers again.' If a writer has never benefited from one of these absurd instructors, it is possible that people might simply not be able to say what they think. Newman Noggs writes to Nicholas, and Nicholas reacts to his handwriting: '"Dear me!" said Nicholas. "'What an extraordinary hand!" It was directed to himself, was written upon very dirty paper, and in such cramped and crippled writing as to be almost illegible."

Only occasionally does the instruction in writing seem reasonable. There is a lovely vignette of a writing lesson in *The Old Curiosity Shop*, in a schoolroom where 'the great ornaments of the walls were certain moral sentences fairly copied in good round text . . .'

> 'That's beautiful writing, my dear.'
> 'Very, sir,' replied the child modestly. 'Is it yours?'
> 'Mine!' he returned, taking out his spectacles and putting them on, to have a better view of the triumphs so dear to his heart. 'I couldn't write like that, now-a-days.'

George Orwell said, vis-à-vis Dr Strong's academy in *David Copperfield*, that Dickens couldn't imagine what a good education might be like. How false that is is shown by a rare and specific account of a writing lesson in *The Old*

Curiosity Shop. It's a sort of vision of child-centred education that still seemed radical eighty years later, when Marion Richardson was starting out.

> Writing time began, and there being but one desk and that the master's, each boy sat at it in turn and laboured at his crooked copy, while the master walked about. This was a quieter time; for he would come and look over the writer's shoulder, and tell him mildly to observe how such a letter was turned in such a copy on the wall, praise such an upstroke here and such a down-stroke there, and bid him take it for his model.

More common is the beautifully sordid glimpse in *Little Dorrit* of the impoverished Professor of Writing who lives upstairs in Bleeding Heart Yard, who 'enlivens the garden railings with glass-cases containing choice examples of what his pupils had been before six lessons and while the whole of his young family shook the table, and what they had become after six lessons when the young family was under restraint.'

Not just the act of writing, but styles of writing, act as little time-bombs in Dickens, often connected to self-improvement and ultimate social isolation. When the young Pip, in *Great Expectations*, writes his first letter to his brother-in-law Joe on a slate, he is starting on a path which will threaten to separate them for ever. 'MI DEER JO i OPE U R KR WITE WELL i OPE i SHAL SON B HABELL 4 2 TEEDGE U JO AN THEN WE SHORL B SO GLODD . . .'

Writing takes Little Em'ly, in *David Copperfield* on the path out of her class; when she is a girl, her ability awes her relations in that upturned boat – '"Her learning!" said

Ham. "Her writing!" said Mr Peggotty. "Why, it's as black as jet! And so large it is, you might see it anywhere!'" We smile at the way simple people think of a good hand. But much later, when she has disappeared, and has been ruined for ever, it is her handwriting, again, that breaks Dan's heart. 'She tried to hide her writing, but she couldn't hide it from Me!' On the other hand, the mastery of hand-writing can offer a way out of a terrible situation. The orphan Charley, in *Bleak House*, is taught to write by Esther, and like Sam Weller,

> she seemed to have no natural power over a pen, but in whose hand every pen appeared to become per-versely animated, and to go wrong and crooked, and to stop, and splash, and sidle into corners like a saddle-donkey. It was very odd to see what old letters Charley's young hand had made, they so wrinkled and shrivelled, and tottering, it so plump and round . . .
>
> 'Well, Charley,' said I looking over a copy of the letter O in which it was represented as square, trian-gular, pear-shaped and collapsed in all kinds of ways, 'we are improving. If we only get to make it round, we shall be perfect, Charley.'*

We can see the same sort of passionate aspiration implicit in a handwriting when Lizzy Hexham's brother, also called Charley, turns up at the Veneering's dinner, and his hand-writing surprises the gentry. 'His voice was hoarse and

* But who, in the whole of the nineteenth century, ever made their o round? It is always an elongated leaning egg-shape.

coarse; but he was cleaner than other boys of his type; and his writing, though large and round, was good; and he glanced at the backs of the books, with an awakened curiosity that went below the binding. No one who can read, ever looks at a book, even unopened on a shelf, like one who cannot.'

Usually, in Dickens, a characteristic handwriting displays a social condition. Only rarely does an observation seem to bear upon a character apart from that. Mrs Clennam, in *Little Dorrit* has 'maimed writing', probably through illness. There is something retrospectively horrifying about Merdle's suicide note being dashed off in pencil – the busy man of business, even in extremis, reaching for the nearest, inadequate writing implement. The pencil is often a harbinger of horror, like the horrible letter in *Our Mutual Friend* which 'was scrawled in pencil uphill and downhill and round crooked corners, ran thus: OLD RIAH, Your accounts being all squared, go. Shut up the place, turn out directly, and send me the key by bearer. You are an unthankful dog of a Jew. Get out. F'.

Dickens was the greatest observer of the human condition, and keenly aware of what people make of themselves, and what people might make of themselves, if society were not in the way. I've looked at some of the ways in which handwriting comes into his books, precisely because he never really focussed on it as a subject. It is just something that it is there. Probably no one in the nineteenth century is a better witness of how handwriting might be an agent for change, and Charley Hexham, with his excellent handwriting and his booklover's gaze, was exactly the sort of person to benefit from Northcote Trevelyan and the Vere

Foster revisions. If he had been born thirty years later, Sam Weller, writing with his head on the desk with his tongue out, would have been one of those persons, too, rather than stuck as the valet to a fat idiot called Pickwick.

10 ~ Print and Manuscript and Ball and Stick

If you think back to how you were taught handwriting, it almost certainly followed a path where, like me, you looked forward to being allowed to do 'joined-up writing', or cursive, as we should call it. You were taught to write with single letters at the beginning – capitals and lower case. Then, when that had been thoroughly mastered, you were introduced to the joys of joining your letters together. This is the process recorded by Geoffrey Willans and Ronald Searle in their immortal masterpiece *How To Be Topp*. Molesworth, the schoolboy hero, says:

New bugs often canot write xcept this way:

However miss pringle soon lick them into shape. She get out her gat and sa: You may look like a lot of new-born babes in yore first grey shorts but it won't wash with me. I am going to hav it MY way. O.K. let's go. All the gifts of sno-drops, aples sweets and ginger

biskits do not alter her iron purpose. Before long a
new bug can do in his copy-book

The cate sat on

And finally

The love of the poets is a ting apart

He is now in the same spot as the rest of us he have
to write home on Sunda.[1]

Despite Molesworth's cynical eye, a very good system is
outlined here, introducing children to processes of writing
one after the other, and advancing at a steady pace. It seems
almost incredible that it was not until the twentieth cen-
tury that it occurred to anyone that beginning writers
might start by outlining individual letters – to print the let-
ters. When the radical change occurred, in the way of such
things, it quickly spawned a fundamentalist movement that
proposed to change handwriting forever, universally.

One of the most familiar and beautiful printing fonts
ever created is the sans serif font made for the Lon-
don Underground during the First World War. Edward
Johnston, who taught Eric Gill, was commissioned by
the Underground Electric Railways Company of London
to create a typeface. Johnston Sans was in use by 1916.

Instantly recognizable, it belongs to that rare historical moment when simplification and the shedding of the inessential led, not to anonymity, but to a richer and more resonant character. The early twentieth century was full of such moments, from Hemingway's stripped-back prose to the house by Walter Gropius in Vienna that the Emperor complained 'had no eyebrows'. It's very pleasing that the same person who was responsible for the sans serif Underground font, decades earlier, was at the beginning of the movement that would introduce the idea of writing individual letters without joins.

Edward Johnston was a remarkable man, a calligrapher and designer who thought things through from the beginning. When he was asked, in 1906, to suggest improvements to the London educational system of teaching children to write, he replied promptly that he could not approve of any of it. Like Vere Foster, he noted that 'children were being set the hopeless task of copying with pens, on paper, letterforms made and partially evolved by gravers on copper plates.'[2] At the same time, he was setting out in his *Writing, Illuminating and Lettering* what he called 'the structural or essential forms of the three main types of letters' – square capitals, round capitals, and small letters, clearly set out as not being joined together. This sense of the single letter, formed from circle and line and nothing else, as lying at the basis of handwriting would have a dramatic effect on the discipline.

Other figures at the time were starting to suggest, heretically, that the sort of handwriting that linked every letter together was quite unnecessary. Johnston's pupil Graily Hewitt called the insistence on a connecting stroke

'a fetish'. By 1916, the educational establishment was starting to reconsider, and a meeting of the Child Study Society explored the possibilities of teaching print script.

The simplicity of a 'print script' recommended itself to beginning writers. The nineteenth century had thought in terms of ovals, curls and other natural forms – very sound philosophically, but extremely difficult for a 5-year-old with limited motor skills to master. It had required long hours of drills, push-pulls and overlapping ovals before any kind of writing skill could be acquired. On the other hand, children could step readily into a world where every letter was made out of combinations of straight lines and circles, or parts of circles. (Because of this simple combination, the new print scripts were often termed 'ball and stick' writing.) There was no requirement to link letters together, something which every teacher knew was a great strain on the beginning writer.

It seems obvious to us, raised as we were, that the print script should be used as a preliminary to writing in a cursive style. Indeed, the early proponents of script understood quite well that print was quicker to write in the early stages, but after the age of nine or so, a cursive hand was swifter. Nevertheless, not everybody thought that the now familiar sequence of print to cursive was a desirable one. This was an age of revolutions, in education as much as in anything else. In *Decline and Fall* Evelyn Waugh's Paul Potts writes to his unfortunate friend Pennyfeather, teaching in a terrible boarding school in 1928:

> There is a most interesting article in the *Educational Review* on the new methods that are being tried at the

Innesborough High School to induce coordination of the senses. They put small objects into the children's mouths and make them draw the shapes in red chalk. Have you tried this with your boys? I must say I envy you your opportunities. Are your colleagues enlightened?[3]

He is probably thinking of such people as Maria Montessori, who first introduced children to letterforms made out of sandpaper, encouraging them to touch them in order to grow familiar with them. Waugh may, too, have heard of Marion Richardson's practice of getting children to draw with their eyes closed.

In handwriting reform relating to print letters, there quickly emerged a fundamentalist and a moderate wing. The fundamentalist position was that cursive was a corrupt and unnecessary skill, and all through adult life, it should not be necessary to do anything other than print letters. A slightly softer version of this position was that letters should be joined 'where natural' – an idea of Graily Hewitt, who had set out the natural ligatures, such as 'am', 'an', 'di', 'ci', 'em', 'hi', and so on, almost all of which joined at the bottom of the letter.

For moderates, the education in print letters was a useful beginning point, and the learner could progress from there to a cursive, or semi-joined-up writing. The cursives that emerged from the print school were markedly different from the sloping, looping style that we saw in Vere Foster and A.N. Palmer, and show the influence of thinking about individual letters in isolation, in terms of circles and lines.

The range of possibilities was set out in a 1923 Board of Education report, which described the views of the pro-print school, and what they said were the advantages of their position. 'The need for two alphabets would disappear . . . they would be more readily learned than the ordinary cursive forms, and would be written by young children with greater ease and accuracy . . . [it] could at a later stage be developed without difficulty either into an ordinary running hand or formal script such as is usually taught in art schools.'

All this seems obviously true, and the idea spread rapidly. The experts disagreed with each other, and sometimes seem somewhat cranky in their devotion to the new style. An A.G. Grenfell has been unearthed, arguing pugnaciously in 1924 for a sort of sloping print script: 'This simple, legible hand . . . is steadily replacing Cursive in many English Schools throughout the world . . . [this book] deals seriatim with the conventional arguments against Script by appealing to actual experience gained by five years trial.' Rosemary Sassoon remarks that 'it is clear from his copybooks that Grenfell meant there to be no progression to a joined hand.'[4]

But for the most part, you can almost see, as print teaching in the early stages spreads, a joyous change of perspective, from the teacher's convenience to the child's advantage. From Spencer onwards, the teaching of handwriting in class was all to do with subjecting the child to the teacher's will, and forcing him to do what must be achieved, at whatever cost. You just look at the print letters which began to circulate from the 1920s onwards, and

see how attractive they are to the child, and how much easier to achieve. At this time, education began to be thought of, for the first time, from the perspective of the child, who was not necessarily merely an inconvenience to the supervising adult. Probably nowhere was this shift in perspective so clearly shown as in the move to a beginning handwriting where the letters are simple, clear, easy to make and easy to read. The fundamentalists, who believed like A.G. Grenfell that cursive should be done away with altogether, or like a Professor Shelley of the same period that 'connecting strokes tend to make words similar, whereas to distinguish one word from another we require diverse elements',[5] meaning print letters, were never going to succeed in making every adult write exclusively in print throughout their life. There are adults who do go on writing in print; they always have a rather rebellious, art-school air about them. But most of us move on to more-or-less cursive writing when we're about seven or eight, and carry on linking most of our letters up for the rest of our lives. When we are learning our manuscript letters, we look forward, as I did, to the day when we're allowed to do 'joined-up writing': it possesses a marvellous prestige for most beginning writers. Print prepares us beautifully for the task of writing in an adult way, and some people will always find it enough for their needs. But handwriting, for many of us, has an element of glamour which the lovely simplicity of the ball-and-stick kindergarten letters can't fulfil on its own. That explains, perhaps, why as some people were moving towards a hand that could be written by pencil out of circular lines and simple verticals, others

were bent on reviving a handwriting style which depended for its full effect on the use, not even of a nib, but on 'the shaded forms of the square-cut quill.'[6] That'll show the proles.

11 ~ 'Une Question de Writing'

All through the 1980s and 1990s, as English handwriting lessons slid further and further down the agenda, teachers were despatched to France to observe how things were done there. They invariably returned with a gleam of shock in their eye. The French were doing things as they had always done them, with great concentration and an attention to detail. The handwriting of a French person who went to school in the 1990s was probably very similar to the handwriting produced by someone who was educated forty or fifty years before. A French grandmother, interviewed for a documentary on the subject in the twenty-first century, says carefully that 'the teacher wrote on the board and we copied it down, and we had lined notebooks, and we did our writing according to the lines . . .' The film cuts to the same scene in a French classroom today. Nothing, apparently, has changed. Her grandchildren are being taught in exactly the same way.

One group of researchers, sent off to northern France in the late 1990s* to examine this question, showed that handwriting was a much higher priority for French

* The report is wincingly titled 'Une Question de Writing?' A research project commissioned by the Teacher Training Agency.

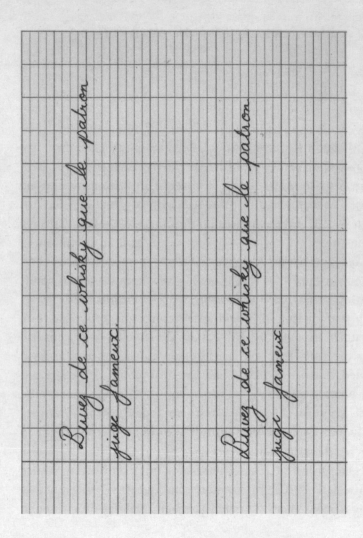

The handwriting of a French woman who went to school in the 1990s.

infant-school teachers. It was, moreover, taught as a skill connected to any number of other skills; to movement and dance, physical education, creativity, and, naturally, this being France, 'the teaching of handwriting in France was closely associated with the French view that it is important for individuals to acquire this skill if they are to access learning and communication as a part of being a French citizen.' A good deal of time was spent on 'fine and gross motor skills' before writing was embarked upon.

In many ways, some of this seems to chime in with Marion Richardson's ideas, proposed to English educators in the 1930s, which we will come to. A film about the modern-day teaching of handwriting in a school in Lyons confirms some of this view.[1] The teacher stands at the board, drawing a lower-case letter t, defined by a three-line stave – the horizontal lines of the stave define where the top and bottom of the letter fall, and where the cross-bar of the t should go.

With letters that go both above and below the line, a stave with as many as six lines is called for. It is explained by the headteacher of this school, Jean de la Fontaine primary school in Lyons, that 'the learning of writing is something that really begins in year One [at the age of five]. But before this learning stage starts, it's important for children to do *graphisme* exercises.' These *graphisme* exercises include the practice of gesture in the infant school. The large fluid movements of dance, taught to the youngest children, moves gradually into the fluid movement of writing.[2]*

* This is not just a French principle. I heard of a lady called Liora Laufer who has set up an exercise class in Charlottesville, Virginia, USA,

Cursive hands are taught from the start – a teacher observes mildly that 'it can be a bit early for some of the pupils.' If handwriting comes from a wide variety of disciplines, it also feeds into many more. One headteacher says that 'Handwriting is an activity which is cross-disciplinary – it spills over into all the different subjects taught at school.'

French education has the reputation of being extremely rigid. The standard joke is that if it's quarter past ten on a Tuesday morning, the department of Education in Paris can be assured that every 11-year-old from Marseille to Martinique is learning exactly the same fact about the principal products of Poitou-Aquitaine in the fourteenth century. But films of French schools make the learning of handwriting look enormous fun, and in many ways very much like the ideas of Marion Richardson, seventy or eighty years ago. Like her, these teachers concentrate on the physical gesture, and like to turn exercises with the pen into drawing shapes, playing with patterns. Here, they draw sheep with large loops and circles, and add some grass – 'Doing the grass with zig-zags helps us with our m's,' a child says. They are encouraged to add some colour to their work – Marion Richardson, returning a child's point of view to education in the 1930s, had said tolerantly that 'it will of course add to the children's pleasure in writing these copies if they use coloured ink as

called 'callirobics'. 'The word combines calligraphy and aerobics . . . the idea is to improve handwriting skills by using a series of repetitive hand movements set to music. We have programs for ages 4 through 80.' It makes me want to buy a leotard.

well as black.' Here, you can see how right she was. And there seems to be as much pleasure taken in the disciplined practice of handwriting skills as in the free play of the pen over the paper. A pupil says, trying to explain how he forms a letter, that 'Some letters need three spaces, some only two, and some need five – we start in the middle then go up and down and then a kind of loop.' He is having fun. And his headteacher is in no doubt about the importance of balancing freedom with discipline, and the end result. 'To write is to communicate,' he says. 'It's forging relations with other people through writing.' The civic duty to be able to write so that your neighbours can read it has never, it seems, gone away in France, and almost everyone who has examined the French model of handwriting teaching has been initially alarmed by the apparent martinet-like quality, and then impressed by the beautiful results it achieves, and the ability of French children to move on and use handwriting as a tool, rather than experiencing it as a blockage.

If very little has changed in French handwriting prac-tice in fifty or more years, the German model has been altered, and altered again, by political considerations. The last of the black-letter prints, the *Sütterlinschrift*, had been introduced into Prussian schools in 1924 and by 1930 in the majority of German schools. You need special training to read German scripts, or *Fraktur*, as the Germans called it, and many aspects of it now strike us as completely insane. The e and n are only differentiated because, in one case, the second hook is connected at the top, while with the other, the second hook is connected at the bottom; the u and the nn are differentiated only by the degree of curve

which the line above it has* and the s takes two forms, according to where it comes, and if a word has two s's in the middle of it, then one form might follow another. *Alles klar?* The main recommendation of the *Fraktur* script is that it is, apparently, quite easy to write, minimizing strokes and not asking the pen to push against the paper or form loops in the way that other styles of writing do. On the other hand, it's extremely difficult to read.

The Sütterlin script was only formally abandoned in 1941, in favour of the sort of universal Western writing then in use in the rest of Europe. The more universal style is referred to as *Antiqua*, or Latin script. Some historians of handwriting assert that Hitler abandoned the teaching of Sütterlin's black-letter script in schools because he believed it had associations with corruption and Jewish influence. This seems unlikely in the extreme. Black-letter had deeply Germanic associations. Moreover, Sütterlin himself was not Jewish, and, since he died only in 1917, it seems probable that people alive in 1941 would have known something about him. In this case, the reform seems likely to have taken place because historical tendency was against the preservation of *Fraktur*, and because the Third Reich wanted a form of writing which was more like the writing of the rest of the modern Western world.

Fraktur is something between a unique script, like the Cyrillic alphabet, and a style of handwriting, like italic or law-hand. Long before the abandonment of the Sütterlin

* What do you mean, why does a u or a double n have a line above it at all? And what do you mean, what happens when the u with a line above it also needs an umlaut above it?

Sütterlin script from a child's workbook, 1929.

script in German schools, individuals were choosing to write German in Latin hands. A small glimpse of a transitional moment, around 1930, will show how painful the transition could be. In 1930, the State Library in Berlin brought together an exhibition of '139 Manuscripts of Living German Authors': the manuscripts were sold to benefit the German equivalent of the Society of Authors. One hundred and seventeen authors were represented. Of these, twelve used the typewriter, which of course wrote exclusively in the Latin script. Of the others, forty-seven used the German, or *Fraktur* script; forty-two used the Latin, or *Antiqua* script; and twenty-one used a sort of mixed script. The authors who used a more-or-less *Fraktur* script included Kafka's friend Max Brod, Thomas

and Heinrich Mann, and Arthur Schnitzler. The users of the *Antiqua* tended to be, but were not exclusively, of a younger generation; Gerhard von Hauptmann, Hugo von Hofmannsthal, Felix Salten (of *Bambi* fame), Stefan Zweig. Klaus Mann used an intermediate style; very modern people like Döblin and Feuchtwanger used the typewriter. At this point, printed books divided pretty equally between black-letter and Latin type – in 1927, 27,794 books were published in Germany, dividing 56 per cent and 44 per cent in favour of the older style.

The commentator Paul Pope, from whom I take these interesting facts, writing in 1931, is in no doubt that the war between German and Latin scripts in Germany had a direct connection with ideas of modernity and political progress. 'One champion of the *Antiqua* asserts that "the [First] World War would have been avoided if the Germans had only introduced the use of the *Antiqua* in time." The Fraktur protagonists [*sic*] on the other hand are prone to overemphasize mystic relationships and *völkische* consider-ations which are often purely imaginary.'[3] The emphasis on Germanic purity in the *Fraktur* script, certainly made by growing nationalist movements in 1931, would hardly have been likely to have made so dramatic a volte-face by 1941 as to declare it a Jewish style. The purity of the writing style, rather, must have come to seem a real disadvantage to wider communication even to people so made as the Nazis. Moreover, when people who were writing in the Sütterlin script came to a foreign word, it was the convention to break out from the black-letter script and write the word in Latin letters, either as an acknowledgement of the limits of German script, or perhaps because even readers of German

script could not be relied upon to understand an unfamiliar word in the impenetrable style. The result was a situation, as Paul Pope points out, where every German had to learn eight separate alphabets – lower-case and upper-case versions of handwritten and printed German and Latin scripts. There can have seemed no point in maintaining a style of writing which not everyone chose to use, which hardly anyone not trained in German handwriting could read or write, and which was in any case not suitable for every purpose. Hitler's ministries decided to phase out Sütterlin in order to communicate more clearly with the subject peoples, I dare say, not because Sütterlin was a script perpetrated by the Jews, gypsies, homosexuals, communists, the disabled, or any of the other people they so took against.

Here and there, pockets of expertise in Sütterlin survive or revive themselves for professional reasons. My friend Chris Clark, the Professor of Modern History at Cambridge, learnt not only to read but to write Sütterlin while writing his magisterial history of Prussia. He told me some interesting things about what it feels like to write in this impenetrable script:

> The pain of Sütterlin is in the reading, because so many of the letters look nearly alike. But this is actually an easier script to write than to read, especially if you are using a quill or a fountain pen. The letters are configured in such a way as to minimize any movements that push the point of the nib back against the grain of the paper. The a is open at the top; so is the 'c', which can be distinguished from the 'i' only by the little horizontal curl above it. The 'u' and the 'n' are

likewise distinguished only by a little curl or dipping line (above the 'u'). And so on. If you're right-handed, the pen simply moves up and down in little sharp oscillations like the needle of a seismograph. Of course everyone was right-handed at the time, because left-handedness wasn't allowed.

Naturally, the Nazi decision to drop black-letter and impose Latin styles in German schools could not be allowed to stand entirely unamended. Almost everything, after the war, was tainted by Third Reich associations. Nor could the new countries of West and East Germany return to the unreadably antique Sütterlin script. Even if roughly the same decision was reached in the end, it had to be reached independently, and for quite different reasons. In 1953, the Model Latin Script was released by the Iserlohn Writing Circle* and on 4 November 1953 decreed for instruction in every school in West Germany. It was followed in 1972 by a slightly simplified version. Not to be outdone, the Democratic Republic in the East produced its own *Schulausgangsschrift* (Model School Script) from 1968. They are rather similar: the principal difference seems to be that the DDR script stresses the upstroke which begins each letter from the baseline. Both are much more looped than English scripts of the period, and closest to the Montessori script, which was a rounded, non-cursive style. When the

* I am sorry to say that when I said the words *'Iserlohner Schreibkreis'* to an educated German friend to ask his opinion of this important moment in postwar German history, he immediately burst out laughing, which just goes to show that it is perfectly possible to get too close to one's subject.

two Germanies united, a unified script soon followed, the 1993 Simplified Model Script.

The idea of a national script, to unite children in a sense of nationhood, was used for good or ill in Germany in its various incarnations – the Wilhelmine state, the Third Reich, the different political ideals represented by West and East Germanies, and finally, the reunified Germany. Only in very recent years have the voices that ask whether it is worth teaching handwriting at all have been gaining much of a hearing.* In 2011, the state of Hamburg unilaterally introduced a simplified alphabet called *Grundschrift* which, like the print alphabets of the 1920s, aims to maintain the same writing style from initial literacy to graduation. Proponents of the change argued that it would allow children to develop their own handwriting in freedom; opponents said that 'the legibility will not improve, but rather noticeably worsen, because each pupil will join up the letters however they fancy. The speed of writing will also decrease.'[4]

The German national union of primary school teachers

* An impressive delay, given that since 1968, Germany has been simply stuffed with people insisting on their right to insult all forms of authority and, in extreme cases, put a bomb underneath it for no very obvious reason. I know quite a lot of people from Berlin days who regard any form of housework as *kleinbürgerlich* in the extreme – one dear old friend confided in me that he thought only pathetically materialistic people ever cleaned their bathrooms, though he admitted that he had, in ten years, cleaned his lavatory three times. Quite a lot of them made a point of addressing their best friends as '*arschloch*', which means 'arsehole', as a clean break from bourgeois conventions. It is odd that they seem not to have succeeded in making a serious dent on national models of handwriting until the other day.

started a campaign in 2011 to abolish the teaching of the national cursive model nationwide. The forces of conservatism and the sixty-eight-ish forces of child-centred freedom square up against each other; the forces of nationhood and duty, impressed upon an increasingly multicultural nation, seem to many an absurd thing to hope to embody in loops and curves, or in a decision about whether your letters should join according to the Model Latin Script or not.

Like Germany, the Scandinavian countries shifted from gothic letterforms to a more universally comprehensible international style. In their case, however, the shift took place in the nineteenth century. Starting with Sweden, and subsequently in Denmark, Iceland and Norway, copperplate was the universally preferred style. Only in the postwar period did a revision of letterforms take place. Alvhild Bjerkenes, in the period from 1947 to 1962, introduced a model in Norway and subsequently Denmark, with, apparently, a great deal of argument about the benefits of handwriting models on medical grounds – 'the ergonomic arguments [were] often mixed with political, moral, social, hygienic and aesthetic arguments'.[5] In Sweden and Iceland, a more italic model was introduced – in Sweden in 1982, after models by Kerstin Ankers. It must be one of the few countries to have adopted the italic schemes so hopefully promoted by British italic campaigners in the 1950s, such as Reginald Piggott, and seems to have pushed handwriting in the direction of formal calligraphy. It introduced the use of a four-lined stave to control the formation of letters throughout the educational system. In Rosemary Sassoon's view, the Swedish experience was

not altogether successful – 'over-emphasis on appearance led to slow and painful writing'.

Perhaps the effects of national writing models are not as long-lasting, or as marked, as teachers hope. When I see a student's handwritten work, more often than not it has a conspicuously round nature, as if someone has sat on the letters and squashed them into cushions. The same writing style can be seen in student work, wherever in Europe they were originally taught. The allure of the fat roundhand, sometimes to the point of illegibility, seems to be stronger than the pull of the four-line stave and Marion Richardson-derived letterforms – strong enough, indeed, to transcend most international borders, and students from North America or anywhere in Europe may perfectly plausibly possess, for twenty or thirty years, the same fat, sat-on sort of handwriting. If, that is, any student writes by hand at all.

12 ~ Witness

Interviewer: 'Have you ever had handwriting lessons at school?'

A: 'No, not proper handwriting lessons, not really. Well, you sort of get lines, and you get letters, and you get dots – you have to follow the dots. Well, you have the L, and you have the dots, and you have to do it, and after three dots they stop, and you have to do it on your own . . . D, A.'

B: 'And then you do more, don't you? You do more flowing ones, don't you?'

A: 'Yeah.'

B: 'And then you do the more joined-up ones, with tails . . .'

C: 'Doesn't really improve my handwriting much. I don't have handwriting lessons any more. It stopped in Year 4. It was boring. Well, you didn't really have handwriting lessons. You did it before the start of lessons, like, when you come in, before you go to hymn practice at assembly, you'd do like three lines of handwriting. I did do the three lines, only I wasn't very neat in doing so. I did it in pencil because I didn't have a pen licence because

I had such rubbish handwriting. I never had a pen licence. I never had a pen licence.'

Interviewer: 'Pen licence?'

C: 'Nowadays you now have a pen licence.'

'A' giggles uncontrollably.

C: 'So that you had to use pencil.'

B: 'I think Robert got so old that they just gave him a pen licence – he didn't actually get it.'

Interviewer: 'What happens when you get a pen licence?'

D: 'You get to use a pen.'

Interviewer: 'No, I mean, is it like a ceremony?'

C: 'No, you just get a licence that says "Pen Licence" on it. In front of the whole class. Everyone applauds. Well, yeah. They're meant to.'

A: 'I guess it depends on who you are.'

D: 'Yes, if you're the last child to get a pen licence.'

C: 'If you're the last child to get a pen licence, it's more like [makes slow handclap]. There's a forfeit for the rest of the class if you're late, you see. I haven't seen anyone's handwriting which I'm vaguely impressed with, yet. I'll see if I can try and understand yours.'

B: 'I always regret that I've got really scrappy handwriting. I've tried to improve it. But it's hard. I remember doing the letters from the books, and then the joining-up bit. After that, I don't think it was the style that you were offered, backwards, upright, slanting. I had a tendency to write like

that – [demonstrates] – to hide the fact that I couldn't spell that well.'

C: '"What should I write to demonstrate the beauty of my hand" – is that what it says? What's that thing there?'

Interviewer: 'It's recording everything you say and it's going to go in my book.'

A: E.L.A., female, 14
B: C.A., engineer, 49
C: R.J.A., male, 11
D: K.Y.A., systems analyst, 49

13 ~ Hitler's Handwriting

Hitler seems to have disliked writing by hand altogether. One of the reasons why it has been possible for extremist 'historians' to make the odious case that he actually knew nothing of the Final Solution was that, in his twelve years as Chancellor, he 'very rarely committed his thoughts on important issues to paper in formal memoranda.'[1] That is true even of typed documents. He himself stopped writing anything by hand long before his death. One of the last surviving examples of his handwriting comes in a private testament of 2 May 1938 – the subsequent testament, drawn up just before his suicide in 1945, is typewritten. Subsequently, he grew worried about the legal basis of this testament, believing that, as an unnotarized will, it had by law to be written entirely by hand, not including the printed headings on his notepaper – this seems not to have been the case.[2]

Hitler had the handwriting that you might expect of someone of his limited educational background. His short encounter with the educational establishment included the *Realschule* in Linz where, for at least one year, his presence overlapped with that of the philosopher Wittgenstein, then at an early stage in his schooling.* Interestingly, Wittgenstein's poor written German led to him failing one exam – the Linz *Realschule* evidently didn't do a good job in encouraging its alumni to write. What we see in Hitler's handwriting of 1938 is a script that must have seemed old-fashioned to some parts of the German-speaking world even at the time of his schooling, forty years before, and by 1938 was certainly passing out of use. For instance, he indicates a double m in *kommt* by a line over the single m, in the black-letter style. After 1938, he apparently gave up writing at all by hand.

As we have seen, that didn't stop him from taking an interest in handwriting, and in 1941 decreeing that the established Sütterlin *Fraktur* hand should be abandoned in German schools in favour of a more modern Latin script. The main interest of Hitler's handwriting, however, is what happened to it after he died.

Because of the abandonment of Sütterlin in 1941, and the confirmation of that decision after the war by the authorities of East and West Germany, by the 1970s only trained specialists could read historic *Fraktur* scripts. By

* Wittgenstein and Hitler were the same age, but as Wittgenstein was advanced a year and Hitler held back, they were two classes apart, and no one knows if they ever really encountered each other.

the 1970s, too, there was an enormous market in fake Nazi documents, including forged signatures and even letters purporting to be by Hitler. The trade was encouraged not only by the fascination and horror of the subject, but also by the fact that it was harder to detect a forgery where not many people could read what was being written.

Around 1980, some diaries, supposedly written by Hitler, started to surface. They were the most abject forgeries, which anybody ought to have been able to see through from the start. The story of how *Stern* magazine and its star reporter, Gerd Heidemann, were fooled by a small-time con man called Konrad Kujau, and how in turn Heidemann defrauded his employer of millions of Deutschmarks before allowing the UK *Sunday Times* to make a perfect ass of itself has been brilliantly told by Robert Harris in his classic *Selling Hitler*. What interests us here is the light cast on the analysis of handwriting by the behaviour of several 'experts' in the field of forensic analysis.

The handwriting of Hitler is a favourite topic of many graphologists, who enjoy pointing out the features in his hand which indicate his megalomaniacal psychopathy. Some graphologists indicate particular graphic features in his writing – for instance the slant of his writing – which indicate his specific politics or even his genocidal tendencies. Given the faint eccentricity of graphologists when in character-analysis mode, perhaps some caution ought to have been exerted when asking them to put on their forensic-analysis hat.

There were a number of problems that arose when considering the authenticity of the 'Hitler Diaries'. First,

hardly anybody in the *Stern* building apart from the crook Heidemann could read the script – this was forty years after the abandonment of *Fraktur* in German schools. Secondly, the handwriting experts who examined the script were either not up to the job, working within a fatally flawed discipline, or given misleading evidence to work on. A Doctor Max Frei-Sulzer, a former head of the forensic department of the Zurich police, was 'provided with two photocopies of documents from the *Stern* hoard: the Hess statement and a draft telegram to the Hungarian ruler, Admiral Horthy.'

> As comparison material, Frei-Sulzer was supplied with . . . copies of authentic Hitler writing . . . a third set of documents for comparison was provided by Gerd Heidemann from his private collection . . . Unfortunately for Frei-Sulzer, these supposedly genuine examples of the Fuhrer's writings were also the work of Konrad Kujau, a confusion which meant that the scientist in some instances would be comparing Kujau's hand with Kujau's.[3]

Another expert, Ordway Hilton, an American forensic examiner, was also roped in, although he could not even understand German, let alone the difficult hand. When his report came in, it stated that 'The lack of lower loop, the flattened single-space letters, the variable use of letterforms and the interruptions in the words especially at points when the letterforms are connected in other instances are all common to both the known and this page of writing under investigation. The combination of all these factors establishes in my opinion adequate proof that this document was written by the same person who prepared all the

known writings . . . I must conclude that [Hitler] prepared the document.'[4]

Hilton was completely wrong, as was Frei-Sulzer, who declared that 'there can be no doubt that both these documents were written by Adolf Hitler'. Only at the very end of the disastrous story was any doubt voiced, when a further handwriting analyst, Kenneth Rendell, carried out a much more systematic analysis of the material, and concluded that 'the capital letters E, H and K in the 1932 volume had striking dissimilarities to the same letters in authentic examples of Hitler's writing.'[5]

Hitler was one of the first people to decide to give up writing by hand. His handwriting, however, had some more life in it. The frightful saga of authentication over the forged diaries suggests that analysis of handwriting on a forensic basis is a much less accurate science than its proponents claim, as we'll explore further in Chapter 20. Most of the graphologists employed by *Stern* couldn't reliably tell the difference between a blatant forgery and the real thing, not even suggesting that there might be room for doubt here. When we come to the much stranger 'science' of character analysis through graphology, we might like to remember the failure to identify Hitler's handwriting. If a professional analyst couldn't tell the difference between a letter written by Hitler and one written by a cheap forger, is it at all likely that he will be able to diagnose Hitler's political tendencies or character defects through the direction in which the letters lean?

14 ~ *Preparing the Boys for Death:*
The Invention of Italic

One of the great things about going to university in Britain is that one leaves home: one meets people from a very wide range of backgrounds. Your eyes are opened a little bit. My very first day at university, I sat next to a boy who observed, when he saw what we were having for dinner, said 'It's strange to be eating chicken with a knife and fork, isn't it?' The next day, I met another boy, who said his father and grandfather and great-grandfather had all gone to Christ Church, and it was a great shame in the family that he'd had to go to Lady Margaret Hall. His father, or perhaps mother, had decided to console him with a BMW with a personal numberplate, RTS 1, which sat opulently in the car park at the front of the college until the porters told Ralph to move the bloody thing, which they did on average twice a day. Possibly poor old knifeless David and personal-allowance Ralph found a suburban child of the middle classes, who had nothing but an enthusiasm for Dickens to recommend him, as exotic as I found them. Probably not, however: there were a lot more of us.

One of the aspects that I found extraordinary and fascinating in the incredibly posh boys who already seemed to

know their way around the place was the italic-influenced way some of them wrote:

> Waxy and quivering,
> jokes fumble the pizza.

Now, the sort of state schools that I went to in the 1970s and early 1980s had a particular model of teaching handwriting, which I will come to. Our handwritings were different, and bore our own stamp, but there was a general style of writing which prevailed. It didn't occur to me that anyone, in England in the 1980s, learned to write in any other way, unless they were doing an art project or something of that sort.

I played the double bass at that time, an instrument which got me into all sorts of odd social situations. One of these was being invited to play in the pit band for a production of Ben Jonson's *Volpone*. The production was immense. The entire text was performed, probably for the first time since 1610. No professional would stand for it, and no audience (as it turned out) either. As the fifth act turned midnight into one o'clock, and the yawning staff of the playhouse prepared to berate us for keeping them up, the last stages of the monstrous comedy were accompanied by the dull, irregular thud of the tip-up seats, as the patrons decided, one after the other, that they'd probably got the point by now.

The music was written especially for the play by a boy called Corin Buckeridge.* There was a cellist in the band, a posh boy with a cowpat of thick hair and an expensive jumper, with the curious name of Paul im Thurn – I discovered much later that his family were Swiss nobility, they lived in rather a grand mansion flat by Putney Bridge and there was a *von* and a *zu* that had dropped out at some point, for no very obvious reason. I rather hit it off with him. In those days – this was 1984 – there were no mobile phones and no Internet. You communicated, in Oxford, by means of small notes which were carted about the place by long-suffering university servants. You wrote the name of your correspondent and his college on a piece of paper, and it was taken to the other side of the university in a van, and deposited in their pigeon hole. I wonder whether the whole thing still goes on – it has an efficient, laborious, Trollopian air, all that twice-daily collecting of scribbled notes. Anyway, just before *Volpone* began to be inflicted on a paying public, I had a note from this im Thurn. What it said has been lost in the mists of time, but the style of the thing was unforgettable: triangular, oval, thick-and-thin pen strokes, meticulous down strokes and curving upstrokes. I had had my first encounter with a living italic hand. I didn't know they still existed. 'Oh, I learnt it at school,' Paul im Thurn said when I asked him. 'There was a master who was rather keen on it, and so a lot of us, we learnt it.' 'What school did you go to?' I said – this was the ˙

* His dad was Antony Buckeridge, who wrote the Jennings books. I was massively impressed, having cast myself and my best friend as Jennings and Darbyshire years before in a playground game.

question that, at Oxford in 1984, you generally didn't ask. The whole question was just a little bit fraught. 'Oh, it was a school called Ampleforth,' he said. I looked uncomprehending. 'It's a sort of Catholic boarding school. You know the story of the Ampleforth headmaster who went to the conference of public-school headmasters, and when one of them said, "Our role in life is to prepare our boys for life," the Ampleforth headmaster said, "All very commendable, but we at Ampleforth see our role as preparing our boys for death."'

It's probably very unfair, but ever since then, the italic hand has always given me the impression of being written by someone preparing for death.

Almost every other revision of handwriting with large-scale ambitions – even Bickham, Spencer, and certainly Palmer and Vere Foster – wanted to simplify matters; to make letters easier to write for the penholder and more lucid for the reader. They wanted to speed things up, to shed unnecessary ornament, and, above all, to produce a hand suitable for contemporary commercial realities. The revival of the italic hand was consciously different. It was ornamental, elegant, produced and designed by people who in many ways were hostile to the world of commerce and efficiency. Moreover, it came not from a consideration of modern styles, but from historical analysis. It tried to go back three centuries, and do something memorable.

To go back a little, the Arts and Crafts movement, in the later-nineteenth century aimed to influence everything in people's lives. Under the direction of John Ruskin's jeremiads against mechanized, soulless production, it hoped to give back to people's lives something of the honesty and

solidity of handmade objects. The movement had an effect on almost every area of life. It was never very practical – it is all very well talking about handmade furniture and handprinted books in a sixteenth-century town of a few thousand people, most of whom are illiterate anyway, but in the hugely expanding London of the last decades of the nineteenth century, it was a total absurdity. Still, though Arts and Crafts was, inevitably, a rich man's occupation and the Arts and Crafts figures the original champagne socialists, the movement exerted an important influence on continental figures belonging to the Vienna Workshop and subsequently the Bauhaus, and all of our lives. The Arts and Crafts motto, 'Have nothing in your house that you do not know to be useful or believe to be beautiful', is a good enough one, and it ultimately resulted in the lovely interiors we English live among today. Go on, look around you. Gorgeous, isn't it?

The chief figure in all of this, William Morris, was very interested in small-scale artisanal printing, setting up his own Kelmscott Press for the purpose. In the first half of the 1870s, he also decided to explore the possibility of reviving the mediaeval art of illuminating manuscripts, which he called 'painted books'.*

* One of the amiable things about the home-weave, hand-carpentry, pottage-and-pottery movement of this time is that some of them decided that Latin words were no good and not homespun enough, and ought to be replaced where possible with Anglo-Saxon invented equivalents. The most amusing of these individuals was the enchanting Australian composer Percy Grainger, who put a good deal of effort extirpating any taint of Italian instruction from his scores, replacing, for instance, 'Crescendo molto' with 'Louden Lots'.

WINTER in the world it is
Round about the unhoped kiss,
Whose shadow I have long moaned o'er
Round about the longing sore,
That the touch of thee shall turn
Into joy too deep to burn.

Round thine eyes and round thy mouth
Passeth no murmur of the south
When my lips a little while
Leave thy quivering tender smile,
As we twain, hand touching hand
Once again together stand.

Sweet is that as all is sweet,
For the white drift shalt thou meet
Kind and cold-cheeked, and mine own,
Wrapped about with deep furred gown,
In the broad-wheeled chariot;
Then the north shall spare us not,
The wide-reaching waste of snow
Wilder, lonelier yet shall grow
As the reddened sun falls down.

'Meeting in Winter' by William Morris, 1870.

Obviously, a new 'painted book' could not be executed in Vere Foster copperplate. The stripped-down copperplate style, now referred to as 'civil service' hand, was not nearly picturesque enough – it suggested South London clerks, not elegance and an age of leisure detached from base mechanical concerns. With characteristic thoroughness, Morris acquired a volume made up of four Italian sixteenth-century writing books, and studied a master called Arrighi with considerable care.[1] Morris evolved his own version of the italic hand, using it to transcribe some ancient narratives for the interest of his own circle. Unlike leaning, looping copperplate, it was upright, made with individual strokes, not a super-efficient, word-in-a-single-movement, and had no particular interest in ligatures or in speed of execution. It is, from the start, legible in every letter.

It was not for twenty years, however, that the possibilities of the italic hand for general, everyday use were pointed out. In a book of 1898, Monica Bridges, the daughter of the great architect Alfred Waterhouse and wife of the then-celebrated poet Robert Bridges, tried to indicate how italic handwriting could be taught in schools. From that point, disciples and serious fanatics started to gather.

Looking at the first attempts of Morris and Bridges,[2] it is surprising that their style gathered followers at all. Though legible, neither of them is very attractive. Morris's is very unlike the airy perfection of Arrighi's, crabbed and stubby where the classic italic hand soars gracefully. His letter sizes seem completely irrational – the ascenders of his d's, b's and l's make up three quarters of the letters, but the

f's are half the height, and the t's just sit there blankly. His links and ligatures seem very awkward – you can see that Morris has more or less worked them out for himself – and the direction of the strokes is really quite chaotic. It is a consciously archaic hand, impressing rather by its difference from the everyday sloping cursive hand deriving from copperplate than by its inherent coherence or elegance. It is also, actually, quite ugly – the really beautiful italic hands still lay in the future.

Monica Bridges must have been an interesting woman. Her upbringing and marriage placed her firmly in one of those engagingly eccentric turn-of-the-century milieux that got interested in more or less any passing fad, plotting ineffectually to reform anything from spelling to dress and the vote.* Her interests, we are told, 'ranged from music to modifications of spelling with a set of phonetic fonts based on Anglo-Saxon letters, and development of typeface . . . she helped Harry Ellis Wooldridge to provide Palestrinal harmonization for nearly eighty plainsong melodies used in the hymnal.'³ Restricting ourselves to her interests in handwriting reform, her surviving work is more rational in the way she links letters and establishes proportions between letters, but she clearly feels the strain. Look at the word 'believe' as written by her, and the strain is obvious. The handwriting has a definite tendency to waver between upright and right-leaning, and the spacing between letters never really establishes a natural rhythm – sometimes they are congested, sometimes more loosely gathered.

* If you want to know what that sort of person was like, there is no better evocation that A.S. Byatt's superb novel *The Children's Book*.

> Read not to contradict & confute,
> nor to believe & take for granted,
> nor to find talk & discourse; but
> to weigh & to consider.
> Some books are to be read only in
> parts; others to be read, but not curious
> ly; & some few to be read wholly, &
> with diligence & attention.

Italic is performed with an italic nib, wider at its point than the usual nib, and the whole point of the style is the alternation between thick and thin strokes as the pen moves through a letter. Look at a word written in an italic hand, and you will see that parts of an s are thick, and others thin. The ligatures between letters are generally very thin, executed with the side of the pen. There is also no fear of lifting the pen between, or even during letters – the italic calligrapher's lower-case e may be performed with two entirely different movements of the pen, with a lift in between. We are back to the Coca-Cola logo. This is not a style for people in a hurry.

It is, and has pretty well always been, a European and predominantly an English style. There have been periodic

attempts to wean North Americans away from their loops and curlicues and whole-arm movements, but never very successful. An inadvertently hilarious 1998 piece of journalism from Ottawa explains, despite itself, some of the difficulties. Italic is a 'less fancy handwriting' than what the author calls 'regular handwriting', or, mysteriously, 'cursive handwriting'. The school board 'gets regular complaints from parents, who are suspicious of the [italic] system [sic].' Italic is 'kinder to left-handed people than traditional handwriting. It's also easier on children with learning disabilities.' There seems to be absolutely no hope here.[4]

As the italic hand took hold, its proponents made ever-bolder claims for it, often seizing on the fact that many schoolmasters had adopted it as evidence that it could be practised from the first days of education. 'The italic school of handwriting is being taught in many schools and as it is traditional, sensible and pleasing, it seems likely that it will establish itself in England and probably in the USA also. If one scans the horizon for a glimpse of any future style that may follow and displace it there is none.'[5] Reginald Piggott, in his 1950s Survey, pretends that 'many younger teachers see in italic the key to legibility, and those who use it in class find that children take to it readily . . . some speak of [italic's] beauty, sharpness and legibility and the ease with which it may be written.'[6] Italic was spread not through commercial writing masters, but through pressure groups, calligraphers' associations and enthusiasts. The Society for Italic Handwriting was founded in 1951, for which Piggott's Survey is a perfunctorily disguised recruiting programme.

The italic style was spread by a few art-school types such as Wilfrid Blunt,* who, as drawing master at Eton, encouraged a circle of boys to adopt an ornamental italic style. I spoke to one of Blunt's pupils, the great painter Sir Howard Hodgkin, about Blunt's teaching, and about his engagement with a correspondent, who Blunt said, replying to a letter, had '"the worst handwriting I've ever seen. I don't know how you manage daily life with writing like that. It was totally appalling." This man replied on a piece of white paper, the same text in perfect copperplate. Wilfrid felt rather put down by this. The man said, "It's not the pen, it's the concentration that does it." Which of course is true. He encouraged the boys to take up italic handwriting. Oh, very much so. Some of the boys complained that if they didn't turn in their homework in perfect italic, it would be ignored. He introduced me to Indian painting.† And to something more questionable, aggressive interior decoration which I had never come across before, and he loved the idea of upsetting the parents. Which he did with great success. He had, hanging in the middle of his room, a splendid wooden dog with a

* Brother of Anthony, the expert on Poussin and traitor. Not Wilfrid Scawen Blunt, an independently fascinating person of rather an earlier date, who as far as I know had nothing to say about handwriting. Robert Conquest wrote a limerick about that Blunt: 'Once Wilfrid Scawen Blunt / While taking some boys out in a punt / Was about to be struck / But by calling out 'Duck'! / Saved the life of the fellow in front.'

† Sir Howard has a great collection of Indian painting, which was exhibited as a whole for the first time in spring 2012 at the Ashmolean Museum, Oxford.

gigantic erection. It was hung at eye level. So that was a great success. I asked him about his interior decoration, and he said I only did that because it would really annoy the man upstairs. There was plenty of scope for upsetting with interior decoration. I didn't really understand about people being gay. My father was not sure about Wilfrid. He thought he had a very unhealthy relationship with . . . Queen Mary. And that was true. There's a wonderful photograph of them looking at a flower book together. It was very eloquent. But he also had an amazing girlfriend whose name . . . I'm afraid I've forgotten it. She was the wife of a very aggressively outdoorsy housemaster and she was quite the opposite, very beautiful and exotic. She may have been either French or Russian, and they had a long affair; which all the boys talked about.

'He was very charming to me. He took me to pick some flowers, and I thought how nice, how kind. He on the other hand was rather un-relaxed. This is all quite separate from his introducing me to Indian painting. Life was so complicated anyway.'

The circle influenced by Blunt no doubt went on to teach and influence whole new circles of boys in their handwriting. Blunt wrote an unmistakably top-person's book about italic, *Sweet Roman Hand*, which contains some very daunting examples of 12-year-olds writing extraordinarily supercilious letters, boasting about the beauty of their handwriting. *Sweet Roman Hand* must have been a minor hit among the sort of public-schoolmasters just beginning their careers in the 1950s. I imagine the very dubious young man depicted in Molesworth saying, 'And when I asked him the supine stem of *confiteor* the fool didn't know'

had almost certainly read Blunt, had probably corresponded with him, and did all his marking with a square italic nib, much admired and imitated by a small coterie in the lower fourth. In any case, there doesn't seem to be much doubt that whoever the Ampleforth schoolmaster who so impressed my friend Paul im Thurn was, he certainly possessed a copy of *Sweet Roman Hand*.

Were there many state schools that found the time to teach italic? Certainly, there were some. But most of the centres of young italic excellence were, surely, to be found in the art rooms of public schools. I doubt, too, that anyone ever had much success in teaching very young children to write italic from the start – it is really difficult to envisage a 5-year-old having anything near the motor skills to even begin on those complex patterns. Italic belongs to a particular stage of development. Often, talking to people about their handwriting for this book, I heard them say that they had deliberately learnt italic in their teenage years – sometimes as a response to an impressive master at school, sometimes independently, in their spare time at their desk in their bedroom, just wanting to be as elegant as possible. It's an aspirational and showy hand, and it comes from very much the same stage of life as sudden conversions to socialism or Roman Catholicism, eating obscene amounts of sweets, and the passionate devotion of unsupervised hours to masturbation, Clearasil and Mahler. Still, it leaves a much more benevolent trace in the lives of its disciples. If you were struck by the italic bug at fourteen, your handwriting at forty will qualify you to be asked regularly to write the inscription on Sue's leaving card by the deputy head of HR.

I don't know. There may be plenty of wonderful people who write in an italic hand – actually, I know there are, some of whom are my dearest friends – but it just seems to me . . . Well. I didn't really pin this unenthusiastic feeling down until I came across a grim book by Tom Gourdie, a pillar of the italic movement, intended to promote italic handwriting.[7] *Italic Handwriting*, published four years after the founding of the Italic Handwriting society, evidently invited letters from all sorts of italic folk, many of which are reproduced therein, as Mr Gourdie would probably put it. What is fascinating is not so much the handwriting reproduced, but the prose style of the letters. If there was ever any doubt that italic is quite a precious style of writing, and that people who went for that sort of thing went for preciousness in other areas, here is proof. 'When I survey the long list of that hand's more distinguished practitioners, I marvel at the continuing reluctance of educationalists to introduce it, at least on trial, with adequate "control" groups of uncontaminated pupils, to guard against any precipitate acceptance of this clearest and flowingest* of all western hands.' (Paul Standard, NY, USA.) 'I'm afraid I make no claim to being a scribe, and when you see this heavy hand – which has been my everyday one for some years – I doubt whether you will feel inclined to include it.' (Some bloke from Chippenham.) 'I have upon occasion made spasmodic attempts to interest the lower forms in the italic hand. There are, I find, many difficulties in the way – notably the prevalent liking for fountain pens

* Yeah, that's a word.

[we do not allow ball pens, thank goodness!]' (Someone called Trodd from Ipswich – seriously, what with the square brackets, the words 'upon occasion' and 'I find' and, worst of all, the exclamation mark, I want to give that one such a slap.) 'I must beg you to forgive me my apparent rudeness in failing to answer your kind letter.' (Nicolas Bentley, W7.)*

Apparently every single one of Gourdie's correspondents was under the impression that 'most' is how the English usually say 'very'. What came first – being an arse, or writing in italics? Did they decide to write in italics because they were arses, or did the habit of writing with ovals and italic flourishes take root and encourage them into arse-like tendencies?

One should perhaps pass on a report of Tom Gourdie's last days, recorded without source by Kitty Burns Florey and, astonishingly, not disapprovingly, either. 'The legendary Tom Gourdie died in 1995 at age ninety-one. In the hospital during his last illness, disturbed by the sloppiness of the name-label attached to his bed, he reportedly began instructing the nurses in the proper way to hold a pen.'[8]

Pass the morphine, Matron.

* That's a familiar name. I hope not the Nicolas Bentley that did the illustrations for Hilaire Belloc's *Cautionary Tales*.

15 ~ *Witness*

'At junior school, we learnt what we used to call copper-plate. We had a copybook. There was a line, and we copied underneath it, in unison, as a class. That's the sort of style I wrote, though it got worse and worse as time went on. To be honest, nothing was fun at my junior school. It was a very miserable school, with a very miserable head teacher, dressed like old Queen Victoria with an old black dress on. Quite apart from the fact that I was bullied from day one.

'The copperplate didn't seem old-fashioned – it seemed normal. Because my parents wrote the same way. My uncle Arthur, who lived with us, he had really good handwriting. My mother's handwriting was quite legible, though it wasn't as formal as Arthur's. Arthur worked as a coffee-roaster at the Co-op, so he didn't need such nice hand-writing, and then later on, when he got a clerking job there, he still wrote in the same fashion, always very clear.

'I never practised my handwriting. When I went to grammar school, it just deteriorated. And of course, towards the end of my school days, biros came in.* It wasn't so

* This is what the witness said. However, he must have left school in 1950, so I think the ballpoint may in fact have arrived in his life a year or two after that.

important to write well, to get a job, as you'd think – I don't think so. So long as you could write legibly. I was working at the [Midland] Bank, and my handwriting got disgusting, and I decided to write italic. It was illegible. I don't know why I learnt it. I think I must have seen examples of it, or something – perhaps I saw somebody that had got nice handwriting. Actually, I think it was one of my girlfriends now I come to think of it. I bought an italic fountain pen, and a book by Gowrie – Gowrie?* I was a clerk in the Midland Bank, late fifties, early sixties. I'd devote ten minutes a day, when things were quiet, to practising a letter, one at a time. I got to be quite good at it.

'I still didn't use it all the time. I used it when I'd got time to do it. I had to be writing things in a hurry, and you couldn't be writing with that, I can tell you. It's not a fast hand. I had to write all the names of the banks that we were going to be sending money to, abroad, and I'd have to decide which banks to send the money to, it was – in the case of America, it was a lot. I had to do something like six hundred or seven hundred of those a day. So you had to get a move on because they had to be done after that by the typists, the machine operators, well before the end of the day. They were dependent on me to turn the work out very quickly and very accurately. The machines were too difficult for us to operate ourselves. In those days, too, it was for you to make the decisions, who would get the business. You learnt all the names and the telegraphic addresses

* The witness means Gourdie. He gave me a second-hand copy of Gourdie's book as a Christmas present the day before I recorded this conversation.

off by heart, from Australia to Spitzbergen. You got to be very good at geography.

'I did it all in my scrappy — well, you couldn't call it copperplate any more — it was just a scribble. There were shortened forms of banks' names, such as Amsterdam, it would be Amrabank. I used my italic only if I wanted to do some nice writing. And also — well, people used to come and ask me to do bits of stuff. And then every year, the Midland Bank had its art exhibition, and they sent out very posh invitations to all the magnates in the City of London, like the head of the Stock Exchange. Me and another fellow would sit down for a couple of days and write invitations to Sir This and Lord This. And we would write their names in the space — the rest was gold-edged and printed. We didn't get paid extra, it was part of the job. I used to be able to do all of them without spoiling any. Five or six hundred invites. And I used italic if I wanted to write a private letter, because then I'd have time to do it. I didn't have a typewriter.

'Italic looks nicer when you're finished, and it's always legible. It's nice to receive a letter like that, when somebody's taken the effort. If it was a letter I had to do in a hurry, I wouldn't bother. I don't really join up my letters, not really — it's a sort of painted style. I used to join up some letters. I can't remember — I don't use it so much now. I'm not too sure about joining up letters. I try to get my letters as square as possible, especially the lower-case ones — they've got to be square. When you do an a, you just go along the top, down to the bottom, then almost diagonally, up, then down, so it ends up square. That's the style I picked up from the book. My friend Dennis, who used to

do the invitations with me, he had a more round style, slightly more florid. It was a sort of combination of copperplate and italic. It had a few more flounces. Dennis Coote, he was a very good painter, he died about five years ago. He made a card for you when you went to Oxford, do you remember? His handwriting slanted, I used to try to make mine upright. Everyone's got a different . . .

'My favourite letter? The one I like making with a pen? I quite enjoy making a D, a capital D. It's got a nice outline to it. I don't like A very much. Don't like E too much.'

Interviewer: 'Do you make those Greek E's? You know, people call them Greek E's, but they're not – you know what I mean.'

'No. Never. Horrible. I used to like y and z, because you can go zh-zh-zh-zh-zh, with the capitals.'

R.J.H., retired bank official, 78

16 ~ *Ink*

In Zachary Leader's superb biography of Kingsley Amis, there is a memorable photograph of the novelist, who has fallen asleep on a beach somewhere. It must be sometime in the early 1960s, during his most libidinous phase. There is a message written in lipstick on his back, by his then wife, Hilly, later Lady Kilmarnock – their marriage was approaching its end. It reads '1 FAT ENGLISHMAN I F— ANYTHING'.

It is worth remembering that writing can be done by any number of substances, on any number of receiving mediums in this case lipstick on skin. Some of these stories fall into the category of urban myth. We have all heard the story of the gentleman on a holiday with his mates whose skin was similarly written on with factor-25 sunblock by a supposedly helpful friend so that, after a long afternoon, his back blazoned BUMMER to the whole beach in spotty white letters. There is a common skin condition of hypersensitivity called dermatographism, in which the pressure of a fingertip on another's skin is enough to raise lines and letters, which might encourage such stories. There is also the story which comes up from time to time about a very helpful and kindly German prisoner of war in Ipswich who announced that he was a gardener in private life. Would the

town council like him to plant some bulbs? Oh yes, please, that would be very nice, as all the town gardeners had been called up. The POW worked very hard, to the delight of all the town. You see, they're not all bad, those Germans, and when the war's over we'll all be friends again. They missed him a little bit when he was transferred to another camp in a month or two. Then spring came and a vast array of crocuses came up, when it became apparent that the German gardener had planted them in the shape of a giant swastika.

We also hear, on good authority, about 'An interesting court case [that] occurred in Germany. A farmer was living on bad terms with his neighbour. To offend him he deliberately sowed seeds on his neighbour's field in the form of libellous words. The seeds grew to plants which were in the exact pattern of the offender's handwriting. The court accepted this as evidence and legal proof of the offender's identity, and he was convicted.'[1] There are plenty of other ways in which writing can be performed in unorthodox ways. In a story by J.D. Salinger, members of that frightful Glass family send nonsensical messages to each other by writing on the medicine-cabinet mirror with soap, such as 'Raise high the roof beam, carpenters. Like Ares comes the bridegroom, taller far than a tall man. Love, Irving Sappho, formerly under contract to Elysium Studios Ltd. Please be happy happy *happy* with your beautiful Muriel. This is an order. I outrank everyone on this block.'*

* Just how big was that mirror? Salinger tells us that the author of this message had 'minute handwriting', but had the author ever tried to write anything on a mirror with soap? There is a size of writing

We all remember the ways from childhood in which writing can be performed in unexpected ways. To a very shy and wary child, one of the few pleasures of Bonfire Night* was the opportunity to light those harmless fireworks known in England as 'sparklers' and spending the next two minutes trying to write your name in the air, its trace retained only by the retina. Still more transiently, there are the famous words on Keats's tomb in Rome, that he was one 'whose name was writ in water'. A little later in the year than Bonfire Night, when snow fell in Yorkshire† rude boys would go out to the field and make a serious attempt to piss their names in the snow — the bladder never held enough to get to the end of Simon Postlethwaite's name, but it didn't stop him from seriously trying. On the same theme, once, two German painters were talking about the German chancellor Hindenburg, whom one of them had been commissioned to depict in an official portrait. The portraitist was bemoaning the difficulty of capturing the Chancellor's facial features, upon which the other said '*Ich kann den Alten in den Schnee pissen*.' And sign his name afterwards, presumably.**

below which soap on glass just will not go. The story is *Raise High The Roof Beam, Carpenters*.

* English festival on 5 November. Celebrates the occasion when a Roman Catholic called Guy Fawkes failed to blow up parliament, by burning him in effigy, in mild disgust, and letting off a lot of bangers.

† Where I grew up.

** The painters were Max Liebermann and Lovis Corinth. The story comes, unexpectedly, from Stravinsky's brilliantly funny conversations with Robert Craft.

There are numerous attempts to write in unorthodox media on unorthodox substances in the kitchen – that festival of hopeless handwriting in icing chronicled in an unmissable website, cakewrecks.com, for instance. (My favourite is the baker who wrote on a cake, in loving Palmerian lettering, 'Happy Retirement. Good Bye Tension. Hello Prison.' The customer had requested 'Pension'.) Loving mothers have for decades proved their superiority by making pancakes in the shape of their children's initials. And so on. All of these methods may record something of their maker's characteristic and individual handwritings.*

Nevertheless, for the most part, when we want to write something to be read later, we don't write in these relatively unorthodox ways. We write with ink, on paper, and have done for hundreds of years.

* This is nothing to do with anything, but searching for narratives about handwriting and food, I discovered a gloriously mad blog about how you can improve your handwriting by changing your diet. 'The treatment I gave Jayson was ridiculously simple. Before even getting his tests back, I knew that he needed to be put on an elimination diet. That meant getting rid of the most common food allergens – dairy, gluten, eggs, and yeast. I also had him get off junk foods and sugar and eat real, whole food. I treated his yeast problem with an antifungal medication for one month. I gave him a daily multivitamin, and supplemental zinc, magnesium, and fish oil, as well as acidophilus to improve his gut and immune system. By getting rid of the things that were keeping him out of balance (food allergies and yeast) and by giving his body the things it needed to function and thrive (good food, fish oil, zinc, magnesium, and healthy bacteria for the gut) Jayson was able to recover his health. Two months later, Jayson returned to my office a new and happy boy. And remarkably, his writing went from illegible to perfect.'

Ink can be made of any number of substances. You remember how, as a child, you discovered that you could write with lemon juice on a blank sheet of paper, and it remained blank until, cunningly, you placed it on a radiator, when it darkened into a readable brown. 'I WILL MEET YOU IN SECRET IN THE WOODS TELL NO ONE AND DESTROY THIS MESSAGE.' Ah-ha! That'll foil those swine who are always spying on 8-year-olds to find out how they spend their time!

Ink, in the normal sense, comes from the Latin word 'encaustum', meaning 'to burn in'. In the Middle Ages, ink was prepared either from iron salt and oak galls, or from some sort of suspension of carbon. The most usual form of this was lampblack – the substance you get if you place a piece of glass over a burning candle. This was usually combined with gum and water. Both these inks had disadvantages. The iron salt and oak gall ink tended to brown with age. The carbon-based method produced a blacker ink, but it needed constant stirring by the writer. Moreover, when it dried, it became brittle and could in time drop off the paper altogether.

For centuries, it was quite normal for people to make ink for themselves. Recipes for ink can be found in most early writing masters' books. In Edward Cocker's 1658 copybook, *The Pen's Triumph*:

Take three Ounces of Galls which are small and heavy and crisp, put them in a vessel of three pints of Wine, or of Rain-water, which is much better, letting it stand to infusing in the Sun for one or two dayes. Then take two Ounces of Coppris, or of Roman Vitrial, well colour'd and beaten small, stirring it well with a

stick, which being put in, set it again in the Sun for one or two dayes more. Stir all together, adding two Ounces of Gum Arabique of the clearest and most shining, being well beaten. And to make your Ink shine and lustrous, add certain pieces of the Barque of Pomgranat, or a small quantity of double-refin'd Sugar, boyling it a little over a gentle fire. Lastly, pour it out, and keep it in a vessel of Glasse, or of Lead well covered.

If that seems like a great deal of effort, you could, by the seventeenth century, buy ready-made ink. The profession of ink seller appears to have been a marginal one, however. Those fascinating volumes which describe the calls which street vendors used to bawl out their wares only occasionally find space for the ink sellers. A 1648 volume of *Cries of London* does show one:

> Number 11 sells ink and pens. He carries an ink-bottle hung by a stick behind him, and has a bunch of pens in his hand:–
> Buy pens, pens, pens, pens of the best
> Excellent pens and seconds the least;
> Come buy good ink as black as jet
> A varnish like gloss on writing 'twill set.[2]

Or from a children's book of 1815:

> Come buy my fine writing-ink!
> Through many a street and many a town
> The Ink-man shapes his way;
> The trusty Ass keeps plodding on,
> His master to obey.[3]

In some of these depictions of ink sellers, the seller himself carries a barrel of ink; clearly this one was unusually successful, as he could employ an ass to carry it. The trade, however came and went, and the itinerant ink seller was evidently not a permanent sight in every town. Not every set of *Cries of London* includes the ink seller – J.T. Smith's famous one (1839) leaves it out.*

By the end of the nineteenth century, it had completely disappeared. Hindley (in 1881) classifies it among the 'itinerant occupations which the progress of society has entirely superseded . . . He who carries a barrel on his back, with a measure and funnel at his side, bawling "Fine writing-ink," is wanted neither by clerks nor authors.'[4]

The mass manufacture of ink in factories began in the early nineteenth century. As its development and constitution was tied up with new developments in the pen, we should now go back to discover what these were.

* Smith is worth our attention. One of the British Museum's first keepers, he spent most of his life sucking up to the notoriously miserly sculptor Nollekens the Younger in the hope of a massive bequest at his death. When Nollekens died, he left Smith all of £50 out of an estate of £200,000. Smith spent years subsequently writing a viciously offensive biography of Nollekens in revenge. *Nollekens and His Times* contains, among other things, a deathless scene in which Nollekens and his equally awful wife ask ten people to dinner and serve them two mackerel and a plate of mashed turnip, half an inch deep.

17 ~ *Witness*

Interviewer: 'You're full of shame?'

A: 'Let's not get into that. I went to see the film *Shame* last night. Quite a difficult watch. This is handwriting, not psychoanalysis?'

Interviewer: 'You made a face there. It's the same one as when I mention your flat.'

A: 'Yes. Let's not go there. I think shame is a thing with me. I think that's your writer's observational shtick.'

Interviewer: 'I'm not really so interested in shame, which I think is a more-or-less universal condition more-or-less successfully concealed, but why does it focus on your handwriting?'

A: 'Maybe it's a self-conscious thing, that you're asking me to reveal something about me?'

Interviewer: 'No, I'm asking you to think about why it's handwriting that people are so often openly ashamed about – this is very common – whereas if you asked someone how they feel about their clothes, people are not so likely to express shame.'

A: 'Women are.'

B: 'Because you can be more in control of your clothes?'

Interviewer: 'People often shrink from discussion of their handwriting.'

A: 'It does feel like a personal thing. It's your signature – it's part of your self. Through your handwriting, that is a mark of you, isn't it? What does my handwriting say about me? It says – I'm feeling self-conscious about this now. This is so difficult.'

Interviewer: 'Let's try a different tack. Have you ever fallen in love with someone because of their handwriting?'

A: 'I've definitely been drawn more to people when I've seen that they had handwriting that I admired. I think there's something about your handwriting which – if you can do it, it's like being an adult. My mother's handwriting is actually perfect.'

Interviewer: 'Perfect? That's a strange thing to say about handwriting. There are so many different ways to write well.'

A: 'Well, to me. I'm in her shadow. Her writing is very straight, it's very clear, it's very neat, but it's also obviously her own hand.'

Interviewer: 'Is there any sort of handwriting that if you saw it after you'd been to bed with them, say, they sent a postcard, you would say "No Effing Way"?'

B: 'No, but once – pitter-patter, head-over-heels . . . Everything that I was falling for in that person was just, oh God, look at that, it was *there*. Stylish, not completely overbearing but a little bit relaxed, not over-thought.'

Interviewer: 'Could you ever go to bed with someone if you discovered that they drew a little heart over their i's?'

B: 'I think he means you. It's unlikely that I would.'

A: female political lobbyist, 46
B: female agent, 36

18 ~ *Pens*

When you are elected a Fellow of the Royal Society of Literature, as most English writers sooner or later are, you are offered the choice of signing the Book during your induction ceremony with one of two writing implements, both inherited by the Society. You either sign with Byron's pen, or with Dickens's quill. The majority, interestingly, go for Dickens's quill, as I did, even though it must have been one of many thousands to pass through Dickens's hands – quills don't last all that long. The counter-intuitive nature of the sequence pen-before-quill suggests, however, that the historical picture that most of us have, that the eighteenth century wrote with goose feathers trimmed and dipped in ink, to be succeeded with much more durable and effective metal pens in a steady sort of way, is quite wrong. Pens co-existed with quills for a very long time.*

The problem with quills, and for many pens, was an obvious one. A quill has a very limited means of holding

* Still do. In May 2012, a reader of the *Daily Telegraph*, a Mr Robin Chapman, wrote to the paper to contribute to a discussion about the ongoing survival of fountain pens to say, 'I use a quill; always have done, always will. Those from a peacock's wing feather are both sturdy and well balanced, and in plentiful supply about my garden.'

ink, as well as being a short-lived sort of tool. Oddly, the problem of increasing the ink reservoir of a pen attracted a solution long before anyone thought of making the nib more durable by making it out of metal. Pepys, unexpectedly, had what seems to have been an early reservoir pen. On 5 August 1663, after a busy day which left him in a sweat after 'towsing' a tart called Jemimah and reading Descartes, he records, 'This evening came a letter about business from Mr Coventry, and with it a silver pen he promised me to carry inke in, which is very necessary.'

By 1710, such pens were known as 'fountain pens'; the term doesn't seem to make obvious sense to us, but the eighteenth century would have seen something which held a body of liquid to be made to flow at will. In any case, in the *OED* it's recorded from 1710, and by 1723 we have a detailed description of its working in English, in Edmund Stone's translation of a M. Bion's *The Construction and Principal Uses of Mathematical Instruments*. Stone, or Bion's, account of how the pen works, or fails to work, makes you realize that the dark corner of the human soul that works for IKEA and tortures us with flatpack instructions is not at all a new phenomenon.

> A pen about five inches long, consisting of a Pen, which ought to be well slit, and cut, and screwed into the inside of a little Pipe, which is soldered to another Pipe of the same Bigness, as the Lid; in which Lid is soldered a Male Screw for screwing on the Cover; as likewise for stopped a little Hole at the Place 1, and so hindering the Ink from running through it. At the other End of the Piece F, there is a little Pipe, on the Outside of which the Top-Cover H may be screwed on.

In this Top-Cover there goes a Porte-Craion, that is to screw into the last mentioned little Pipe, and so stop the End of the Pipe at which the Ink is poured in, by means of a Funnel. When the aforementioned Pen is to be used, the Cover G must be taken off, and the Pen a little shaken, in order to make the Ink run freely. Note, If the Porte-Craion does not stop the Mouth of the Piece F, the Air, by its pressure, will cause the Ink all to run out at once.*

The other problem that writing implements faced were the poor durability of goose quills as nibs. The answer ought to have been plain – to make them out of metal. But in fact it is not quite as simple as it seems to make a metal nib. What quills had strongly in their favour is flexibility. You can't write with just any narrow piece of metal: as the historian Joyce Irene Whalley points out, 'If you try to write a good hand with, for example, a knitting needle, or even a piece of metal more nearly adapted to pen form, you will have a good idea of the problem facing the would-be pen improvers.'[1]

The technical demand that the nib be flexible was also supplemented by an aesthetic demand – the predominant style of writing, from Bickham's ideal copperplate in the eighteenth century onwards, required an alternation

* Seriously, this passage makes me want to cry with frustration, and I haven't even gone through the horrible procedure of fixing the bits together, only to find that the Porte-Craion has not stopped the Mouth of the Piece F, and the Ink has run out upon my Wife's finest Carpet, ruining it forever and causing my Wife to belabour me about the Head with Cudgels.

between thick and thin strokes that required a flexible nib, such as a quill. There was also the point that the inks of the day corroded metal, which would require the replacement of a relatively expensive item.

These questions were worked on, and the manufacture of steel pen nibs for general sale started about 1829. Most steel pen-makers set up in Birmingham. The firm of Joseph Gillott is credited with being the first to improve the flexibility 'by making three slits in a nib instead of one – one in the centre of the point and one on each side of the "shoulder".'[2] These manufacturing processes were complex and highly intricate. Nineteenth-century authors describe 'fifteen or sixteen distinct processes [that] have to be completed' in the making of a nib.[3] By 1840 Joseph Gillott was Steel Pen Maker to the Queen, and boasting in an advertisement that he

> has been for Twenty Years engaged in the Manufacture of Steel Pens and during that time has devoted his unceasing attention to the improving and perfecting this useful and necessary article; the result of his persevering efforts, and numerous experiments upon the properties of the metal used, has been the construction of a Pen upon a principle entirely new, combining all the advantages of the elasticity and fineness of the Quill, with the durability of the Metallic Pen, and thus obviating the objections which have existed against the use of Steel Pens.

These pens were not, for the most part, fountain pens in our sense, but just nibs. Your metal nib, held by some sort of 'pen-holder', had to be repeatedly dipped into the bottle

An advert for Joseph Gillott's pens, 1900.

of ink as you wrote. It was tiresome, inconvenient, and it went entirely against the rule of writing-masters that a smooth and cursive hand be maintained with a steady flow. Reading copybooks like George Bickham, with their uninterruptedly smooth flow of line, it is difficult to believe that their authors seriously expected many people to be able to achieve the same effect without a steady flow of ink. Apart from anything else, the transfer of the pen from ink-pot to foot of page must have been a constantly perilous step, and many pages must have been ruined by a falling drop of ink.

People had attempted to create a pen with a reservoir for many years, without a great deal of success, battling against gravity's demands on ink. The early years of the nineteenth century were lively ones for patent fountain pens. The incitement, which just went on growing as the century went on, was that people were simply writing a very great deal more. The vast expansion of trade, of industry and of the public service; the creation of the penny post by Rowland Hill in 1840, which meant many more people were communicating with each other, and communicating with each other vastly more; the expansion of education, culminating in the introduction of universal education in 1871, which meant that everyone not only had the means to communicate, but was able to communicate; all these led to a need for cheap, effective, efficient methods of writing with pen and ink that could keep on going all day. The problem with a new writing device was, first, of getting the ink out of the nib in a steady, blotless flow, only when the writer wanted it, and not when, for instance, the pen was sitting in one's pocket – a problem that fountain pen manufacturers have never overcome. 'The fountain pen has never

quite lost the tendency to leak its contents – although almost all pen manufacturers when putting a new model on the market claim it as the final leak-proof fountain pen.'[4]

Secondly, more obviously, the demand was to provide a reservoir of some sort to allow the writer to carry on without a break, for line after line. Pen patents from this time onwards show any number of solutions to this problem – 'by means of plungers, pistons, rubber tubes to be operated by hand or by some mechanical device'.[5] Most inventors went along the path of an internal reservoir, as far down as those disposable ink cartridges of the twentieth century, but not all. They start being called wonderful things like 'Scheffer's patent penograph, or writing instrument' – an invention, or pseudo-invention, of 1819. Joyce Irene Whalley has a delightful diagram of a Galland-Mason external ink vessel of 1900, looking remarkably like a colostomy bag. It would be perfectly all right if you never had to leave your desk to write anything.

Some advance, too, had occurred with inks, which were now much less likely to corrode metal nibs. Stephens's ink was first made in 1834, and proved a popular and stable success. Further improvements were made with the discovery of aniline dyes in 1856. Aniline dyes were themselves an accidental discovery by an 18-year-old, William Henry Perkin, who was attempting to produce a synthetic version of quinine.* I quote Wikipedia, having no intellectual alternative here:

* Those were the days. Most 18-year-olds today would regard sitting through an episode of *Dr Quinn, Medicine Woman* for their Media Studies A level as enough of an intellectual challenge.

In one of his attempts, Perkin <u>oxidized</u> aniline using <u>potassium dichromate</u>. Under these conditions, the aniline reacted with <u>toluidine</u> impurities in it to produce a black solid, a fairly common result in 'failed' organic syntheses. While trying to clean out his flask, Perkin discovered that some component of the black solid dissolved in alcohol to give a purple-coloured solution, which proved to be an effective dye for <u>silk</u> and other <u>textiles</u>.

Perkin called his new colour 'mauveine' and subsequently 'mauve' – Queen Victoria had at least one gown made out of mauve-coloured silk to encourage industry, modernity, Prince-Albert-like go-aheadness and so on, and for a brief period it didn't seem like a fairly hideous colour. Still, inventing an entirely new colour seems like quite a dashing thing to do for a teenager, as they then weren't called. Mauve was the first of the synthetic aniline dyes, and a series of stable, synthesized dark inks for pens was a still-less predicted outcome of Perkin's initial attempt to find a synthetic quinine.*

Coloured inks were much older than one presumes, however. Red ink had been around for printers' use for centuries, and indeed had found its way into the language in the form of 'red-letter day', a day marked on the Roman Catholic calendar as a feast day, which had been in metaphorical use as a day of celebration at least since the 1770s – Coleridge uses it in a jovial way. 'Rubric', too,

* A formal chemical synthesis of quinine was only accomplished in 1944 by two American chemists. I don't know what new colours they discovered on the way.

which now just means 'running head' or 'summary' or something of that sort, specifically meant a heading printed or written in red ink, and actually goes back beyond the birth of printing to the age of incunabula.

Social functions started to evolve around the provision of ink. We still say 'ink monitor' in a jocular way, sometimes alternating it with 'milk monitor' when we refer to a sort of upper-junior-matron figure in an office – the sort of person who will, when faced with a pot of tea and a cup, ask 'Shall I be mother?' Ink monitors survive in idiom, but were once real roles in schools and perhaps in offices, too. 'It would have been the duty of one pupil to issue the daily supply of ink. He would have used a tray-like container with special holes to keep the desk inkpots steady while they were refilled. This tray also had handles so that the monitor could carry the full pots round the class and hand them out. Trays like this have mostly disappeared as have the once-common china inkwells with the maker's name lettered round the rim.'[6]

It may seem excessive to dwell on the details of pens, inks, inkholders and the like. But it is worth considering how much human investment was placed in these things. People would have used the same pen from day to day, and the same 'china inkwells with the maker's name lettered round the rim.' Each step forward in the technology would have been experienced not just as an improvement in technology, but a letting go of some element of the writer's past. The wonderful transformation of writing with a reliable ink reservoir, or transportable bottles of ink, would have been accompanied by a jettisoning of the writing companions of decades – sometimes without the faintest regret, sometimes

with a tinge of sadness that things had changed. We gaze at these things, now so useless, and try to garner the faintest sense of the human investment which once went into them.

19 ~ *Marion Richardson*

If this book has a hero, it's the proponent of child-centred art and writing, Marion Richardson. She was primarily a teacher of art, and fascinated by children's art years before the avant garde turned it into a cult object. She must have been a woman of extraordinary energy and originality of mind. Born in 1892, she brought Roger Fry a portfolio of work executed by her pupils at Dudley Girls' High School in 1917. It was a remarkable collection. Only in her mid-twenties, she had removed her pupils from any notion of copying and rote imitation, going as far as to ask 'her pupils to sit with closed eyes, perhaps listening to a description, and [waiting] for images to appear in "the mind's eye".'[1]

Across the world, traditional methods of teaching and perception were up for grabs. It's interesting to speculate what Richardson would have made of Paul Klee's teaching methods, just then about to be launched on an unsuspecting Bauhaus in Weimar. Klee's teaching was based, in a revolutionary way, on theories of colour, patterning and many other abstract designs in ways that refer back to the pleasure of the moving body and idiosyncratic ideas of movement and form. In the same way, Richardson regarded movements not as things to be subdued and made to

The Marion Richardson alphabet.

conform, but things to master and control for expressive purposes. I have a copy of the Teacher's Book which went with Richardson's unassumingly titled *Writing and Writing Patterns*, published in 1935, and it's an object of strangely alluring physical beauty. It's just the size of a floppy school exercise book, covered all over with five-pointed stars, a pleasure to handle and full of unexpected delights. A book full of a kind of spiritual beauty, too: Richardson's love of children in all their weird variety and inventiveness, and her love of the presence and energy of simple shapes on paper just shine out of her work. She was a solid, plain-looking, intelligent woman: Klee would have loved her.

Richardson's programme aims towards a free cursive handwriting, and she says, as A.N. Palmer was saying shortly before her, that it should use 'only easy movements of the hand and arm'.[2] Richardson's wonderful insight was that these easy movements were to be found in children before they even thought of writing, 'in primitive forms of decoration and in childish scribble'. Unlike Palmer, whose classes centred on the blackboard, and on grim unison drills, Richardson wanted the child to explore a range of patterns for themselves, playing with crayon on paper as a foundation of good handwriting. She warns against imposing an 'adult sense of correctness' on children. After reading of handwriting masters whose interest is in conformity, duty, and preparing for a job in commerce or the civil service, it is a pleasure to come across someone who really knows what it is to be a child, and sees that not as something to subdue in the interests of a professional future in an office, but something valuable in itself.

These pre-writing exercises are of very great importance. Not only are they a source of delight to the little child, being but a development of the spontaneous scribble that children make in imitation of 'real' writing, but by presenting the several writing rhythms in isolation one at a time, they make it possible for him to experience the essentially cursive nature of handwriting from the beginning, even before he has actually learnt to write.'[3]

You want to cheer. For the first time ever, perhaps, a reforming figure has not only noticed that the child can have pleasure and even 'delight' in making marks on paper, but has made that absolutely central to the programme. I had to sneak off to make looping cursives that resembled handwriting before I could actually write anything in it. If Marion Richardson had been anywhere in the vicinity, I would have been actively encouraged to do it in the classroom as an important stage in learning to write.

Richardson sets out a series of patterns to inspire the child – she's very clear that they should be allowed to invent their own patterns rather than slavishly copy these. They are a line of zigzags, a looped pattern 'which is a great favourite with children . . . and goes well to the jingle "up curl, down curl"', broken patterns, and still more. 'A rich and almost endless variety of patterns will appear if the children's powers of invention and visualization are encouraged, and if they are allowed to colour the shapes of their patterns after they have outlined them.'

You could have a small pause at this point to imagine what would happen if anyone suggested to A.N. Palmer, Vere Foster, Spencer or even Edward Johnston that students

be 'allowed to colour the shapes' in handwriting practice. Even when we get to children up to the age of nine, when Palmer was no doubt starting to think they ought be sending their CVs out to the blacking warehouse, Richardson is still thinking of ways to make writing fun in this way – 'it will of course add to the children's pleasure in writing these copies if they use coloured ink as well as black'. Utterly true: it was a delight at Christmas to get a small box of Winsor & Newton coloured inks, with those interesting pictures on the side* – canaries to indicate the yellow, and so on – and then to spend the patch between Christmas and New Year writing thank-you letters to all the rellies in one lurid shade after another.†

* I see they haven't changed in thirty years and more, and I hope they never do.

† A note about writing in coloured inks. There are strange prejudices at work here which ought not to bear much examination, but seem more or less insuperable. The colours of inks have proper associations, and proper standing in the world, not limited to inks used for writing. I was deeply, inexplicably shocked the first time I saw one of Joseph Beuys's drawings executed in blue ballpoint pen – the medium and the colour clearly and unarguably limited to doodling in a meeting, not for something to be exhibited in a gallery. Not for the first time, but very economically, Beuys is doing your head in with this one.

I'm not quite convinced about writing with blue ink, either. It is cosy and friendly, but perhaps not very serious – I wouldn't mind it from a friend on a postcard, but I think if I saw a student essay written in it, I would have to make an effort not to deduct three or four points absent-mindedly. Black, or blue-black is the neutral choice. You're allowed to make marginalia, and to comment rebarbatively, in red, but you wouldn't write a letter in the stuff, surely?

Beyond that, we are really into exotic and faintly frightening territory. I had heard the phrase 'green-ink letter' before I started work in

Trembling, not quite expressed, in Richardson's argument is a sense that every stage in the learning of handwriting has its own value and beauty; they shouldn't be rushed through in order to attain the perfect adult handwriting. And this is true. We certainly recognize, without any hesitation, the difference between a neat child's handwriting and an adult's. A mixture of cultural development and of educational accomplishment means that we can probably tell the difference in most cases between the hand of someone of twelve, twenty, forty and eighty. But should any of them be automatically regarded as inferior to any other? Aren't the delighted discoveries of a new writer of seven as rewarding and satisfying as an old writer of thirty? These questions hover over Richardson;

the public service in 1990, but I didn't realize it was literally true that eccentrics despatched letters to authority in emerald shades. One gentleman used to write to us weekly – I was working as a clerk on the House of Commons's Energy Select Committee at the time – in green. His complaint was that he lived on the borders of Scotland, on the English side, and had discovered that his electricity was being supplied by Scottish generators. As a patriot, he objected to his kettle and lights being powered by Scottish electricity. Moreover, he went on to explain, he was strongly of the opinion that the Scottish electricity companies were using the opportunity to influence his thoughts and indeed alter his personality for the worse, and he was already finding himself saying 'McTavish, the noo' on unexpected occasions. Could we, as the ENGLISH parliament, take up his cause?

A reply went out, wearily, weekly, regretting that the committee could take no action regarding this situation, and signed by the most junior member of staff, i.e. me, in black ink.

The Prince of Wales is said to send out long letters to government ministers debating policy, written in purple ink. Whether we can draw any conclusions from the sorts of people who use eccentric inks to

none of her predecessors would have found them the slightest bit comprehensible.

There are two photographs of classes at work that show the immense shift between the pseudo-militaristic approach which culminated in Palmer, and Richardson's ideas of starting with what the child can do, and what he will enjoy doing. If you look at one of Palmer's classes the desks are arranged in rows; the students sit facing the same direction; their pens are poised at exactly the same angle, as, indeed, are their heads. Their own mothers couldn't tell them, or their work, apart. And on the wall − it is quite hard to see, but it looks rather as if what hangs on the wall are photographs of Great Presidents of the USA, or possibly even Mr Palmer's own face. Compare this lovely

write letters with is unclear, but I can't resist sharing this lovely paragraph from Piggott's Survey. After receiving 25,000 samples of handwriting, he analysed them according to the colour of ink used − as well as many other factors − and concluded that they could be assigned as follows. 'I find generally that blue is favoured by the ladies whilst the men prefer the non-committal blue-black. The majority of those using black were artists, architects, university lecturers, R.C. priests, students, and upper-form grammar-school boys. Brown ink was used in the ratio of 1:1,600 chiefly by typographers; violet ink, 1:4,500 by ballet dancers and entertainers; and green by lady novelists (1:1,950).' I have more than a few lady novelists among my acquaintance, and I am pretty sure that none of them ever write a word in green ink. When did this interesting tendency, if it ever was a tendency, die out, to be handed on exclusively to total loonies?

Mr Piggott goes on to complain about 'names almost household words' writing to him in 'combinations of red ink on bright blue paper, green ink on brilliant yellow paper and blue ink on blue paper of almost, but not quite, the same shade', but I think those people must have been having the poor man on.

An exercise from a Marion Richardson textbook.
The patterns on the left-hand page are meant to aid
with the letters on the right.

The Cuckoo

The cuckoo is a pretty bird,
 She singeth as she flies;
She bringeth us good tidings
 She telleth us no lies;
She sucketh all sweet flowers
 To keep her throttle clear,
And every time she singeth
 Cuckoo - cuckoo - cuckoo!
The summer draweth near.

 x x x x x x x

A sunshiny shower
Won't last half an hour.

and very period photograph of Marion Richardson's pupils. They are standing up at easels – it was clever and observant of Richardson to know that very young children find it easier to wriggle than to sit still, and prefer to work where they can move about freely. Sitting still is a perfect torture to many small children, and it is much nicer to stand up. These ones are dressed in sensible, loose clothes that can bear an ink stain or two. They are making different patterns on their sheets of paper, and have reached different places. Their work is not lined up in rows, but positioned wherever they happen to be, and, working on either side of an easel, two children can happily talk to each other as they concentrate on their work. Best of all, on the walls, properly framed, are examples of the nicest of the children's work, coloured in and there for everyone to enjoy. In other photographs, if children have to sit at a table, they face each other as they work, not the authority at the front; in another, they lie prone, the paper on the floor; in another, they have been encouraged to build pretend shops in the classroom. It must have been fantastic fun to have had Miss Richardson teaching you. She says, in her book, that 'the [photographs of] classroom scenes are given as being the next best thing to seeing the children themselves at work'.

Richardson was an art teacher before she interested herself in handwriting teaching,* and her joy in pattern-making in small children is like a Mameluke master of decorative geometry, saying approvingly, 'The movement is very light and swift', 'the added rings complete the pattern

* Her *DNB* entry doesn't mention her handwriting project at all.

very successfully', 'the movement is swift and beautifully controlled', 'an ingenious variation', 'the contrast between the large pattern . . . and the small pattern made from *ea* is very happy', 'a fine swinging movement makes an interesting shape'.[4] And they are beautiful; they look very much like the patterns that Paul Klee was introducing into his own painting at around the same time, and was to go on to encourage in Bauhaus students.

The letterforms that Richardson encouraged students to work towards have a slightly italic quality to them – they are upright, and the students' books progress towards the use of a broad-edged nib. But her style is generous and broad, and throughout stresses what is easy to write, and a pleasure, and what is easy to read. Unlike the masters of italic, Richardson felt that the number of lifts of the pen should be limited in the interests of speed and ease – some italic teachers have no particular objection to repeated lifts in the course of a word, and even in the middle of letters. As a model of teaching and learning, enabling the child to progress at his or her own pace, with pleasure at their own achievements at every stage, it could hardly be improved on. The basic style of Richardson's letters were nearly ideal: stripped of obfuscating ornament, but still able to move at a smooth cursive pace. There are no loops in Richardson, though I know plenty of people who have chosen to introduce them subsequently, in the interests of ornament.*

* This is what distinguishes Richardson from Maria Montessori, whose ideas were transforming education across Europe. Montessori, too, believed firmly in the child directing the pace of his own education, and had all sorts of ingenious ideas about how to introduce children to

As I said earlier, though I admire Richardson's style immensely, I did feel, at ten years old, that there must be more to life than her distinctly no-nonsense f's.

By the 1930s, the principal schools of handwriting were established, and by the 1950s, the different schools were fighting for dominance. The old-style copperplate had its refined proponents; the Civil Service/Palmer hand was still claiming efficiency in the business world; educationalists were fighting over the different principles represented by print hands – even the fundamentalists who insisted that cursive should never become necessary – and Marion Richardson's running cursive, child-centred at every stage; and somewhere, the italic obsessives were forming societies and pressure groups and writing each other letters beginning 'I wonder if I might momentarily crave your distinguished attention.'

letters – famously, she would let them handle letters made out of sand-paper to impress the shape on their hands. Her letterforms, however, are very curious. They maintain some elaborate loops on the ascenders and descenders, but, weirdly, don't use the loops for the purposes of joining up the letters. What the point of loops in print writing might be, I can't understand. I guess the intention was that children could make the loop and then, at some later point, would find it easier to join letters up – the leap from print to cursive would be much less in the Montessori models. The cost, however, is that children start to write with an obviously and completely irrational style of writing. The looped print hand of Montessori schools, however, does have a distinct charm, suggesting to me all sorts of flavours of a European childhood, including wooden toys on strings, cobbled streets, being sent at six to fetch a baguette and a litre of red wine, and 14-year-old thugs still obliged to wear grey shorts and possibly even capes to school. Look at it, see if I'm not right.

20 ~ *Reading Your Mind*

Like most people, I have a set of unexamined prejudices about handwriting. It's not so much a set of prejudices about the look or style of writing. It's more about the ways in which characters reveal themselves through handwriting. Probably we all believe that we have some sense of what people are like through the way they write. That is one of the reasons why it was so disconcerting to realize that I didn't know what the handwriting of a good friend of mine looked like. Because of the way we live and write now, I had been deprived of a crucial piece of evidence in the art of reading, interpreting, discovering the personalities of my friend. For all I knew, his handwriting slanted backwards at forty degrees.

We needn't make a systematic study of character through handwriting to realize we have some firm principles. We've seen that Dickens already in the nineteenth century had views about what constituted a woman's handwriting, a villain's, perhaps (in Little Em'ly's too-large and too-black handwriting) that of a woman with too-strong sexual desires. I don't suppose he had thought about these matters precisely; all the same, he had made his mind up.

Here are some of the things which I believe can be inferred about a person from their handwriting. If I had a

letter from a stranger, I would have a sense of what they were like almost before I started reading.

1. People who don't join up their letters are often creative, and often visually imaginative. Alternatively, they may be a little bit slow.

2. People whose handwriting leans forward are often conventional in outlook; people whose handwriting leans backward are often withdrawn.

3. People who don't close up their lower-case g's are very bad at keeping secrets.*

4. People whose writing doesn't have much in the way of ascenders or descenders – stubby f's and y's which just gesture downwards deadly – don't have much of a sex life.

5. If someone's handwriting leans to left and right and upright like a drunk sailor in a gale, and sometimes joins up and sometimes doesn't, then they might one day murder someone for no reason at all.†

* This is cheating. I once read it in a 'How To Graphologize Yourself And Others' popular guide. I can't remember anything else from the book, but I remember this, largely because my g's gape like a yawning whale, and I am, indeed, pathologically incapable of keeping a secret if it's remotely interesting. At the time, an interesting question arose, which I still haven't had an answer to: if I took to closing my g's scrupulously, would I start to be able to keep other people's secrets?

† A terrifying example here is the last letter written by one of the 11 September hijackers to his girlfriend, reproduced in Anthony Summers and Robbyn Swan, *The Eleventh Day*, p. 350. Ziad Jarrah has no idea at all which way his letters might slope, and where he might want to join them up. Plenty of people have handwriting like this and don't go on to do anything very bad at all, but anyone looking at Jarrah's handwriting would have realized how unstable and insecure he was.

6. People whose handwriting is mainly round are generally nice. Generally, I said, generally.

7. Someone who uses the Greek E probably had an early homosexual experience. Might have had a homosexual experience last night, too.*

8. People whose signature is wildly different from their normal writing may or may not be trustworthy, but they aren't altogether satisfied with their existence.

9. People who underline their signature are convinced of their own significance in the world.†

10. If you ever come across anyone who signs their name and then, instead of underlining it, runs a line through it, run a mile. Years of therapy await.

11. Anyone who writes a circle or a heart over their i's is a moron.**

12. A handwriting where the crossbar of the t doesn't touch the upright is that of an impatient person. Hire them. They get stuff done.††

* Sheer prejudice, not backed up by any evidence at all.

† Not necessarily a bad thing. Actually, I do it, in my conceited way. But just think of Elizabeth I's signature, wending its way downwards through a sequence of ornamental underlinings like the path through the Red Queen's garden. Some of Dickens's signatures are underlined seven or eight times, but then you may feel he had a point in conceding his own excellence.

** Also prejudice. Everyone agrees on this one, to the point where one could say that the prejudice happens to correspond to the truth. You would think the word had got back by now.

†† Look at Mrs Thatcher's signature, and see if there's not a point to this one.

13. Someone who has unexpected upper-case forms for lower-case letters, often R and Q, would jump out of an aeroplane, fuck a pig, steal and drink the homebrewed absinthe of a Serbian warlord, just to see what the experience was like. Go for a drink with them. Just not in Serbia.

14. Anyone who puts a loop on their ascenders in b, d, f, h, k, l, and t is either an American who went through the Palmer programme or someone who puts on their pyjamas and bunny-faced slippers to watch *The X Factor* with a nice cup of cocoa.

15. If there are big gaps between your words as you write, then you're a little bit lonely. If your words come close together and even join up, then you're more likely to be gregarious.

All this is not very systematic. It comes from decades of observation and mindless prejudice, and in some cases the single source of the observation is clear to me.* But the skill of reading character through handwriting has been developed over hundreds of years. Its specific insights into aspects of handwriting have hardened into firm principles, and have been used for a number of purposes. Graphologists often make a good living through various applications of their skill. They may be called upon by the courts to pass judgement on the authenticity or otherwise of a handwriting or a signature. They may be employed by companies to examine the handwriting of candidates for a job, to explain what signs of strength and weakness they

* Number 11 is principally a girl called Amanda I used to know.

have discovered. Or they may be used to give a sort of mock-occult reading of someone's handwriting for their personal interest and curiosity – a sort of palmistry with, it must be said, more reliable results.

It may seem peculiar that the legal/forensic and character-reading side of the graphologist's trade are practised at the same time. It would be grossly improper, for instance, if a graphologist said that he discerned a criminal or a psychotic personality in the handwriting of the man in the dock. But these strands of graphology developed more or less at the same time. Graphology started as a means of distinguishing the extraordinary – the genius and the criminal. What you were like, and what people could be like, was the driving force behind graphology from the start.

Before the nineteenth century, handwriting was not thought of as something which was particularly individual. Now that we communicate almost entirely through typing, we may be in the process of stripping writing of those individual associations again. Before the very end of the eighteenth century, it didn't seem at all desirable, or indeed probable, that handwriting was one of those things which separated men out from each other. People learnt to write in a particular school, and practised until they could exe-cute the style of that school, more or less anonymously. They wanted to turn themselves into typewriters, or word processors, and different styles of handwriting were akin, as it were, to fonts, just as we now distinguish ourselves only by our choice of words and our choice of pre-prepared fonts. Of course, this avoidance of the individual style was not always completely executed, and people could always be distinguished by their writing. We know this, among

other things, because of a dirty joke in *Twelfth Night* as Malvolio reads a forged letter from his mistress, Olivia: 'These be her very c's, her u's and her t's, and thus makes she her great P's. It is in contempt of question her hand.'* It was not until much later, however, that this individuality began to be seen as important, and later still that it started to be interpreted as a clue to what people might be like as human beings.

The eighteenth century was interested in the ways in which the personality reveals itself through external means – the pseudo-science of physiognomy, in which a criminal or a noble character is shown in the face,† and the even odder one of cranium-reading, or phrenology, according to which if you had a big bulge at a certain point, it showed you were musical. More productive was the study of gesture at the time. Previous ages had settled for a survey of how ladies and gentlemen moved, and presented the facade of gentlemanly behaviour as an ideal for study.** The end of the eighteenth century started to think of gesture as

* Well, it's a slight improvement on some of Shakespeare's jokes, such as this stinker from *Love's Labours Lost*: '"I love not to be crossed." "He speaks the mere contrary – crosses love not him."'

† Still believed in by many people, including my favourite novelist: 'The fleshy fold under his eyes denoted sensuality, and she had never, never been wrong about that, she was sure . . . There was an arrogance about the deep lines from nostrils to mouth, and in the set of his lips.' Elizabeth Taylor, *Blaming*.

** Lord Chesterfield, in his letters to his son, often seems to regard the personality as something to be suppressed under a facade of gentlemanly behaviour – standing correctly, speaking correctly, and indeed writing correctly, just as other gentlemen do. A particular low point is his suggestion that it is frightfully common to laugh.

something which revealed thoughts and emotion, and, to a certain extent, character. When, in Maria Edgeworth's *Patronage*, we are told of Lady Jane Granville that 'in all her Ladyship said, in every look and motion, there was the same nervous hurry and inquietude', we see a growing interest in the ways in which people's outer crust gives away their inner concerns. That interest would soon spread to the ordinary person.

With regards to writing, it was not altogether clear that people wrote in individual ways. The principle that a person could be identified by their writing was established in English law in 1836.* It had been suggested as early as 1726, by Geoffrey Gilbert in *The Law of Evidence*, that the differences between men's handwriting could serve to identify them. By 1836, the question was settled: a handwriting was individual, and possessed something called 'the general character of writing, which is impressed on it as the involuntary and unconscious result of constitution, habit, or other permanent cause, and is therefore itself permanent.'[1] The power of handwriting, thus impressed on the reader in a permanent way, had an awesome authority.

It was not just in the legal arena that a handwriting's individuality was being examined. This was the age of the cult of personality, and of the autograph collector. The odd hobby of acquiring the signatures of famous, notorious or completely unknown figures rose to great heights in the nineteenth century. Some of the collections amounted to more than 100,000 individual signatures, and were sold for large sums of money. In an essay of 1840, Edgar Allan Poe

* Doe vs Suckamore. The judge was Coleridge's nephew.

examined some autographs of famous literary figures, and suggested that 'a strong analogy does generally and naturally exist between every man's chirography and character.' He took the opportunity to talk about some celebrities of the day, in sometimes rather sharp terms: you feel that his view of their literary qualities preceded his analysis of their handwriting. The worst thing that can happen to a writer is that their hand shows no individuality. The genius, it seems, should reveal his character through the strokes of his pen. William Cullen Bryant had 'one of the most commonplace clerk's hands which we ever encountered.' The forgotten poet Rebecca Nichols's writing was 'formed somewhat too much upon the ordinary boarding-school model to afford any indication of character'. Another writer, David Paul Brown, had trained as a lawyer, and this, Poe thought, had suppressed any kind of character other than that of the professional class. When Poe admires someone, you can't but feel that he is not really describing the handwriting: William Ellery Channing, a clergyman, has writing with 'a certain calm, broad deliberateness, which constitutes force in its highest character, and approaches to majesty'.

People like Poe might be on to something. The qualities which he identifies – boldness, conventionality, unpretending simplicity, deliberateness – are surely ones which we have privately identified ourselves in reading the handwriting of a stranger. It's true that it is hard to see what led him to the conclusion in each case, but there is no reason to think that Poe was not sincere, or that his mass audience thought that what he had identified was implausible or random. But there was a gap between the handwriting

and his impression of it. Now that many people thought that the individual character was manifest in handwriting – even if it was only a character impressive for its commonplace nature – and that many people might agree, in general terms, on the impression given by a man or a woman's handwriting, the time had come to move beyond the general, and to produce a systematic, detailed guide to the elements of handwriting, and what they might mean.

Edgar Allan Poe

21 ~ *Witness*

A: 'We were taught normal and cursive – I forget the name for normal, standard? – but I remember cursive. Normal was print, cursive was joined-up. I remember handwriting lessons in school. We had special tabs of paper that had two horizontal lines, and you filled them in, and did the letters over, and over, and over, and you were done. Or were there three lines? We faced the front of the room, and we did it all together, all at the same time, took the pen off the paper, and then handed it in. That was in the Miami Dade County public-school system, circa late-seventies [laughs]. My handwriting's changed completely. I only do cursive s's now – I never do standard. I only do a cursive s with a standard t. I mix it all together, it's not anything like it was before. I'm always getting complaints about too small, spidery – my father calls it stick and scratch. An example is 'Steve' – the way I write my name. A sort of cursive S, then a standard t, e, v, e, with joins. It's just a mish-mash. That's Miles, that's me [shows interviewer signature on Christmas card]. Miles is much clearer than I am. Is my signature really so unlike my handwriting? Well, there's always the big S, and it's more joined, obviously, and when I write things I don't ever write things in cursive.

'And we did calligraphy at school. So. Picture it. This

is in the sixth grade, so I would have been twelve, and we'd do these mini-courses, and we did a four-, five-week course. We did calligraphy. And I can remember using the utensils, and learning how to do it, and you lay the pen flat, and make the letters the right way . . . that's all I remember. We had special pens, and we had the ink to dip it in. So it was all done very authentically. Very alien to all of us . . . Such a waste.

Interviewer: 'What?'

A: 'Did you see that straight guy?'

S.B., financier, 39

22 ~ *Vitativeness*

A chart of 1900 or thereabouts[1] aims to show readers what qualities may be revealed through a person's handwriting. The chart displays dozens of human characteristics, written in a handwriting that is supposed to embody that characteristic. They include 'amativeness, conjugality, inhabitativeness, philoprogenitiveness, destructiveness, approbativeness, concentrativeness, vitativeness, firmness, veneration', and many others, some of which seem actually to be words. Charts like this beg a question. Is it really the case that human beings embody single predominant emotions, to be exhibited on all occasions? Or could it be that all of us have our destructive moments, possibly followed by a conjugal mood in the evening over dinner?*

* This is not the place to go into it, but many people in the past did firmly believe that the characters of individuals had a rigid predominant mood which could be defined by their dark faces, their posture, even their dress. Deriving ultimately from Greek theories of the humours, it emerges in refined and complex forms in the eighteenth century. Alexander Pope believed that everyone had a sort of guiding spirit which defined them, and when he came across a class of human beings which he felt could not be explained away like that, he airily remarked that 'Most women have no characters at all', meaning that they had no fixed characters. The Swiss pre-anthropologist Lavater

The late nineteenth century saw an explosion of interest in the external signs that people carry with them; they were ways by which strangers could be read. Think of Conan Doyle's Sherlock Holmes stories, wildly popular from their first appearance in 1887, and Holmes's initial remark to Watson, 'You have been in Afghanistan, I perceive.' Holmes's famous facility to 'read' an individual through a hundred minuscule external signs appealed to an audience who were tickled by the idea of understanding strangers without having to speak to them. Slightly surprisingly, Holmes, or Conan Doyle, doesn't show a great deal of interest in handwriting, and what interest he does show can be absurd. In 'The Reigate Puzzle', Holmes not only deduces someone's age from their handwriting, but says, 'There is something in common between these hands. They belong to men who are blood-relatives. It may be most obvious to you in the Greek e's, but to me there are many small points which indicate the same thing. I have no doubt at all that a family mannerism can be traced in these two specimens of writing.' In 'The Naval Treaty', he is confident of the sex of the writer of a note. In 'The Norwood Builder', Holmes rather brilliantly works out that a note which goes from fluent to wobbly to illegible has probably been written on a train which was periodically passing over points. The nascent science of graphology suddenly and unexpectedly enters into 'The Sign of Four' in the following exchange:

started a hare running in the 1770s with his *Essays on Physiognomy*, explaining how people's fixed personalities were exhibited in their equally fixed faces.

'Have you ever had occasion to study character in handwriting? What do you make of this fellow's scribble?'

'It is legible and regular,' I answered. 'A man of business habits and some force of character.'

'Holmes shook his head. 'Look at his long letters,' he said. 'They hardly rise above the common herd. That d might be an a, and that l an e. Men of character always differentiate their long letters, however illegibly they may write. There is vacillation in his k's and self-esteem in his capitals.'

The analysis of handwriting is only part of it, however, and one which would appeal to other people much more than to Holmes – it is quite striking, as a measure of Conan Doyle's modernity, that he is at least as interested in the supposed individuality of typewriters as he is in the handwriting of individuals. But the examination of individual traces was, in itself, of great modern necessity. The range of disciplines supposedly mastered by Holmes would hold no appeal in a society where everyone lived in a small community, and knew everyone's business. It is a fantasy from an urban world, where almost everyone is a stranger, and almost anyone could be dangerous.

Not everyone could be a Holmes – actually, nobody could, since he's a fictitious character.* But everyone could

* Something many people forget. There may still be a fundamentalist sect of Holmesians who flatly deny the existence of Conan Doyle, as there is an extremist wing of *Archers* observers, for whom any denial of the existence of Ambridge or the profound reality of Linda Snell is the utmost blasphemy.

acquire some skills which would enable them not to employ an embezzler or marry a libertine. At the beginning of the nineteenth century, for an Elizabeth Bennet to discover the truth about a Wickham was comparatively straightforward: you balanced his account of himself against Darcy's and Darcy's apple-cheeked housekeeper, and came to a conclusion. When external signs are noted in Jane Austen, they don't necessarily signify anything very much. Jane Bennet writes, we are told, 'remarkably ill'. Thirty years later, a novelist would expect his readers to understand something because of that. In Austen, everyone lives in a small society, so that they don't need to examine Jane Bennet's handwriting to understand that she's made of sterling stuff – you just had to ask her friends and acquaintances. By the end of the century, an adventurer who was carrying on Wickham's old trade had a much better chance of success. He could appear out of nowhere, with nothing but a vast and indifferent urban landscape to appeal to. The wary employer or fiancé had to appeal, Holmes-like, to some means of diagnosing vitativeness in a stranger, before they emptied your safe or gave you syphilis. Whatever vitativeness may be.

The end of the nineteenth century saw an explosion in books explaining how to discern character from handwriting. All of them emphasize the essentially mysterious, hidden quality in handwriting, and the fact (naturally) that you'd have to buy a book and master the system before you could begin to understand the principles involved. Their titles tell the story, from the 1870s onwards, and what had been an occasional, speculative idea spun out into an essay becomes a dauntingly pseudo-scientific school: *L'art*

de connaître les hommes d'après leurs écriture (1878);
*Chirography, or the Art of Knowing One's Character Through
Handwriting; How to Read Character in Handwriting* (1890);
How to Read Character From Handwriting (1891); *Talks on
Graphology: The Art of Knowing Character Through Hand-
writing* (1892); *The Mystery of Handwriting* (1896); *Reading
Character From Handwriting: A Handbook of Graphology for
Experts, Students, and Laymen* (1902); *What Handwriting
Indicates* (1904), and so on, in a virtually unbroken line to
the present day.

Some of the interests of these books are in enabling
people to understand their own characters better, in the
way that people read horoscopes, star signs, and go to
palm-readers to listen to someone else talk about them.
Probably the initial interest in graphology was exactly that,
to discover what sort of person one was from analysing
one's own character. In the maelstrom of the late-
nineteenth-century City of Dreadful Night, a Holmes could
discover not only that the world was full of strangers, not
only that the partner of one's life and bed was a stranger,*
but that you could perfectly well be a stranger to yourself,
in need of the professional and occult services of the
graphologist. Nevertheless, though this was certainly the
primary appeal of the new school of handwriting analysis,
it was often sold as a means to detect imposture and char-
acter flaws in others. The early graphologists boasted about

* The whole point of many Sherlock Holmes stories could be summed
up as 'My Wife Married a Darky' or 'My Boy's a Secret Murderer';
someone you thought you knew turns out to be a near-complete
stranger, with long stretches of history unaccounted for.

their ability to detect marital incompatibility, and thereby prevent a long-term unhappy marriage, to advise people about the sorts of work they were most fitted to, and, on the other side of the coin, to advise employers about the qualities which a candidate for a job might be concealing, or perhaps not really understand himself. A 1911 *Practical Method of Reading Character Through Handwriting* claims to understand 'whether or not two persons are suited to each other', and by the 1920s, business clients of the graphologists William French and the sonorously named DeWitt B. Lucas were happily indicating that they would be willing 'to admit that I should take Mr French's delineation in preference to my own judgment'. Lucas claimed that he could give the executive 'unusual wisdom and sagacity in dealing with people near or far, known or unknown to him.'[2]

Of course, nobody would pay good hard cash for an analysis which had remained on the level of Edgar Allan Poe's impressions of people from their autographs. Some kind of systematic basis for the analysis must have evolved for people like DeWitt B. Lucas to make a living among respectable folk. The origins of the analysis of individual strokes lie with a French priest called Michon. In 1875, Michon not only coined the word 'graphologie', but assigned systematic features of character to particular variations in the rendering of letters. Michon seems to have been the first student of handwriting to make a methodical collection of samples of handwriting, amounting in the end to thousands of examples. Whether he systematically studied the characters of the authors of these handwritings is not quite so clear. Nevertheless, Michon had no hesitation in declaring that, for instance, 'all weak-willed people cross

their t's feebly'. Michon's analysis, going far beyond Poe's generalized impression and possessing every appearance of a proper analytic science of character, inspired disciples to specify still further. These disciples, whatever the end they had in mind, contributed to a useful analytical sense of what handwriting might be made up of. A Crepieux-Jamin, conducted his analysis according to seven characteristics – slant, pressure, letter size, strength of ligature, speed, letter shapes and organization. Michon's disciples probably assigned some human characteristics to each of these – at least, that was their declared purpose. But probably nobody had thought of handwriting in these systematic terms before the late-nineteenth century French graphologists. Their work, propagated through idle fashion, might have been of great use to people who had no other intention than improving the elegance of handwriting through teaching. It helped them to understand what handwriting was.

In the first half of the twentieth century, the different components of handwriting had been broken down by graphologists. Each, they believed, could yield a different insight into the individual writer's personality. At the very beginning of curiosity into the psychological yield of handwriting, Isaac D'Israeli (father of Benjamin) had written that social pressures and schools of writing had suppressed individuality. In an ideal world, D'Israeli thought, 'Nature would prompt every individual to have a distinct sort of writing, as she has given a peculiar countenance – a voice – and a manner'. He conceded, however, that even in this ideal state, analysis could only go so far. 'One great truth must however be conceded to the opponents of the

physiognomy of writing: general rules only can be laid down.'³

Those general rules, and translating the general impression given by handwriting into a description of character, continued until Michon. As the school of graphology developed, so did the number of ways in which handwriting could be described, going well beyond Crepieux-Jamin's seven characteristics. A manual of graphology of 1969⁴ lists sixteen separate factors which the graphologist will want to consider: '1. Size; 2. General layout; 3. Direction of lines; 4. Degree of connection (we call it connected writing when at least four or five letters in one word are connected); 5. Form of connection of upstrokes and downstrokes; 6. Regularity; 7. Rhythm*; 8. Degree of broadness; 9. Speed of writing; 10. Form of letters; 11. Covering of space; 12. Shading of writing; 13. Angle of writing; 14. Right and left tendencies; 15. Spacing; 16. Degree of attention.'

Some of these are more obviously real factors in creating handwriting than others, but some attempt is being made here to systematically analyse what goes into handwriting. Schools of handwriting, such as Palmer's or the italic proponents, too, were considering many of these factors, and indeed arguing very strongly over factors like 'degree of connection'. The graphologists, however, took these factors and tried to match them with psychological

* The reader may wonder what the difference between 'regularity' and 'rhythm' is. This writer assigns to 'regularity' things like the size of small letters, the angle of writing and the distance between downstrokes, which, if constant, can term the writing 'regular'. Rhythmic writing is 'when the tendency of the writing, whether regular or irregular, is maintained from beginning to end'.

properties. Here is Singer's partial list of characteristics which may be identified in specific features of someone's handwriting – I don't think he would have claimed this to be a complete list: 'natural basis of character; intelligence; general inclination; artificial basis of personality; basic objective qualities; basic subjective qualities; individual perspective; social tendencies; degree of dependency on others; social behaviour; approach to money; temper; personal standard of happiness; special professional abilities, inclinations and talents; working qualities; moral qualities; special tastes; sexual peculiarities; abnormal state of mind.'

There are things which few graphologists claim to be able to divine – most professional graphologists, before embarking on an analysis, will ask for the age, sex and country of upbringing of the subject. Plenty of them don't go as far as Singer, and say that they can't tell about someone's sexual nature. No wonder, however, in the light of these lists, graphology became a full-time profession in the course of the twentieth century. By hunting through sixteen or more parameters of a subject's handwriting for indicators relating to personality features ranging from 'special tastes' to 'artificial basis of personality', an analyst could confidently come up with statements linking psychological insight with the smallest features of a hand. Singer, for instance, says quite confidently that if a downstroke of the h goes under the line to the left, then it means 'unwilling to talk things over and compromise, believes in fighting things out'.[5] How did he come to this conclusion, one of hundreds? Michon collected hundreds, if not thousands, of examples of handwriting and, where he thought

people were of similar types, tried to find similarities in their handwriting. Have any such exercises been quietly carried out in recent years? Given the immense change between nineteenth-century French handwriting and twenty-first-century hands, it would seem extraordinary to assert that any difference could only be psychologically superficial, and that nothing of significance had been lost in the characteristic degrees of connection, forms of upstroke and downstroke, and so on. It seems most likely that many of the principles that graphologists work by have been passed on through the generations without being re-tested from time to time.

Just how far graphology can go from a neutral analysis of psychology through handwriting is shown whenever many of the pre-war graphologists get onto the subject of nationality. Now, it seems fairly obvious that your nationality will principally influence your handwriting according to the preferred national styles. A Palmer-style method of writing in an individual doesn't tell you much about his personality in itself, only that he was taught to write in an American school. Those curious Montessori print letters with loops will not tell you anything other than that the writer was taught in a French or Italian school. Many pre-war graphologists let their xenophobia get the better of them, and the characteristic styles are seen to demonstrate something specific about national characters.

A Rosa Baughan quotes the eighteenth-century physiognomist Lavater: 'The more I compare different hand-writings, the more am I convinced that handwriting is the expression of the character of him who writes. Each nation has its national character of writing, as the physiognomy of

each people expresses the most salient points of character in the nation.' This is about as bad a parallel as one can think of; of course people aren't taught their face as they are handwriting – they are born with it. Nevertheless, Miss Baughan believes that national characters, as well as individual ones, can be analysed by the graphologist. When she talks about a French style of handwriting, a sense of style, of psychology, and a gruesome national stereotype all muddle together:

> The graceful insouciance of the French nation, its dislike of fixed work, and inability to 'buckle to' steady labour, are shown in the rounded curves, the long and sloping upstrokes and downstrokes of the most ordinary type of French writing; the vanity and boastfulness of the nation are shown in the liberal amount of flourish in all the capital letters, and in the exaggerated ornamentation of the signatures of almost all French writers, whilst the delicacy of the lines of the letters, the fineness of the upstrokes and downstrokes, are all typical of the grace and refinement for which the nation is celebrated all over the world.[6]

Other graphologists, much later, seem to believe in national characteristics in the most rigid and stereotypical ways. It doesn't seem to occur to this particular graphologist that people might be taught different styles in different educational systems for reasons only tangentially related to something called the 'national character'. Interestingly, when it comes to her own nation, she refuses to accept that there is any such thing as a national character, for the same

reason that when we are complimented on our accent in a foreign place, we tend to have to choke back the suggestion that we have no accent; it is the complimenter who has one.*

> The Italian handwriting usually contains flowing capital letters showing much romance and gaiety. French writing generally shows meticulous letter formations . . . This may show cool and logical thinking, and fine sensibilities . . . The Spanish writing usually contains ornate capital letters, signifying a stately pride . . . In the German writing we find more intricate letter forms, which usually show careful and detailed thinking . . . Russian handwriting usually contains long connecting strokes . . . these point to garrulity and outgoing personality traits . . . There is no such thing as 'an American style'.[7]

In the work of these early graphologists, the reputation of individuals often seems to precede them, whether for good or not, and is often tied to their nationality. Ms Baughan

* The other day I was in New York and staying in a hotel called the Eventi Kimpton, a name which no taxi driver could understand when spoken in English, by an Englishman (me), from England, which of course is just another exotic accent nowadays, and good luck to us. After three fruitless days of me saying *Eventi Kimpton* to a response from the front seat of silent, puzzled idling, I started saying *Uh'venny Kinduhn*, which proved more like the correct pronunciation. Often, abroad, I hand over the job of explaining where we want to go to my husband, who is Bengali and has a much more universally acceptable and understandable English accent, though even he drew a blank when the hotel we were once staying in in Houston was the Warwick, pronounced *War Wick*.

remarks of the really quite innocuous signature of Louis Philippe, 'What egotism and pretention in all those twists and flourishes . . . and yet, with all this parade, what a compression, amounting to meanness, there is in the letter – egotism, pretension and vulgarity of mind are here rampant!'[8] Spotting psychological tendencies which you knew about anyway in the handwriting of famous people is, I have to say, the occupation of idiots. Everyone knows that Louis Philippe was somewhat vulgar and egotistical; how easy to find that his handwriting bears this out. Of course, if this sample turned out to be taken from a letter by Berlioz, it seems all too likely that the graphologist would find the same twists and flourishes the signs of an idealistic and imaginative nature, somewhat detached from reality, full of dreams. My endeavours to find the most stupid observation made by a graphologist about the handwriting of a well-known person culminated with the graphologist who tells us solemnly that 'Sometimes, however, the writing leans extremely far to the right . . . One name that stands out in this category of handwriting was Hitler.' Well, I'll go to the foot of our stairs. Where else would Hitler's handwriting lean towards?[9]

The suspicion that, for some writers, graphology was only a means to be rude about people they disliked anyway, or, *mutatis mutandis*, suck up to their friends, can't be dismissed. In one dilettante-ish work by a Russian princess, the pretence at analysing handwriting barely covers the observations she would make anyway about an Italian music teacher – 'Imagination is denoted by the eccentric form and overweening vanity by the absurd flourish'[10] Richard Wagner – 'Here we have extreme originality,

courage, imagination, and a certain doggedness of will in the thick downstrokes which made him stick to his own convictions in spite of the many obstacles put in his way' – and someone called Countess Sophie Torby: 'This shows a very sweet, kindly nature; possibly a little impulsive, but her impulses are always good. She is generous and unselfish and a true friend.'*

For other, more serious or more ambitious graphologists, handwriting was a tool of professional psychology, often used to uncover aspects of a life which might remain hidden even to the subject. A truly hardcore study by Nadya Olyanova is actually called *Handwriting Tells*. Handwriting can uncover the most secret parts of a personality, and lead to a diagnosis. Some of Ms Olyanova's case studies claim an extraordinarily implausible insight into aspects of the patient's history:

> This handwriting of a so-called hippie shows the child plainly in the very rounded formations, coupled with the weak t-bars that do not (or barely) go through the stem. But there is hope for her making a practical adjustment, since she has a desire to study beauty culture; some day, and with the proper encouragement and help, she could succeed. The circle i-dot tells us

* I hate to be cynical, but it does cross my mind that one person the Countess Sophie Torby may be 'generous' and 'a true friend' to is the Princess Marie Bariatinsky. Is a Princess paying a Countess back cheaply for hundreds of sponged lunches at Lyons's? Some of those expelled Russian princesses were pretty hard up in the 1920s, and might even, I suppose, have resorted to performing a party turn called Revealing Character Through Handwriting at tea parties for a bob or two.

that she considers herself different; it also means she could develop manual deftness, as she has a natural bent in this direction. The vertical angle expresses signs of passivity and isolation, forced on her by elements in her environment. Yet she can also be outgoing and responsive when she senses she is on friendly soil. (The unfriendly soil is her home environment in which a stepfather subjected her to physical cruelty and threatened to shoot her in the back!)'[11]

Another writer still more explicitly links handwriting to the 'tells' of Freudian analysis:*

Just as we give something of ourselves away when we say the wrong word, or stutter over a psychologically important name, so the forms of handwriting can be significant. In speech, a slip of the tongue can reveal the speaker's true intentions; in handwriting, it is the insignificant-looking middle zone, and the initial and end adjustments that may give the writer away. A 'Yes' all over the capitals is a mere boast concealing the middle zone's 'No'.[12]†

There is even a small but mesmerizing body of work by practising psychiatrists which claims to be able to diagnose

* Set out in Freud's *The Psychopathology of Everyday Life*, full of tales of people hoping to say 'Pass the salt, Father', but mistakenly saying 'Rape the innocent child, arsehole', instead.

† In the course of preparing this book for publication, my lovely editor, Mr Jon Butler, flagged up this comment with the words 'Sorry, P: I may be slow but I can't for the life of me work out what this means.' That makes two of us.

mental illness, schizophrenia, paranoia, compulsion disorder and drug addiction, to say confidently that 'studying the boy's handwriting revealed that his relationship with his foster mother was not entirely felicitous'[13], even to judge the sincerity of a threat to commit suicide,* from people's handwritings.

These Freudian analyses ultimately result from the work of a Swiss graphologist called Max Pulver. In his *Symbolik der Handschrift* of 1930, Pulver elaborated a theory of 'zones' of handwriting which corresponded to a key element of Freudian theory. Handwriting, according to Pulver, operated in three horizontal zones. The top one, where the upper strokes of the letters b, d, f, h, k, l and t were to be found; the lower one, where the downstrokes of f, g, j, p, q, y and possibly z were located; and the middle

* Billie Pesen Rosen, *The Science of Handwriting Analysis*, p.188. This last one, so airily despatched, I don't think any responsible psychiatrist would nowadays risk – the possibility of a law suit is just too strong if the suicide threat proved more genuine than the handwriting suggested. Also, I have to say, I wouldn't trust Ms Pesen Rosen from the moment she kicks off with the imprecation, 'Supplement your knowledge of human nature with the rich revelations of graphology!' She is, too, the only graphologist-psychologist I found who seriously revived the Spencerian suggestion that handwriting was not just a way of analysing your character defects, but that through making conscious changes in your handwriting, you could actually improve your character, in this case by boosting your self-esteem: 'To prove to yourself that you have faith in the well-known power of the will, and to encourage the fruition of this plan, remember to raise the height of the personal pronoun I while you are writing. After a while your unconscious mind will accept this new concept of yourself, and when you write, the letter I will take on new height without any conscious effort on your part.' [p.35].

one, for everything else. Pulver believed that lively activity and movement in the top zone corresponded to imaginative, philosophical, intellectual, aesthetic aspects of the brain – so a capital T with squiggles at either end might indicate a poet or a mystic. The lower zone corresponds to base urges and appetites, sexual desire, the subconscious mind, so the highly libidinous might produce swirls at the bottom of their lower-case y's. The middle zone, where lower-case a, e, i, m and so on are written, relates to the facts of everyday life. The three zones corresponded loosely to Freud's idea of the super-ego, the ego and the id, as immortalized in that great classic remake of *The Tempest*, *Forbidden Planet*.*

Looking at a particular hand, one disciple of Pulver observes that 'The lower zone may be sadly neglected, with very short loops to the letters y, g, etc. Here we have a writer who shows a certain lack of realistic outlook, a lack of sense for material necessities. There will probably be sexual immaturity, sexual fear or trauma. Doctors have also found this writing trait in the script of patients with damaged or incapacitated legs or feet.'[14]

He was doing so well until that last bit.

Pulver, on closer examination, seems a weird mix of the plausible and the utterly fantastic. My generalized sense that people with abruptly shortened downstrokes don't have much of a sex life accords in a detailed way with Pulver's theory of zones. On the other hand, there is this belief, which underlies the whole exercise:

* Monsters from the Id!

The point along a line of writing at which the moving pen of a writer arrives becomes a symbol of his own position in the world around him; to the left of this point lies the past, origin, mother and childhood, to the right lies the work to be done, the future, the writer's fellow men and the social world. Movement upwards . . . symbolizes gravitation towards spiritual and intellectual spheres; movement below symbolizes a dive into the material, sub-human and sub-conscious world.'[15]

If by now, you are raising an eyebrow, you may be right to do so. Apart from anything else, this seems weirdly culturally specific. What can graphologists do with a script like Arabic which moves from right to left, or with bilingual writers in English and Arabic who write from time in different directions, and may therefore have two different concepts of the direction on the page in which the future, the work to be done, lies? What should they do with Indian scripts which are experienced by their writers not as rising from the line towards spiritual and intellectual spheres, but as hanging from a line like washing?

It is perhaps worth noting at this point that most of the books I have been quoting from were published between the First World War and the very early 1970s. There is a reason for this, and it is that professional mental-health associations worldwide, such as the British Psychological Society, have declared graphology to be of 'zero validity'. One recent study has demonstrated that graphologists are no better than random choosers at identifying the occupation of individuals from their handwriting.[16] Two hundred objective studies have failed to establish reliable connec-

tions between personality and handwriting.[17] You would be about as likely to meet a proponent of bibliomancy, palm-reading or haruspication among psychiatrists these days as someone prepared to write the sort of handwriting-analysis case study that Irene Marcuse did as recently as 1969:

> The light-pressured and loose script, in addition to the ever-changing slant, shows the inconsistency of her personality. She clearly was mentally disturbed. Her exaggerated sexual desire, which remained unful-filled, is shown by the inflated lower loops, some turned back to self. Since she had neither physical nor mental resilience, no one was ever able to help her, and she eventually committed suicide.[18]

So what could graphology do? The graphologists, whether professional or popularizing, make several suggestions. A lot of them view handwriting as a diagnostic tool in mental health, though only very rarely as any kind of cure. As we have seen, Spencer thought that improved handwriting could improve a moral character, and keep potential drunk-ards out of the ale house. Few of his twentieth-century successors thought that you could cure sexual obsession by advising a patient to make his lower loops more restrained. A lot of them, from the beginning of commercial graph-ology, thought of the tool as a way of advising whether an engaged couple were compatible. A good many of them, probably with their eye on the main chance, recommended graphology as a business tool. One graphologist, Dorothy Sara, cites the question, 'We are a credit house. Will this customer, according to his handwriting, be a good risk and will he repay a loan?' as an example of what graphology

might usefully address. The author, however, probably considering the consequences of getting it badly wrong, somewhat hedges her bets. 'While the credit house may be wise in having the client's character analysed, that firm cannot be promised that the loan will be repaid.'[19]

Another question to the same graphologist, in the copy I read, inspires an interesting marginal addition from a reader: 'I met this man, but I think he is married. Is he?' Sara responds lapidarily: 'The graphologist cannot know, as handwriting does not reveal if a person is single or married.' Where the published author can only venture so far, the author of marginalia can speculate without bounds. On this page of the London Library copy I consulted, someone has written 'But one can discover whether he is sexually satisfied, which in America is almost as good.'* I notice, incidentally, that this writer's D has a particular shape, which according to Eric Singer's catalogue suggests 'erotic dreams, lowered resistance to sex excesses and perversions', which is either a vindication of the science of graphology, or proves that experts in graphology alter their handwriting to prove a point. Take your pick.

* What did he mean? (I have reasons to think this marginaliast was a man.) That no American has sex before marriage? That every married American is perfectly satisfied with the amount and quality of sex he has?

23 ~ Not Being Able to Read: Proust

Proust, as a novelist, has been rightly praised for his psychological penetration. But for the most part, he doesn't explore the minds of his characters directly, as Joyce or Virginia Woolf do. The first-person narrator of his novel *In Search of Lost Time* tells us a certain amount about what he thinks and feels. Only occasionally do the thoughts and feelings of other characters dominate his fictional texture. Otherwise, Proust explores the great surface of things. Nobody has ever gone more deeply into the superficial than Proust did. Take the moment when the narrator first sees the Baron de Charlus, the great sensuous villain of the whole piece, in *In the Shade of Young Girls in Bloom*:

> I had a sudden feeling of being looked at by someone at quite close quarters. I glanced round and saw a very tall, rather stout man of about forty, with a jet black moustache, who stood there nervously flicking a cane against the leg of his trousers and staring at me with eyes dilated by the strain of attention. At times, they seemed shot through with intense darting glances of a sort which, when directed towards a total stranger, can only ever be seen from a man whose mind is visited by thoughts that would never occur to anyone else, a madman, say, or a spy. He flashed a final look

at me, like the parting shot of one who turns to run, daring, cautious, swift and searching, then, having gazed all about, with a sudden air of idle haughtiness, his whole body made a quick side turn and he began a close study of a poster, humming the while and re-arranging the moss rose in his buttonhole. From his pocket he produced a little notebook, and appeared to write down the title of the performance advertised; he looked a couple of times at his fob watch; he pulled his black straw hat lower on his brow and held his hand to the rim of it like a visor, as though looking out for someone he was expecting; he made the gesture of irritation meant to suggest that one has had enough of waiting about, but which one never makes when one has really been waiting; then, pushing back his hat to reveal close-cropped hair with rather long, waved sidewings, he breathed out noisily as people do, not when they are too hot, but when they wish it to be thought they are too hot.[1]*

A scrupulous observer of the externals like Proust will, naturally, be fascinated by moments of illegibility, of which this is one – the narrator completely fails to realize that Charlus's performance is entirely directed towards the end of trying to pick him up. A novelist interested by how people send themselves out into the world, either through choice or inadvertently, was always going to focus at that particular moment in time on handwriting, legible and illegible. What is peculiar and near-unique in Proust is the

* The last two observations precede the great sociologist Erving Goffman's observations of performed actions by forty years or so.

erotic thrill attached to the literal illegibility of handwriting, as well as the illegibility of people as a whole.

In his voluminous correspondence, Proust often finds the time to reply flatteringly and volubly to letters which, he says, he can't actually read at all; it is sometimes difficult to pick up his exact tone of flirtatiousness and comedy when he writes to Emmanuel Berl about 'the mysterious arabesques which you ironically call handwriting . . . [the] signs which, though devoid of rational meaning, nevertheless conjure up your face.'[2] Only occasionally does he express some sharpness, writing to the Princess Soutzo that 'you wrote very illegibly and the little I was able to decipher seemed to me rather offensive.'[3] We know that, for practical purposes, Proust liked, or at least valued, legible handwriting up to a point; we are told that his awful secretary Henri Rochat 'had only one thing in his favour: he had beautiful handwriting . . . [and M. Proust] soon got tired even of the beautiful handwriting.'[4] Rochat is partly skewered in the novel as the appalling Morel, who has 'a magnificent handwriting marred by the crudest spelling mistakes.'[5] With his correspondents, moreover, Proust could give signs of actually preferring illegible hands, writing to Anna de Noailles, 'What a resurrection of joy after so many years to see that Handwriting, whose wondrous machicolations would seemingly suffice to protect the Garden of Eden, where the Angel (now redundant) bearer of the flaming sword, stands sentinel . . . Need I tell you that your wonderful letter is no more than an exquisite drawing as far as I'm concerned, and I can't make out a single word.'[6]

To judge from the completed novel, Proust was much

more fascinated by the illegible, in every sense, than by the readable and lucid. He often links this to handwriting, and once or twice expresses his boredom at the perfectly legible. He compares, for instance, the dull face of the hotel manager at Balbec to a legible text:

> As I passed the office, I gave the manager a smile and received one in return, signalled by his face, which, since the beginning of our stay at Balbec, my studious attentiveness had been injecting and gradually trans- forming as though it was a specimen in natural history. The features of his face had become nondescript, expressive of a meaning which, though mediocre, was as intelligible as handwriting one can read.'[7]

The action of *In Search of Lost Time* turns on a moment when handwriting at its most intimate is misread by an anonymous reader in the shape of a telegram operator. After the death of the narrator's lover, Albertine, he receives this telegram while trying to recover in Venice: 'Dear friend you believe me dead my apologies never more alive would like to see you to discuss marriage when do you return affectionately Albertine.'[8] In fact, the person who handed a written form to the operator to transcribe was not Albertine at all, who really is dead, but the narrator's old friend Gilberte. The telegram operator has misread Gilberte's absurd and affected handwriting on the initial form, which makes her signature open to mistake. We have long ago been told, when Gilberte was a girl, that she was in the habit of drawing her capital G's into near circles ('the G leaning against an undotted i was so embellished that it looked more like an a')[9] and writing in 'an expansive hand,

which seemed to have underlined nearly all the sentences because the cross-bar of every t was dashed above the letter and not through it'[10]: now, many years and thousands of pages after that initial observation, we are reminded that a telegram clerk has misread a signature with tragic, grotesque consequences.

Initially, however, that illegibility of writing exerts a powerfully seductive spell, as Gilberte writes on a series of grotesque notepapers: 'Once, the monogram G.S., hugely magnified and elongated, was bounded by a rectangle running right down the page from top to bottom; on other occasions, it would be the name Gilberte either scrawled across one corner in golden letters imitating her signature and final flourish, and sheltering under an open umbrella printed in black, or else enclosed inside a motif in the shape of a Chinaman's hat, on which the name figured in capital letters none of which was individually legible.'[11]

Illegibility and legibility play seductive tricks with the reader and the narrator, not in predictable ways; legibility may have something shallow and cruel about it. There is something instantly peculiar and untrustworthy about Albertine's first romantic communication with the narrator, a message where

'she took much trouble over shaping each letter, resting the paper on her knees; then she handed it to me, saying, 'Make sure no one can read this.' I unfolded it and read the words she had written: *I like you*.'[12] Mostly, the narrator finds erotic satisfaction in letters where no one has to say 'make sure no one can read this', because no one can anyway: the letters from

mistresses where the phrase we know by heart is pleasant to reread, and with those we have learned less literally, we want to verify the degree of affection in a certain expression. Did she write 'your dear letter'? A small disappointment in the sweetness we are breathing in, to be attributed either to our having read too fast or to our correspondent's illegible handwriting; she has not put 'and your dear letter' but 'on seeing your letter'. But the rest is so affectionate.[13]

Charlus finds a letter immensely erotically exciting when he cannot guess who has written it − a special form of illegibility, like the tragic error between Gilberte's and Albertine's signature.

About this time, M de Charlus received a letter written in these terms: 'Dear Palamède, when am I going to see you? I'm missing you ever so much and thinking about you all the time [etc.] your loving PIERRE.' M de Charlus racked his brains to discover which of his relatives had dared to write to him in so familiar a style; it must be someone he knew very well, and yet he did not recognize the writing . . . at last, suddenly, an address written on the back of the letter gave him the answer; it was the work of the pageboy at a gaming club where M de Charlus occasionally called.[14]

Passionate handwriting is always cast down at great speed, like Charlus's glimpsed eight-page letter to Morel, written 'with a strange rapidity. As he covered sheet after sheet, his eyes were flashing with some furious daydream,'[15] or at

great extent, like the child narrator preceding his declaration of feelings for Gilberte by writing 'on every page of my notebooks . . . her name and address endlessly . . . those indeterminate lines which I wrote without asking her to think any more of me because of that.'[16] When the same name, in the same handwriting, goes out into the world written on an envelope, it instantly becomes strange and unimportant. 'I had addressed an express letter to her, writing on the envelope that name, Gilberte Swann, which I had so often copied out in my notebooks . . . on the address of the pneumatic [response] . . . it was hard for me to recognize the insignificant, solitary lines of my handwriting under the printed circles apposed to it by the post office . . .'[17] Perhaps it is the act of being read, of being shown to be legible by strangers, which robs the individual handwriting of its erotic magic, even for its author.

Proust lived at a time when handwriting, as well as many other things he was passionately interested in, was undergoing a pseudo-scientific change, and he was clearly interested in the systematic analysis of handwriting. He is from one of the first generations of thinkers to stress that handwriting is utterly individual, saying that 'everyone, however humble, is a master of those familiar little household creatures whose life lies as it were suspended on the paper, that is, the unique characters of his handwriting which he alone possesses.'[18] He accepts that handwriting is a guide to the personality, once comparing it to hereditary features – 'the features that made [aristocratic women's] faces distinctive were a big red nose next to a harelip, or two wrinkled cheeks and a faint moustache. Such features

cast their own spell well enough since, like a merely con-
ventional form of handwriting, they enabled one to read a
famous and impressive name . . .'[19] When handwriting,
through extraordinary circumstances, alters, it is as deeply
disturbing and unnatural as a character change, as in the
case of a manservant of Mme Verdurin who, after a fire,
'became a changed man with a handwriting so altered that
when his master and mistress, then in Normandy, received
his first letter informing them of the occurrence, they
imagined it to be the work of a practical joker.'[20] The
manservant's personality, too, changes, and he becomes
a drunkard. Writing, for Proust, can be a means of regis-
tering the most deeply held thoughts, just as the most
fundamental nature of a human being can be compared to
an act of writing which has long ago been formed in habit:
repeating the name of a woman 'seems as if you are writ-
ing it inside yourself.'[21]

We know that Proust in real life liked to cast his eye
over correspondence, trying to guess the author before
knowing for certain; he 'would examine the envelope or
the writing, trying to guess who it was from.'[22] In the novel
that same art of divination is practised by the family ser-
vant Francoise when she examines the fatal letter which the
child narrator wants her to deliver to his mother at the
dining table at the very beginning of the book: 'She looked
at the envelope for five minutes as if the examination of the
paper and the appearance of the writing would inform her
about the nature of the contents or tell her which article of
her code she ought to apply.'[23] Many years later, the same
servant is caused great distress by being 'obliged one
morning to hand me among others a letter where she had

recognized Albertine's handwriting on the envelope'[24] after Albertine had precipitously departed. When the narrator sets the Balbec maître d', Aimé, on to tracking down the reality of Albertine's sex life, we are told that the arrival of a letter with his handwriting on it 'was enough to make me tremble . . . I knew it was from Aimé.'[25] The legibility of handwriting as a guide not just to character but to the specific intention is frequently demonstrated by the writing on an envelope; this is taken up by the narrator's grandfather who on 'recognizing his friend's handwriting on the envelope, would exclaim, "It's Swann, about to ask for something: on guard!"'[26]

When the narrator comments on Gilberte's handwriting that 'the rather factitious originality of Gilberte's handwriting consisted principally in placing, in the line above the line she was writing, the crosses on her t's, making them look as if they were underlining the words higher up, or making the dots on her i's look as if they were breaks in the sentences of the line above, and on the other hand to insert in the lines below the tails and the curlicues of the words that were written above,'[27] he is clearly drawing on the systematic analysis of recent French theorists of psychology in handwriting strokes like Michon. The particular strokes he observes have specific, rather deplorable meanings for Gilberte's personality, as well as for the plot – 'it was natural that a telegraph clerk should have read the scrolls of the s's or the y's of the upper line as a final 'ine' closing the name of Gilberte . . . as for her G, it had the appearance of an A in Gothic script.'[28] As a final cruel touch, this is another of those moments when a character is excited by the appearance of a recognized handwriting on

an envelope – this time, the narrator's mother recognizes Gilberte's handwriting on the envelope of a follow-up letter. Only rarely do these specific observations take on a cultural dimension – the curious comment about Odette's handwriting 'in which an affectation of British stiffness imposed an appearance of discipline on ill-formed letters that would perhaps have signified, to less prejudiced eyes, an untidiness of mind, an insufficient education, a lack of frankness and resolution.'[29]* Odette knows that handwriting can be read, as in her observation, rather like Sherlock Holmes talking about the letter written on the train, that 'my dear, my hand is shaking so hard I can scarcely write.'[30] The novelist-narrator, however, sees beyond her self-analysis, and through it. The analysis can go further than many later graphologists would like. Mme de Cambremer's handwriting spurs the narrator on to make an observation not just about family resemblances of handwriting, but of similarities in social class; that 'in these few lines of ink, the handwriting betrayed an individuality recognizable for me from now on among all others, without there being any need to resort to the hypothesis of special pens any more than rare pigments of mysterious manufacture are necessary to the painter to express his original vision. Even a paralytic, suffering from agraphia after a stroke, and reduced to seeing the characters as a pattern

* An interesting light is cast on this peculiar observation by Charlus's claim, much later in the novel, in *The Prisoner*, that Odette 'couldn't spell to save her life, I had to write all her letters'. Does Charlus's handwriting have an affectation of British stiffness on ill-formed letters? Or is he boasting pointlessly and wrongly at the Verdurin's, much later?

without being able to read them, would have realized that Mme de Cambremer belonged to an old family in which the enthusiastic cultivation of literature and the arts had let some air into its aristocratic traditions.'[31]*

But what was Proust's handwriting itself like? In the novel itself, Francoise complains about the narrator's *paperoles*, the little pieces of manuscript which the narrator sticks together, and the manuscript eaten away 'like wood that insects have got into.'[32] About his own handwriting, the narrator has nothing to say. We have to go to the lovely memoir of Proust's devoted servant, Celeste Albaret, to discover that 'his writing wasn't easy to decipher', and this magical account, practical and specific, of what a great writer writes with:

> The pen flew along, line after line of his fine cursive writing. He always used Sergeant-Major nibs, which were plain and pointed, with a little hollow underneath to hold the ink. I never saw him use a fountain pen, though they were becoming popular at the time. I used to buy stocks of nibs, several boxes at a time. He always had fifteen or so pen holders within reach, because if he dropped the one he was using it could only be picked up when he wasn't there, because of the dust. They were just little bits of wood with a metal holder for the nib – the ordinary kind used in schools, like the inkwell, which was a glass square with fan grooves to rest the pen and a little round

* Few graphologists would seriously suggest, subsequently, that family resemblances to one's ancestors or (more plausible a reading of Proust's point here) social class can be deduced from handwriting.

opening with a stopper. 'Some people need a beauti-
ful pen to write with, but all I need is ink and paper.
If I didn't have a pen holder, I would manage with a
stick.'[33]

24 ~ Gissa Job, Siegmund

One place where graphology persisted was in one of the chief money-making endeavours of early proponents – the advice over careers. The astute ones quickly realized that there was more money to be made advising employers over a choice of employee than telling people what jobs they ought to pursue, which most people can work out for themselves anyway. Graphological analysis of job applicants has always seemed somewhat morally dubious, and is now considered probably illegal in many places by most legal authorities. After Merrill Lynch acquired Mercury Asset Management in 1997, for instance, the American bank's lawyers ruled that Mercury's habit of using graphology as part of its recruitment procedures had to stop; handwriting analyses, they said, could be construed as discriminatory if they were obtained under the Freedom of Information Acts by employees in dispute with the company.[1] As long ago as 1989, the *Washington Post* was recording actions made by the American Civil Liberties Union against firms using graphologists in employment practices, saying they were 'strongly oppose[d to] all arbitrary pseudo-science employment practices'.[2]

For this reason, it is impossible to gather any firm information about the levels of use of graphology in professional

recruitment, now or in the past. What figures have been produced seem wildly at variance, and sometimes intrinsically implausible. A recent commentator on the practice said that between 38 per cent and 93 per cent of French firms used graphology in selecting staff, a range so wide as to make the statement more or less meaningless.[3] A 1979 academic study[4] claimed that graphology was at the time routinely used by 85 per cent of European firms hiring staff, which can't possibly be true. On the other hand, thirty years later, the use of handwriting analysis by firms was declared by another study as a 'total myth', and that nobody at all did it.[5] Is this any more true? Certainly, as the author of this study acknowledged, anyone who was asked to supply a handwritten letter automatically assumed that it was for graphological analysis. As well they might – employers, even if they don't plan to subject a letter to formal graphological analysis, could feel that they had more of a sense of a candidate once they had seen their handwriting.

There is a famous case of an important figure who had, to his contemporaries, what often seemed like an eccentric faith in graphology as an insight into character. The financier Siegmund Warburg, it was well known, demanded to see the handwriting of applicants to his bank, as described in jeering tones by *Private Eye* in 1970. 'Apparently the young gentlemen are instructed to write out 500 words with pen and ink on stout paper and this is then dispatched to old Siegmund Warburg's Swiss lady graphologist.'[6] This is a more or less accurate account. Warburg's Swiss graphologist was a woman called Theodora Dreifuss. Niall Ferguson, Warburg's biographer, who has

looked into Warburg's faith in graphology with open incredulity – 'Not a single former Warburgs director I interviewed shared my scepticism [about graphology]. I began to wonder if I was writing the history of a bank or of a cult' – thinks that Dreifuss had a standard and undisprovable formula for these analyses. It 'consisted of asserting that intelligent men had buried weaknesses of various sorts'. Ferguson has no difficulty in finding examples of Dreifuss's analyses which, in the light of subsequent developments, are comically inaccurate. '"Tiny" Rowland* was "very careful and circumspect in his business dealings."'

But there is the point that, since Warburg used graphology over rather a long period to filter out employees and would-be associates, he could easily test the accuracy or shrewdness of Dreifuss's analyses. He funded an Institute of Graphology in Zurich, to be headed up by Frau Dreifuss, and made a startling public statement in a speech at its opening: 'Many sciences have started as myths. The knowledge of the stars began as astrology and only gradually became the accurate science of astronomy. Today no one would call an astronomer a crank. Eventually, I am convinced, graphology will become *hoffähig*.'[7†]

Clearly, however, some myths start out as myths and turn into end-of-the-pier party tricks, or get completely forgotten – phrenology, palmistry, mesmerism. Would that

* Of Lonrho, responsible for one of the most famous crooked episodes in the City, described by the British Prime Minister Edward Heath as 'the unacceptable face of capitalism'.

† Presentable at court, used in a metaphorical sense.

happen to graphology? There is a curious fact here, which is that even the most bluntly sceptical writers about graphology are sometimes taken aback at the accuracy of graphological analysis when it is applied to them. Even Niall Ferguson, who was required to undergo formal hand-writing analysis before he could be signed off as Warburg's biographer, confesses himself truly surprised by the perceptiveness of the result – it is impossible to imagine someone as smart as Ferguson being taken in by the flattery of palmistry or astrology. There is, too, a surviving account of Warburg's own, a graphological/psychological portrait of the Conservative leader Edward Heath, embarked upon while he was still in opposition in 1968, before he became Prime Minister in 1970: 'Basically weak – self-indulgent, almost narcissistic . . . very intelligent but without character. Much too easily influenced by people who fascinate him. His own opinions are not founded strongly enough . . . He is not good at defending himself in face of unexpected and hard difficulties. He will change his standpoint not because of unreliability as such but because the necessary inner force in him is lacking.'[8] The analysis is absolutely spot on, but the interesting thing is that it has an element of prediction contained in it. The 'unexpected and hard difficulties' came not in the 1960s for Heath, but in 1972, when he was Prime Minister, upon which he did exactly what Warburg said he would do: he changed his standpoint out of weakness, self-indulgence and narcissism in one of the most celebrated and disastrous U-turns in British history. One can't know which elements in this were contributed by Warburg's beady eye over the lunch table and which from a glance at Heath's handwriting. But I think

you would expect a devotee of graphology to follow those principles, and probably get some things dramatically wrong through a too-dogmatic approach. Warburg is right about Heath from top to bottom. That is one of the very weird things about graphology – it really does sometimes know much more than it reasonably could be supposed to.

25 ~ Witness

Interviewer: 'Where did you go to school?'

A: 'Bangladesh. Where did I pick up my handwriting from? Well, I had a bit of an unconventional schooling. My parents took me out of proper school because you have to choose a religion when you go to school. So they put me into a tutorial where my mother was a teacher, and some of the other mothers were teachers, and they taught me to write. It wasn't really a formal thing. What does that prove? I'm so intrigued.'

Interviewer: 'Your handwriting's really beautiful – it looks like American handwriting, but the sort of American handwriting you just don't see from Americans your age.'

A: 'Oh! Did you hear that? Did you hear that, B—? Do you find it difficult to read? See? See? B— can't read it. Did you hear what he said, B—? There are lots of people who can't read it. And you know, for finals, if they can't read your paper, you have to read it out while they type. I had to do that.

'I learnt to write with a group of mothers, yes, that's right, I suppose that was it. We didn't have special hand-writing lessons in Bengali, just as part of the lessons. Not

separate handwriting lessons. I suppose they taught us to form the letters – I can't really remember.'

Interviewer's husband: 'Did they teach you to make AWWW and ARRR?'

A: 'There were books, but no, I never did that. I never had those. Now tell me! What's going on?

'If B— has to write a letter, he types it out first – that gets him flowing, he's more comfortable like that. Then he writes it out.

B: 'My handwriting is slow and bad. I probably wasn't taught properly, or taught up until the age of ten, then I slackened.'

Interviewer: 'Do you judge other people by their handwriting?'

B: 'I'm sure I don't. Well, unless it's very childish. I judge A— a bit for being a bit of a pain.'

Interviewer: 'Surely not.'

B: 'Her handwriting's beautiful, but it's a pain. Nobody can read it.'

Interviewer: 'I can totally read it!'

B: 'I think you're among a special club. I was taught. It wasn't a rebellion, slackening off. I think the standard, the level of pressure to maintain it wasn't there in my later teenage years. I worry that people might judge me when I write a letter. I worry that they might not think of me to

the high standard that I would perhaps like. A— writes our Christmas cards, because her handwriting is actually pretty.'

A: *Political activist, female, 28*
B: *Financier, male, 28*

26 ~ Biros and Not-Biros

If you refer to a ballpoint pen as a biro, as we all do, in lower case, then lawyers will descend on you in droves, demanding that you withdraw the calumny of suggesting that all ballpoint pens are biros. So this chapter is about Biros REGISTERED TRADE MARK, as well as ballpoint pens.

The biro, in popular parlance, is named after a person, like hoovers, quislings, boycotts and peach Melbas, or peaches Melba, if you prefer. It is one of those moments where the inventor is commemorated when, perhaps, the commercial exploiter performed just as remarkable a task. Someone, sooner or later, was going to invent the ballpoint pen, and it might as well have been László Biró. The dedication of Marcel Bich, the man who bought the patent and turned the ballpoint pen into one of the most remarkable commercial successes in history is, in its way, as impressive. We say 'Pass me that biro'; we ought just as readily to say, as the French actually do, 'Is this your bic?'

László Biró was Hungarian, born in 1899. His famous invention was only one of several in his life – including an automatic washing machine. His obituarists tell us that, in early life, he developed an interest in the use of hypnotism for pain relief after having to leave medical school after a year. Tantalizingly, we also hear of an interest in hand-

writing analysis a fashionable interest in the 1920s, of course.

From the late 1920s onwards, Biró was developing a ballpoint pen. His initial interest came not from a desire to create a simpler pen than the fountain pen, but simply from wondering about ink. Ink for writing by hand was slow-drying, and needed blotting paper if there was any haste in the matter. On the other hand, Biró observed, printers' ink dried almost immediately. Why could not ordinary people write by hand using printers' ink?

The initial answer was that printers' ink was far too viscous to flow through an ordinary pen nib. Through trial and error, Biró came to the insight that a rolling ball, held lightly at the tip of an ink reservoir in a loose cradle, would move easily across paper without leaving a wet trail of ink or smudging. Biró was not the first inventor to think up the marking possibilities of a ball moving in this way; there are some patents dating back to the 1880s which work on similar principles. In 1938, Biró patented the ballpoint pen in France and Switzerland. At the outbreak of war, he moved, with his brother Georg, to Argentina to escape Nazi persecution. In Argentina, he took out a new patent in 1943, and his invention came to the attentions of the British.

Biró is a national hero to the Argentinians, who celebrate something called Inventors' Day on his birthday, and I am sorry to say that Argentinian biographies of Biró[1] omit all mention of the support which the British armed forces lent to Biró's invention, for reasons of their own. The British Air Force had been frustrated by the ways in which ordinary pens tended to run out of ink or leak or freeze at high altitude. Biró's invention came to their attention in

1943 through an English accountant called Henry George Martin, who was working in Argentina. The RAF bought 30,000 pens after Biró's design. Licensing rights to Biró's pen were bought by the British, and the success of the Biro pens popularized the product. It's important to remember, though, since we so take ballpoint pens for granted, that at this point many people thought of them as an extraordinary futuristic invention rather than a mass-market one. When ballpoint pens began to be sold in Britain by the Miles Martin Pen company in 1946, they cost £2.15s, the equivalent of a secretary's weekly wage.[2]

By this point, the ballpoint pen was out of Biró's hands. In 1944, Biró sold the American patent to Eversharp Faber for two million dollars, and the European patent to a man called Baron Marcel Bich. Bich was one of a rare number of men who genuinely transformed the world. When he died, Stephen Bayley observed that 'if the mass-market had a patron saint it would be Bich: for mere pennies the ordinary man can write more clearly, shave more closely and have more reliable access to fire than a renaissance prince.'[3]

With his business partner, Edouard Buffard, Bich had been manufacturing penholders and pencil cases from a leaky shed in Clichy, north of Paris. He acquired Biró's ballpoint patent, without, apparently, immediately seeing the potential. Corporate legend tells of a eureka moment: Bich was pushing a wheelbarrow one day when he realized that 'the ballpoint running over paper was as revolutionary as the wheel'.[4] More to the point, he realized that there was a possibility of selling this remarkably reliable invention very cheaply. This insight, and the Bic Cristal which he began to sell in 1950, would make him a very rich man indeed.

The Bic corporation makes its money now not just out of stationery, but out of razors, which I don't recommend, and small disposable lighters, which are as good as any, I suppose. It is the original product, however, which possesses the true poetry. You probably have a Bic Cristal somewhere not very far away. It's probably as familiar to you as the back of your hand, so take a moment to look at this marvellous object. It has hardly changed at all in any visible way since 1950. The major change, which the company highlights as a significant step in its development, was that in 1990 the cap was pierced to guard against suffocation in the case of 'involuntary ingestion'. That's more or less it. It was perfect when it was invented, and it is still perfect now. It weighs 5.8 grams – just enough so as not to feel flimsy, but not enough to feel heavy. Some thought has gone into the barrel – its hexagonal form means that it won't roll off the desk, and won't hurt your fingers – five sides would be painful, and seven unstable. It was a stroke of genius to make the barrel transparent, showing you how much ink you have left, always assuming you haven't chewed it to bits long before the ink runs out.* The ball, since 1961, has been made out of tungsten carbide, an incredibly hard substance.† The one alteration not very obvious to the naked eye is in the ink, which has gone on

* Transparent casing for objects which carry out a task ought to be much more common than they are. I've never understood why all toasters aren't transparent, allowing you to avoid that tiresome popping up and replacing of the bread until it's reached the exactly right stage of browning.

† It scores 8.5 on the Mohs scale of hardness. By comparison, steel scores 4–4.5 and diamond scores 10.

An early advert for Bic pens.

bcing improved over the last sixty years – a great deal of thought has gone into extending what is known as 'cap-off time', or the time you can leave the lid off the pen without the ink drying up. The ink, as Biro had hoped, dries almost instantly on contact with the paper, in less than two seconds.* By 2005, 100 billion pens had been sold worldwide. In 1970, with six million Cristal pens being sold daily, Bic was not only the most successful pen brand in the world, but the best-selling brand of any sort. At the present moment, I can buy 50 of these miraculous objects for £7.78 on Amazon.co.uk, or 15 ½ p each. Incredible.†

* We forget what a miracle this is – I mean, everything has to dry, and it's beyond me to explain why all inks don't dry with the slowness of poster paint. For the record, experiments involving transferring large amounts of ink from page to paper have just now shown that Waterman's ink out of my fountain pen takes nine seconds to dry completely.

† A comedian reviews the wonderful Bic ballpoint pen on Amazon.co.uk, drawing attention to many of its miraculous qualities as though they were too ordinary to be worth mentioning. Should have spent more time in school learning to spell, and less in attempting to be cool:

'I was looking for an upgrade from my HB2 Pencil and I was unsure about what to go for until I came across this Bic pen.

I was realy excited about opening my new product once it had arrived, I removed a pen from its protective packaging which was realy well sealed. For the first few days after ordering my new pen I was slightly unsure about how to actualy use it, it came with no instruction guide, it was untill later on in the week and countless hours of attempting to write I hit Google and realised that the black tip at the end was removable only to reveal the 'nib' of the pen. This black romovable think was infact a lid to keep ink fresh.

In the past, the story of Baron Bich and the Bic Cristal has been told in the form of a graphic novel by Christian Rossi and Xavier Séguin. I wish I could get hold of a copy of *La Très Véritable Histoire du stylo Bic*, first because I don't think there are enough stationery-based comics out

Ok so onto performance, after I started to write(also this pen may be used for doodling and scibbling) I was amazed at the quality of the ink, it was no cheap ink like you would find in other cheap pens at your local retailers, this ink is something special, and it does not smudge either.

The biggest major flaw with this pen(which is possibly a design fault) is that I am assuming this pen is for left handers only(although the packiging did not mention this) I think this because I can write superbly neat in my left hand but when I switch over to my right hand I start to write as if i were wearing a blindfold, so to all you 'right handers' stay away from this product.

The design of this pen was realy well thought out, the 'see through' barrel of the pen allows you to keep watch over how much ink you have left to write with in the pen, so when you are running out you can simply order a new pen in time.

A few days ago I stupidly lost the lid to my pen, I got onto Bic customer service to see if my pen was under warranty to see if they could send me a new one or simply replace my lid, the lady on the other end just laughed at me and hung up, this goes to show that the customer sevice for this company is not very good at all!

I take my new pen everywhere with me and could not leave home without it, somebody even saw that I had a brand new bic and asked me if they could borrow it! The cheeky fella must have realised how good this pen was as he tried to walk off with it, but I managed to get it back and he claimed 'he forgot'.

Anyway I am overall pleased with this product.

Only negative points are the lack of instructions on operating this pen and the customer service is atrocious.

Three ***

there, secondly because it looks a whole lot of fun ('Clement is right! The ballpoint is the future! It rolls over the paper! Writing is easier!') and thirdly because it really is an exciting story which deserves celebrating.

Marcel Bich's spirit is well summed up by a gloriously up-yours letter which he sent to the shareholders of the newly public company Bic, explaining exactly what is wrong with French society, though nothing that a sufficiently can-do entrepreneur, such as, for instance, a certain Baron Bich, might put right. I'm going to quote it in French, because it has such a pungent flavour that my translation can't really convey.

> Nous sommes férocement anti-technocratiques. On ne tient pas de prix de boeuf en contrôlant les bouchers, on tient le prix du boeuf en produisant du boeuf. La technocratie est le mal de notre époque; partie du plus haut (E.N.A.)* elle gagne tous les échelons; elle séduit particulièrement les français – cartésiens de nature – elle aboutit à une pléthore de gestionnaires, d'organisateurs, mais quand il s'agit de faire le 'boulot' il n'y a plus personne. Cette technocratie entraîne un coût de production élevé et ce qui est bien plus grave, elle rend les gens moroses parce qu'ils s'ennuient dans leur travail sans initiative.

* *École Normale d'Administration*. An institution for turning out supercilious French public servants, known as *Enarques*, some of whom subsequently become notably inefficient politicians, and just now (May 2012) President of the Republic without ever having run anything. It was set up by General de Gaulle in 1945 and has been loathed by most right-thinking Frenchmen ever since.

Or:

We are fiercely anti-technocratic. One does not hold
down the price of beef by controlling the butchers;
one holds down the price of beef by producing beef.
Technocracy is the evil of our age, emanating from on
high (E.N.A), it holds every level of society; it particu-
larly tempts the French – Cartesians by nature – it
ends up in a plethora of administrators and managers,
but when it's a question of 'elbow grease', there's no
one to be seen. This technocracy leads to a raised cost
of production, and, more seriously, it crushes the
people, because they're bored with their work with-
out responsibility.

That's the stuff to frighten Giscard. Bich launched the
Bic Cristal in 1951. It's doubtful whether even he saw
the full potential of the cheap ballpoint pen to begin
with. Strikingly, the first press adverts don't try to appeal
to everyone, or to suggest the democratic revolution about
to be launched by the Bic Cristal: the earliest one is of a
concierge-type, or perhaps a superior sort of shop-woman,
looking up and saying, 'C'est déjà noté, Madame.' If Bic
first imagined that the ease and cheapness of their pens
would appeal to the hardworking servant classes, they
quickly came to understand the potentially universal
appeal of the object. Of course, by 1953, they were linking
their company's product to that most national of excite-
ments, the Tour de France. You can trace the spread of their
appeal, or the company's grasp of their product's potential,
through their advertisements – they are delightfully pre-
served on the company's website. There are some space-age

modern graphics, suggesting speed through sport – 'It runs, it runs – the ballpoint BIC!' Then a moment of sheer class in the form of a cinema advert. It is rather a period piece of abstract ballet, as the pens, without the help of human hands, congregate, dance, circle and construct patterns with that very 1950s-chic soundtrack, '*un fragment musical de J.S. Bach*'. The pen is still an exotic, even futuristic triumph; the camera here occasionally swoops down for a fascinated examination of the ballpoint. It must be a cinema advert, and I like to think of this early colour advert diverting Jean-Luc and Solange before their Saturday-night date, say *Jules et Jim*.

The advertising of the first years was at pains to suggest the technical breakthrough of the Bic Cristal. This advert suggests the almost inexhaustible ink supplies of the Cristal – it can write, the company has established, a line two kilometres long, which is surely long enough for anyone to expect for 15p. Other print advertisements draw attention to its indifference to gravity, as people write standing on their head – a Pierre Fix-Masseau print to the slogan 'J'écris aisement avec Bic'.

It's only when Bic moves into America in the 1960s, however, that its advertising reveals the full scale of its confidence in its products, with an unmissable series about the indestructibility of a pen retailing, at the time, for 19 cents for a medium-point pen.* In one madly sadistic advert, a

* I've just checked on American Amazon, and you can (2012) buy ten Bic Cristal pens for $1.47, or a shade under 15 cents a pen. There are things which have got cheaper in cash terms over fifty years, but somehow you don't expect the Bic pen to be one of them.

BIC pen is strapped to the boot of an ice skater. After twirling about the ice for a bit, the ball of the pen taking the full brunt of the punishment, she unstraps the pen and thrusts it into a burning brazier which just happens to be sitting on the ice. She takes the pen and writes BIC on a sheet of paper on a desk which, also conveniently, is by the side of the brazier. Works first time. In another advert, a BIC pen is loaded into a gun and fired directly at, we are told, 'SOLID OAK'. The plastic casing disintegrates; the cartridge and nib penetrate the SOLID OAK. It writes, First Time, Every Time. Don't try this with your Mont Blanc. It's easy to be amused by these ancient product demonstrations, but in a world where you had grown up with expensive, laborious, endlessly refilling fountain pens, the appeal of a 19-cent Bic Cristal pen which couldn't be destroyed by fire, ice or being shot through SOLID OAK by a rifle obviously spoke for itself.

Not for the first time, advertising reveals the curious impression that, for many American businessmen, like the handwriting gurus Spencer and Palmer, writing is something you do in the office. Under that slogan 'Writes First Time, Writes Every Time', Bic sells the Cristal pen with photographs of office situations, mostly of people leaning over each other's desks and a loaf-haired secretary taking notes. 'There Is Nothing More We Can Say About BIC Pens That Using One Doesn't Say Better', an advert tells us, and it seems fair enough as a claim. The product – cheap, beautifully designed, working every time – just sold itself to business. Another advert in the late 1960s places the business appeal in a global setting – there are successive vignettes in the Far East, the Middle East, Africa and

Europe. Tellingly, the camera ventures into the picturesque sights of Bangkok, Cairo and an African souk before zooming in on, in each case, a modern skyscraper with, inside, a secretary in Western dress taking dictation. The message: BIC is modern! BIC is business! Why the crooks in the souk couldn't sign an invoice with a BIC pen is not made clear. The fact is that the crooks in the souk did use BIC pens as well as the beautifully dressed secretaries in the Bangkok skyscrapers. They were, and are, completely universal. In the rest of the world, it doesn't seem amusing to claim, as the company did in one African advert, that *'Dans le monde entier, les hommes d'action écrivent avec un BIC.'* In a later emission of fairly sickening sentimentality, an African couple getting married take a blue Bic pen to sign the register, turning to smile at each other first. It was simply what people with an idea of modernity in their heads wrote with. The savages were rather closer to home. It is said that it took until 1965 for the French state to acknowledge the Bic Cristal as an officially sanctioned writing implement in schools because, as we all did, French schoolchildren had discovered on day one that the Bic casing, with cartridge removed, made an absolutely perfect blowpipe for back-of-the-classroom missiles.

'Ballpens are not recommended for good writing,' one handwriting guru wrote as late as 1970.[7] Resistance to the ballpoint pen had been strong from the start. Reginald Piggott dramatically claimed that 'wherever the ballpoint replaces the fountain pen illegibility ensues, for used at excessive speeds the point goes out of control lacking even the stability of the pencil.'[8] Even in 1958 this must have been bollocks. It's worth noting that the anti-ballpoint

brigade can't agree on this simple point, either. Where Piggott says that ballpoint pens produce a patchy supply and a 'broken line' through changes of direction, another eminence tells us that 'Ballpoint pens produce a monotonous even line which, lacking the discipline of resistance between pen and paper, tends to degenerate into a formless scrawl.'[9]

But it hardly matters. From the moment that Bich issued a press advertisement for a cheap, reliable ballpoint pen under the slogan 'Madame, I've already written it', the battle, from the point of view of many handwriting enthusiasts, was lost. They would have been much better off taking the ecological route in protesting against its spread – after all, those 100 billion pens have to go somewhere, and it's mostly to landfill, despite the best efforts of the Bic corporation to persuade us to recycle, and to use our Bic Cristals to the very end of its allotted two kilometres. A fountain pen, with all its difficulties, is a much more ecologically sound writing implement, which will last a lifetime, where nobody much cares whether a Bic Cristal lasts an afternoon. All the same, the Bic Cristal is one of the great designs of the century, and one of the greatest aids to communication and civilization ever conceived.

27 ~ Witness

A: 'I find my father's handwriting interesting, particularly since he's died recently and so you kind of find bits of his handwriting, and you think you must save it because . . . it's him, it's an extension of him. But also because he's got this incredible, beautiful script. He was an art dealer and had an eye for beautiful things. He's got this very old-fashioned handwriting with lots of loops – almost impossible to read, unless you know him – had known him for a long time. And I've always found it odd that, in comparison to his beautiful long hand, I've got constricted, bad, mashed-up handwriting. It's quite embarrassing. I got very bad marks at school for it. And I'm very bad at spelling.'

B: 'They gave you marks at school for handwriting?'

A: 'Yes, oh yes. I couldn't copy a joined-up e from the chalkboard. This is in a private, all-girls' school in London. I have revolting handwriting. It looks like a . . .'

B: *(Inaudible)*

A: 'Yes, but you – you've got your own special way. You're very good at typing.'

B: 'My friend said of me, that my handwriting looks like a disabled child holding a pen in their mouth during an earthquake.'

A: 'B— does have special handwriting. You can always tell that it's B—'s handwriting. I feel mine is just generic.'

B: 'You know, if it was Jack The Ripper's handwriting, you'd say to him, that's very, very special handwriting.'

C: 'I think we're using "special" in the same sense as "special needs" here. There's typing too. I've got such an aggressive typing style – my keyboard, all the letters are erased from the keys.'

D: 'I can hear him from upstairs.'

Interviewer: 'How do you feel about your handwriting, C—?'

C: 'I don't actually feel too embarrassed about it. I don't have many feelings about it. I don't think it's very good.'

Interviewer: 'Do you admire other people's handwriting, or is it something you don't care about?'

C: 'Yes. I quite admire yours.'

Interviewer: 'Yes, I've got extraordinarily beautiful hand-writing, it's true.'

D: 'When you send a postcard to us, C— has to read it.'

C: 'Yes, he says, "Tell me, tell me, what Philip says."'

D: I know it's Philip, because I can recognize it, but I can't read it.'

Interviewer: 'I don't really have beautiful handwriting.'

A: 'My father's grandfather was the Dean of Windsor –'

Interviewer: 'No!'

A: '– he's in the Coronation, walking along, wearing a dress, going hur-di-hur-di-hur, you know, the recent

Queen's one, the coronation, and so I've always assumed that my father's handwriting, it's sort of Biblical, it's so beautiful. You've seen it, haven't you, B—? It's almost illegible. I showed you that Christmas list. My dad died in November, and before he died, for some reason he tried to remember every single Christmas since my brother and me had been alive. He wrote down the dates, and he tried to remember backwards. Dickensian. It's hard to read.'

Interviewer: 'But . . . he must have known what the date of Christmas was.'

A: 'Yes, the twenty-fifth . . . etc. Writing down the details of the turkey. Sometimes we were in Australia, sometimes we were in Peckham, sometimes we were in Efford. But yes, generally Christmas was at Christmas.'

D: 'When I was younger, I used to admire my mother's handwriting. But now it's more like my father's. I can't read my own handwriting, and my father can't read his handwriting, either. Maybe to you, it would look like the handwriting of every other French person, but to my eyes, it's all different.'

A: 'French people have the most enviable handwriting. The little grids, amazing. With a proper pen.'

D: 'For me, all English handwriting looks the same.'

B: 'Do you join up? Because I made a very conscious decision not to join up.'

A: 'Conscious decision!'

C: 'My mother did calligraphy and so all her writing was in italic. Every morning she would be doing Sanskrit calligraphy by candlelight in the kitchen with an italic pen.'

A: 'My Australian grandfather was a sign-maker, but for things like pie shops, so he would use these neon colours, the most gross colours to write with. There is just so, much, pie in my family.'

C: 'What is pie? Where does it come from?'

A: 'There's beautiful versions of writing, like your mother, and then my grandfather who did incredibly ugly writing, but all by hand, so you think if it's done by hand, it must be worth something. And still in the town where he lived in – he died about fifteen years ago – still at Christmas, they bring out the same banner with the same horrible 1950s-style Father Christmas face on, all in neon yellow and orange. Look at your pens, Philip!'

A: E.W., novelist, female, 31.

B: J.C., literary agent, male, 31.

C: Y.A., charity administrator, male, 48.

D: R.H., financier, male, 39.

28 ~ *My Italic Nightmare*

So. Two days after Christmas, I suddenly decided that I wanted to upgrade my italic fountain pen. The one I had been using was a perfectly good, highly functional pen made by the German firm Lamy, in brushed steel. It had a refillable, pump-action reservoir which I hadn't used before I'd bought this pen, six months before. The whole process of refilling the reservoir was a pleasant one, new to me – when I had used fountain pens before, even when quite young, they had had cartridges to be plugged in and then thrown away when empty. With this one, the familiar-unfamiliar addition of a bottle of ink was necessary, and I had taken the advice of the pen merchant, and bought a bottle of Waterman's ink.* The top half of the pen was removed; the lid of the ink was taken off, carefully, reverently, and the nib lowered fully into the ink.† The

* The shape of a bottle of ink is surely unique, designed for maximum stability – you really don't want to upset a full bottle of ink over anyone. There is something pleasing about an object whose exact nature and function you could identify without any hesitation if it were handed to you blindfold, just from its shape. I don't suppose anyone will ever want to change the shape of a bottle of ink, as first-year design students of my generation were constantly being asked to rethink the CD rack.

† Reginald Piggott, whose Survey has already supplied one eccentric

screw-top of the reservoir was turned in a counter-intuitive direction, downwards, and when it was quite empty, it was turned in the opposite direction, to refill it. I loved the magical rise of the ink against the screw — I know, hydraulics which everyone has known about for three thousand years, but I like it when it happens on so tiny a scale. The new process, done three times a day, was a whole new pleasure to me.

Nevertheless, it occurring to me that, for once in my life, I could justify the purchase of a rather posh new pen of the sort advertised in the *New Yorker* and the *Spectator* to their supposedly plutocratic readerships, I set off to get an upgrade. My demands were simple. I wanted a solid fountain pen that would last me for years. I wanted an italic nib. I also wanted a refillable, pump-action, hydraulic-type reservoir. I hadn't known I wanted one of those last ones a month before, but now I wanted a refillable, pump-action,

moment to this book in his study of different-coloured writing inks and what they signify in the hands of ballet dancers and lady novelists, now supplies another with a madly instructive drawing headed 'Correct Method Of Filling Fountain Pen'. In three drawings, Mr Piggott shows us INCORRECT METHOD, where only half the nib is in the ink, CORRECT METHOD, with labels indicating LEVEL OF INK, POINT OF NIB CLEAR OF BASE, and NIB COMPLETELY SUBMERGED. In the third drawing, a totally reckless penman is shown INCREASING INK LEVEL, where a half-filled bottle of ink is apparently tipped off the side of a table at an angle of about 30 degrees without evident support, while the pen is dipped into the deeper end. Thinking about the white sheepskin rug which inevitably sat under this suicidal enterprise, it took me some time to realize that Mr Piggott was actually recommending this procedure, rather than just warning against the consequences of doing anything other than going to buy a fresh bottle of Waterman's.

hydraulic-type reservoir. That's how capitalism works. I set off for Peter Jones.

Peter Jones, for anyone who doesn't happen to live in London SW-something, as I do, is the best department store in the world.* John Betjeman, the poet laureate, is said to have remarked that if he heard the siren going off warning of imminent nuclear destruction, he would head to Peter Jones on the grounds that nothing really awful could ever happen there. It caters to the English gentry, is run along the lines of a co operative, with the assistants called Partners, and is not a bad place for a first port of call. Personally, when Christmas approaches, I decant myself into a taxi with eight hundred quid, go up the road to Peter Jones and emerge several hours later with presents for everyone I know and love. Of course I would go to Peter Jones to buy a fountain pen with an italic nib and a refillable, pump-action, hydraulic-type reservoir.

* It is part of the John Lewis group, whose indefatigably well put motto is 'Never Knowingly Undersold'. Until some years ago, every department store in the group was permitted to keep its original name, although they all retained the corporate logo and style and ranges of goods – the one in Sheffield was called Cole Brothers, for instance. For no very obvious reason, all of a sudden they were all renamed John Lewis, except for the one in Sloane Square, which was permitted to retain the name of Peter Jones. Everyone regretted the change – the different names under a single umbrella was a charming nod to local sensibilities while retaining big-corporation reliability. I suppose Peter Jones's clientele was just the sort of person the senior partners of John Lewis were more likely to encounter at the dinner table, complaining about the loss of their shop's well-loved name, so they kept that one. Anyway, I don't think anyone took much notice. My parents still say 'I'm sure you'll find it in Cole's', of anything at all, from cummerbund to cherry-stoner, about twice a week.

Peter Jones's pen desk is on the fourth floor. There is a glass kiosk, under which the better class of pen are displayed under lock and key. You have to summon a shop assistant, and engage with them, tell them precisely what you want to look at. To one side, there is the cheaper sort of pen. Those you can pick up and put down, poke and rifle among the stock to your heart's content, and take yourself and your new purchase to the till without troubling the Partners at all. Peter Jones's pen lady was engaging with an elderly mother of commanding appearance and her middle-aged failed son, still evidently having his clothes bought for him by his military-widow mother. The mother had decided that the time had come for Nigel, nearly forty, to write with a proper pen. She was going through all the possibilities. 'Now this,' she said. 'This is what I call a *pen*. That really is a pen. Go on, Nigel, write with it.' 'Is it a fountain pen?' 'Yes, it's a fountain pen. Look at it. It's just like your father's pen, I must say. Now. Can he write with that on something or other – do you have a sort of scrap of paper?' The engaged assistant produced a pad, encased for some reason in a leather binding, to suggest the gravity of the task. I stood by with that fixed half-smile with which you try to suggest Yes, I'm waiting, No, I'm not in a particular hurry, Yes, I'm quite patient with my lot for the moment and Yes, it would be nice to be served at some point, I must say. 'I can't write with that,' Nigel said, defeated. 'Don't be absurd,' the mother said. 'Try again.' 'Oh, there's no ink in it,' the assistant said, and produced a bottle of ink and a rag. Without looking at me, she reached across the counter and rang a bell. I went on looking at cripplingly expensive pens under glass. 'I don't know, Mummy,' the man said. 'I think

I'd honestly be much better off with a biro, really, I've never written with anything else.' 'A biro!' the mother said, attempting to make common ground with the shop assistant. 'He wants a biro!' 'There are lovely ballpoints, too,' the shop assistant said, reprovingly, meaning ones which cost a packet, rather than the useful 15p Bics we all use. I had a vision of this pair's Chelsea terraced house, pastel blue on the outside, ramrod standard bay trees guarding the French windows behind, and filled to the brim with Christmas objects which might improve the lot in life of poor old Nigel. The assistant rang the bell again.

The sub-assistant who arrived was not, I am sorry to say, up to the standard of Peter Jones's staff. He had so very revolting a cold that I took two steps back, involuntarily. 'I am looking,' I said carefully, 'for a fountain pen with an italic nib and a refillable reservoir.' 'We don't stock italic pens,' he said. 'Really?' 'No. All our fountain pens have fine-point nibs.' 'Don't the manufacturers supply a range of nibs?' 'We only stock fountain pens with fine-point nibs.' 'No, I understand that. What I meant was, could I buy a fountain pen from your stock and then have an italic nib fitted?' 'We don't do that. All we stock are fountain pens with fine-point nibs.' 'Yes, I understand that, now. Could you tell me if there is anyone nearby who might stock italic pens?' 'You could try Rymans.' 'And if I wanted a good quality pen, for instance?' 'Well,' he said, and sniffed gigantically, a sputum-reversing inhalation of epic

* Stationery shop, which, considering the innate joy of such places, manages to be about as joyless as a stationery shop could conceivably be, rising to the dizzy height of different-coloured box files.

proportions, 'there's always Harrods. They've got a pen shop, I reckon.'

Across the counter, the mother and her son were still at it. 'Now that – that is what I really call – a *pen*,' the mother was crying. She was going to get her way.

Harrods is not a shop that caters to the English gentry. There had been a lot of comment in the papers that year about shopping expeditions mounted from remote corners of the world into the luxury-goods quarters of London. It was a sort of reverse colonialism: just as we had once descended on the courts of Asia to offer them an over-elaborate civil-service model, a long-lasting sense of inferiority and the interesting idea that it might be sensible to stop burning widows, taking from them in exchange various gross baubles and an ingrained sense of post-colonial guilt, so our unfortunate subjects' descendants were now turning up in Knightsbridge with fully charged credit cards to acquire some tat. One newspaper had tried to interview some of these shoppers, and had got hold of a Singaporean fashion queen, a Chinese woman, the chauffeur of a Dubai property magnate lovingly ladling shopping bags into the boot, and, disappointingly, a man who may have looked Indian but was in fact a third-generation German citizen. Harrods is the centre of the international shopping trip. I had heard stories of its sheer horror after Christmas, though, like everyone else, I don't suppose I had stepped through its doors for ten years.

Still, it had a pen shop, and, as the saying went, you can buy anything at all in Harrods, even fountain pens with an italic nib. I walked up Sloane Street from Peter Jones in the direction of Knightsbridge. On the right, there

is a shop of the luxury goods firm, Mont Blanc, which of course sells fountain pens. I did not go in. In part, I wanted to see a range of manufacturers; in part, I had the idea that Mont Blanc pens were dizzyingly expensive. The make is one of those luxury-goods brands with a supposedly telling logo – in this case, I discover, a sort of white splodge on the top of the case, by the clip. To master all such telling logos from the world of luxury goods would take a lifetime, to the preclusion of any other intellectual activity, and I'm not sure how many people one would ever meet who would see the splodge on the end of your pen and say 'Ah – Mont Blanc'.* So I went onwards, to Harrods.

The layout of Harrods is constantly confusing, laid out in a kind of spiral which leads you from one chamber to another, round and round. Hellish as it normally must be, two days after Christmas, with great mobs of monoglot Chinese punching each other to get to the Crème de la Mer concession proved almost too much. There are no maps of the shop anywhere, and since the whole thing is sold off to individual stall-holders, none of whom have any grasp at all of the layout of the shop, you wander about pointlessly until you happen upon one of the lifts. The stationery is on the lower ground floor, and to reach it you need to pass through a Disco Street Youth concession blasting hip hop at full volume, and harassed shop assistants carrying

* Anyway, you can lie to people, who tend to be credulous in this area of life. For years, I got a rise out of visitors by telling them that the ornamental double C on lamp posts in the City of Westminster, including Soho, was because Coco Chanel had designed the street-lighting there.

armfuls of shawl-collared cardigans from the changing cubicles back to the racks. Then there is the bold monument to Diana Wales and Dodi Fayed, the son of the shop's previous owner, Mohammed Fayed – the shop is now owned by the princes of Qatar, who haven't found the right moment to remove this extravaganza.* And finally you get to the pen department.

The pen department was a comparatively quiet patch, with thick carpets underfoot, and smooth young men standing behind glass cases. It was the Peter Jones pen desk in large – the cheap pens were in a busier room next door. I spoke to an assistant. 'I am looking for a fountain pen, with an italic nib, and a refillable, pump-action, hydraulic-sort of reservoir thingy,' I said. The lady looked doubtful. 'I'm not sure that we stock anything like that,' she said. 'Parker do the biggest range of nibs, but you have to order one especially – I'm not sure how long it would take. And Mont Blanc do an oblique nib – I would have to pass you over to my colleague Mr Assad. Mr Assad, could you help this gentleman?' I repeated my request at the Mont Blanc desk. Mr Assad produced an elegant case of ten black Mont Blanc pens, each labelled with a cryptic designation. He handed me one labelled OB, and a leather-bound notebook to scribble on. He explained the difference between an oblique nib and an italic nib – I saw that the oblique, slanting nib produced a more subtle variation between thick and thin strokes than the italic nib, and

* Signalled, inevitably, in a copperplate sign propped up on a sort of easel.

spent a few pleasant minutes writing my favourite pangram, 'TV quiz jock, Mr PhD, bags few lynx.'* I tried a thicker oblique nib, this one labelled OBB, and this pen, curiously, was filled with brown ink, like a typesetter's.† The oblique effect was not what I had been looking for, exactly, but it was very pleasing. 'How much was that?' Well, the oblique nib could be fitted to any of the Mont Blanc range. How much? Well, the range started at WHITE NOISE. Look, see, this one here, it's roughly the size of an eyebrow pencil, though a proper Mont Blanc pen. Yes, all very well, but I'm not going to write a great novel with a pen the size of an eyebrow pencil. How much was the one I was writing with, the one that fit so nicely into my hand and made my handwriting so very elegant? Well, that one would probably be WHITE NOISE. Thank you very much, Mr Assad. I am so sorry to have taken up your time. 'You could try next door,' Mr Assad said, genuinely helpfully.

The distinction between glass-case Writing Instruments, as some manufacturers term their products, and the

* Pangram: a sentence containing all twenty-six letters, useful for handwriting exercises and to test keyboards. The most famous is the classic 'The quick brown fox jumps over a lazy dog', which dates back to 1888, making it coeval with the invention of the typewriter. People often write 'jumped', which makes it no longer a pangram. Other pangrams worth considering include 'Waltz, bad nymph, for quick jigs vex!', 'Amazingly few discotheques provide jukeboxes' and 'My jocks box, get hard, unzip, quiver, flow', which you might write on a pad in Harrods, but never, ever, ever, in Peter Jones. A charming novel by Mark Dunn, *Ella Minnow Pea*, is about an island whose inhabitants worship the creator of the 'lazy dog' pangram.

† According to Reginald Piggott, v. supra.

things you can pick up without an invitation is one jealously preserved by department stores. Where the distinction lies is not altogether clear, or what it is based on. In part, it rests on the different cost. Harrods goes further than Peter Jones, and has two entirely separate rooms. It was to the second that I went now. Strangely, within this second room, there was also a glass-countered element, and a woman standing behind it waiting to serve the customers. Something about it was subtly different from the magnificently leisured offerings being prepared next door, however. I approached and, for the third time, explained that I wanted a fountain pen with an italic nib and a refillable, pump-action, hydraulic-type reservoir. The girl behind the counter listened. 'Yes, this range does do something like that,' she said. 'I don't know if we've got one in stock, though.' I looked down at the range. It was Lamy, the German brand that I already had.

Lamy's range is, I think, a complete knockout. They have obviously thought through about as full a range of possibilities as a schoolful of idiosyncratic writers might want. Their range goes from a beginner's fountain pen in more-or-less indestructible rubber and steel at £11.23, if you buy it online, to a rather wonderful bit of German design in the form of a pen with a retractable nib at a hundred quid or a touch over. There is something perverse about turning the barrel and watching the nib emerge, like the tip of a ballpoint. Lamy's selling point is that it produces nibs in a range of sizes and shapes, including a number of italic nibs. The disadvantage was that I had a Lamy already – in fact more than one. I had started with a bright-red model with a plastic barrel, moving on to the

brushed-steel example after a month or so. I reminded myself that I had come out to buy a long-lasting, good-quality, slightly flash model, not another perfectly serviceable pen from the Lamy range. 'Does nobody else do a range of nibs?' I asked the girl behind the counter. 'Well, Parker do. But we don't stock Parkers with italic nibs. You'd have to order one from next door.' 'Do you know anyone else in London that might stock them?' She thought, and suggested a shop called the Pen Shop. There were branches in different parts of London. There was one on Regent Street, definitely. There was one in a shopping centre in Shepherd's Bush. And she thought there might be one in South Kensington. But she wasn't at all sure. 'I don't live round here,' she said helplessly. I decided to go to Regent Street.

And at Regent's Street, I queued behind a Japanese tourist who spent £250 on a Graf von Faber Castell pen, and was offered a Lamy with an italic nib, exactly the same as the one I already had. For some reason, when on these fruitless shopping expeditions, you feel the obligation to feign a lack of experience. It would feel wrong, somehow, to start sharing the findings which you had amassed in previous emporia; you feel you have to keep up some kind of pretence, out of politeness, that this is the first shop that you have gone into, and listen to the same information with a double ear: with the first, you assess any chink of difference which might suggest that you have been misled, that some overlooked brand does a perfectly good italic version; with the other, you listen for confirmation of what you already know. At the Pen Shop, I said with a concealed vagueness that I was surprised that Mont Blanc didn't make

an italic version. 'Oh, no, they don't,' the assistant said. That was surprising, I said. Then, as if a random thought had come to me, I said I thought I had heard that they did a, what was it called, an oblique nib. Yes, that was true; they did do an oblique nib, she told me. However, they didn't stock it: there was very little call for such a thing. I could try Harrods. What, I said, was the difference between an italic and an oblique nib? But at this point, two days after Christmas, I had outworn her patience, and the shop was busy. Like most people who work in specialized shops, she must have been able to recognize the difference between a real inquiry after knowledge and one where the inquirer is just asking to preserve the social niceties and pretend he knows less than he does. She must have seen that this was the third shop of my morning. 'One goes like *that*,' she said, making a horizontal chopping gesture, 'and the other,' she sliced at an angle, 'goes like *that*.' Something about her warned me not to pursue the matter further, with airy questions about whether it mattered if you bought a right-hand or a left-hand nib. I took a Lamy, exactly the same as the one I already had. I asked if they had a slightly wider italic nib that I could try. I dipped the pen in an open bottle of ink, and wrote on a pad on the desk; this one without benefit of leather casing. I wrote a pangram; I signed my name; I handed over forty quid. There had been a murder on Oxford Street the day before, a boy being stabbed among the crowds in Foot Locker, the shop for teenage sports shoes. It had made no difference to the flood of shoppers. I stood for some time with my arm out-stretched, outside the Pen Shop, before a taxi drew up.

It had taken me all morning and half an afternoon to

establish definitely that there was only one pen to be bought in London which fit my description: a fountain pen with an italic nib and a refillable, pump-action, hydraulic-type reservoir. That pen had to be made by Lamy, and I already had one. I had gone about in a bus and the tube and a taxi. I had had a cup of coffee at one point. It was one of the most crowded days of the year in that corner between Chelsea, Knightsbridge and the West End of London. I had seen tens of thousands of people. All about me, they had been engaged in the act of writing, of sending messages. People had been gazing into their small electronic devices and pumping away with their opposable thumbs. Customers in shops had been paying by putting their cards into machines and pressing their four-digit code. In Caffè Nero, the faces had been down at the portable screens, and three different people had been checking and resending their e-mails. Probably at no time in human history had so much writing in public gone on: it was like an eighteenth-century coffee house, with small corners of scribble and despatch. All morning, I had seen exactly four acts of writing with a pen on paper. They had been performed three times by me, on scribble pads, leather-bound or not, in Peter Jones, Harrods, and the Pen Shop, and once by poor Nigel, being forced to buy a fountain pen and to try it out. At no other point did it seem normal or natural to anyone to write anything by hand, in handwriting. A visitor from another place would have concluded that handwriting with a fountain pen was exclusively something that you did in a shop, when you wanted to try out a fountain pen.

29 ~ *What is To Be Done*

From 1989, two professors of education at the University of Washington, Virginia Berninger and Robert Abbott, carried out research on the knock-on effects of good handwriting. They examined beginning pupils at eight state schools in the greater Seattle area, and took a sample of 700 children, of whom 144 had been identified with writing problems. The problem children were divided into groups, and subjected to a variety of remedial approaches. One group did very much better than the others, and not just in writing. Berninger and Abbott found that the group with improved handwriting also had improved reading skills, better word recognition, better compositional skills, and better recall from memory. They began to enjoy learning more: they certainly took more pleasure in writing. They were just much better students. Would the same have been true of skilled keyboard operators? Berninger and Abbott didn't think so. 'Handwriting is not just a motor process; it is also a memory process for letters – the building blocks of written language.' And what happened to these students later on? 'Older students who have done poorly from the beginning come to think of themselves as not being writers, so they don't like writing and avoid it. As a result, their higher-level composing skills don't get developed,'

Berninger says. 'We think that if we intervene early with handwriting and spelling instruction, we can prevent problems with written expression later.'*

And what if there is no intervention – no teaching – no effective engagement with pen and ink on paper? What problems arise in later life? What diminishment of a human being takes place?

Writing this book, I've come to the conclusion that handwriting is good for us. It involves us in a relationship with the written word which is sensuous, immediate, and individual. It opens our personality out to the world, and gives us a means of reading other people. It gives pleasure when you communicate with it; when done at all well, it is a source of pleasure to the user. No one is ever going to recommend that we surrender the convenience and speed of electronic communications to pen and paper. Once typed into cyberspace, information remains there for ever, infinitely retrievable by typing a few key words into a search engine. By contrast, handwritten communication can only disappear into an archive, awaiting its transcription into type. Though it would make no sense to give up the clarity and authority of print which is available to anyone with a keyboard, to continue to diminish the place of the handwritten in our lives is to diminish, in a small but real way, our humanity.

In all sorts of areas of our life, we enhance the quality of our lives by going for the slow option, the path which

* 'In spite of computers, handwriting instruction is important because of carry-over to composition', *University of Washington News*, 30 January 1998.

takes a little bit of effort. Sometimes, we don't spend an evening watching Kim Kardashian falling over on YouTube: we read a book. Sometimes, we don't just push a pre-prepared meal into the oven and take it out some time later. We chop and prepare vegetables; we follow a recipe, or some procedure we remember from our family kitchens, and we make dinner from scratch, with pleasure. We often do this because we love people, and think they are worthy of our effort from time to time. Sometimes we don't get in a car and get to where we have to go as soon as we possibly can. Sometimes we open our front doors, and go for a walk in the spring sunshine. We might not get anywhere very far in two or three hours on foot, whereas in three hours by mechanical means you can get to Yorkshire (by car) or Paris (by train) or Istanbul (by air). But on the other hand, you've had a nice walk in the spring sunshine for very little expenditure, and you feel better for it.

Perhaps that is the way to get handwriting back into our lives – as something which is a pleasure, which is good for us, and which is human in ways not all communication systems manage to be. It will never again have the place in people's lives that it had in 1850. But it should, like good food or the capacity to take a walk, have some place in our lives from which it is not going to be dislodged. I want to know what people are like from their handwriting – friends, intimates, acquaintances, strangers, and people I can never and will never meet. I want everyone to maintain an intimate and unique connection with words and ink and paper and the movement of hand and arm. I would love people to lose shame in their own handwriting, and

develop an interest in the varieties of writing instead – something which might lead them to do something about their handwriting, rather than regarding it with despair. I want people to write, not on special occasions, but daily. I want to maintain a variety of ways to engage with the silent word and the considered record of a sentence – typed on keyboards, thumbed on keypads, handwritten – and to enrich our relationship with language through a variety of means. We are fighting a losing battle. Few people gave up writing by hand before the last decade or two – perhaps only odd people like Hitler here and there. I heard, repeatedly, in talking to people, the claim that they 'never wrote anything' these days. The unconsidered movement away from handwriting is gathering pace, without anyone really deciding to stop, and once it's gone we will have to ask whether we really wanted to lose the modest, pleasurable, private skill.

I don't believe that it needs to be like this. We can let handwriting maintain a special place in our lives, if we choose. If someone we knew died, I think most of us would still write our letters of condolences on paper, with a pen. And perhaps there are other occasions when we still have a choice whether to write with pen and paper or with electronic means, and we should make the right, human choice. I dream of creating a space every day where we write with pen on paper, whether for ourselves or to communicate with other people. I think we would feel happier about ourselves, and I think we would feel more secure in our relationships with those around us. Here are some small suggestions of ways in which we could reintroduce handwriting back into our lives.

1. Handwriting should be taught in schools. This seems obvious. Too much time has been spent discussing what letterforms are best for children to learn. In my opinion, it hardly matters. Schools should be offered a choice of Palmer-derived script, italic, Marion Richardson, ball-and-stick, and any other style that comes to mind. Let schools compete over the best method; let some boast to parents that they produce children with the most beautiful handwriting in Hampshire. Children will move from school to school and be confused when they encounter a completely new model. So what? Children are small bouncy things. They'll catch up.

2. The teaching of handwriting doesn't have to take up much time, but it has to be bound into something meaningful. The laborious performance of pothooks and ovals to a set rhythm by Palmer and his disciples seems abstract, militaristic and pointless, and in the end gave handwriting lessons a bad name. If you want to subject small children to your will, make them take up drill practice. Better still, examine your own motivation and think better of it. There are three useful points of contact with the rest of the school calendar. The rooting of handwriting in dance and movement that the French curriculum insists on, making rhythmic movement the basis of every movement of the pen, is bound to create confident writers. Many of the best handwriting reformers came out of the school art room, such as Marion Richardson and Blunt. The love of shape-making and patterning, which every child understands, easily relates to the making of letters in the early years. Finally, the study of language could be so much more

imaginatively linked to the writing of letters and words in schools. But why make a choice? Why should handwriting be only taught from one angle?

3. Enjoy your own handwriting. Start from the good psychic point that you can always value it, because it has so much of you in it.

4. Rediscover the joy of writing by hand, all for yourself. Go and find some writing equipment – a 15p Bic Cristal pen, one black, one red (let's say). Get a couple of pencils – a soft 2B pencil, a hard 2H. A fountain pen, a felt-tip pen, preferably in a garish colour. Get a whiteboard marker – those joyous things with a blunt tip. Anything else you can think of – I like those green Pentel pens with a rollerball at the tip. Get some paper – cheap, shiny, ordinary, handmade, recycled, writing paper, nothing remarkable. Just write on them, one after the other. Enjoy that slightly chocolate-bar softness of the 2B pencil under the hand, the faint greasiness of it; the floppily spongy way the felt-tip pen squeaks over the cheaper, shinier paper, giving way under pressure; enjoy what we take for granted, the super-efficient, disposable, space-age design of the Bic Cristal, mastering kilometres of line under its tungsten ball; the elegant swoop of the fountain pen over good-quality paper. Nice, isn't it? Write anything you like; write a pangram about jocks or discotheques or lynx or anything you like, and then sign your name, unembarrassedly, with a big gesture. Write your name on the wall with the whiteboard marker. That was fun! It's washable, isn't it? Whoops. Well, it was fun, anyway, and the dining room probably needed redecorating, I dare say.

5. Play with your letterforms. Do you like your hand-writing? If not, do something about it. Whose handwriting do you like? Copy it. The other day I was overcome with jealousy at the terrific swoop and hook of a friend's y, and promptly started trying it out on paper. It looked completely absurd, and nothing to do with my handwriting at all. Doesn't matter. Your handwriting is a living thing, or should be – if it looks the same as it did ten years ago, even, give way to boredom – do something about it. Mix it up a bit. After all, do you still have the same haircut that you did ten years ago? You do? Nutter.

6. There are some ways to reintroduce handwriting into our regular daily lives. The first is to make space in the day to write notes for yourself. When you go to the supermarket, make a shopping list with a pen on a scrap of paper. As you go round, buying your stuff, tick it off – 'Does that say "rosemary" or "Ryvita"?' – resting on the bar of the shopping trolley, probably tearing through the paper with the tungsten ball as you go. Write notes on the kitchen corkboard; enjoy the sensuous pre-Gutenberg quality of the scribbled reminder, to yourself, to your nearest and dearest, to the cleaner. Make lists by hand. Keep a small volume for thoughts and observations, small enough to keep in a pocket or a coat.* Great for passing reflections, ideas, plans,

* I have a succession of notebooks, each about the size of my palm, bound in bright leather so you can't mislay them about the house, with the perfect addition of an elastic cloth strap to stop the pages from flapping open and, more usefully, allowing you to keep your pen and notebook together and not to have to go delving into your man-bag

recording those kind of idle wonderings which come in a moment and which you promise yourself you'll look up next time you're in a library and of course forget because you don't write it down. There's really nothing nicer than looking back through a notebook full of a year's casual thoughts. I personally don't keep a diary, but who could doubt that a diary, written by hand, is a million times nicer than a bloody blog?* The nicest of all private, handwritten journals is a dream diary; you keep it on your bedside table, and when you wake, you write down what you've been dreaming about. It looks so odd after a few weeks; your handwriting in such a state, all manner of sizes, and full of things which you can't remember why you felt so intensely about them. A dream diary belonging to some-

saying that you could have sworn you had a pen with you. The notebooks are Swedish in manufacturer, and I would tell you where I get them, but the shop in Geneva is staffed by such up-themselves shop assistants that I really don't think I want to put any more custom their way. Still, their notebooks are gorgeous, well worth it if you find the shop through your own initiative.

* The Queen, it is known, writes a diary by hand. In some documentary about 'A Year In The Life of Her Maj', the Archbishop of Canterbury was discovered finding out, while in the Presence, that this was so, and was recorded saying something to the effect of 'What? You write it on your own? In your own hand?' The Queen responded by saying, 'Well, I don't know any other way of doing it', the implication being that she thought the cleric was suggesting that she dictated it to a flunky, writing with a swan's quill on vellum. I dare say that, as time has gone on, the question of security and privacy has arisen, and the Household, or just her Majesty, has rightly concluded that what is written by hand can't be sent off to the *Daily Express* with a press of a button by some disgruntled and underpaid junior in her private office.

body else would in the end be the most fascinating thing in the world.

7. When something important that you need to understand and remember is being said to you, make a note of it by hand. To be able to write down a summary with pen and paper is, I'm convinced, a quite different and superior skill to making notes in any other way. I talk regularly to a lot of students on academic themes, and, despite institutional pressure, don't use anything like Powerpoint to get my argument across. I write with a marker on a whiteboard. It forces everyone into a more active engagement. From the other side, the students who make no record, but stare astonished into space, wishing they were still on the ski slopes, do worst in the end. The second worst are the ones who plonk a tape recorder on the desk in front of them and record everything you say with the firm and honourable intention of listening to it again later. The worst ones after that are the ones who get out their laptops, and type furiously as you speak. Those, I have to say, are often still pretty bad students, because typing as someone talks encourages transcription without much thought. That's great if what you are hoping to do with your laptop is to transcribe a stretch of overheard dialogue, not so great if you are trying to understand what people say. But the very best students are the ones who take out a piece of paper and a pen, and write down the things that they think are interesting as you talk, making sense of it as they go. Those are the good students. Yes, you should make notes of anything important, because that's how the mind works.

8. Write to other people. Write to people you love, people you like, people you work with. Write postcards. When you go somewhere remotely interesting – when you drop into the National Gallery, when you have a nice day out,* when you go away for a weekend or an overnight, when the firm sends you to Crawley or Khartoum or New York for one of those dull/frightening conferences – find some postcards and send three to your mum and dad, your siblings and nieces, your significant other, your best friend or that old friend you haven't seen for a while. What could be better than to know that you'll be the only nice thing in your old friend's postal delivery that day? Is there anything that gives such pleasure so cheaply as an amusing postcard with thirty sharp words about the delights of Crawley on the back? Make a habit of it. Send letters on special occasions. Write to your husband or wife or children and tell them that you love them. Or tell them they're

* For non-English readers: the Nice Day Out is a national pastime and institution. The rules are as follows: you identify a beauty spot, country house, small historic town, within forty-five minutes to ninety minutes of your home. You travel there by bus or train or (slightly inauthentically) your own transport made by M. Citroen or the Bavarian Motor Company or some such. You get off, and take a walk round the designated destination. You and your chosen companion have lunch in a pub or teashop. After lunch, light-headed with pleasure, you buy an absurd souvenir of the place, OR have a short but telling argument over nothing very much. Late in the afternoon you take the public transport back home, remarking as you get off at Clapham Junction that you don't know why, but you don't think there's a single thing in the fridge for dinner. At some point in this outing, from now on, you will also buy a postcard and send it to your mum and dad.

arseholes. It will have a lot more impact than a text message either way, perhaps usefully keeping them on their toes. Keep a supply of postcards handy, and a book of stamps. Scribble away. It doesn't cost much.

9. Don't be in a rush. Why are you in a rush? Why don't you have two minutes to write something down? Why is your pen dashing in that awful way over the paper? Whoever described, or thought of describing, their handwriting as executing so many w.p.m.? Why can't you breathe, and lift, and take a moment to enjoy this small sensuous act? Do you stuff food pointlessly in your mouth, hoping to get it over with as soon as possible? Or do you hope to enjoy it? Writing can be like that. Sometimes, all we have is two minutes to eat a sandwich or we aren't going to get anything to eat until six. At other times – let's hope at least once a day – we like to sit down in company, and take a little bit of time to chew and anticipate and sit afterwards. That would improve our lives, just as taking a moment to write something by hand, to ourselves, to friends, to our families, is always going to improve their lives and ours.

10. Let's not be snobs about implements. Let's enjoy the pleasure of nice paper, and using a nice pen, and writing well and carefully, but let's not insist on it. There are pleasures, too, in the torn-off piece of paper bearing a few words of casual reminder in hasty blue ballpoint, if we recognize the hand of the person we love best in the world in it. The simplest writing implement is as wonderful an object, properly regarded, as the most luxurious fountain pen; the most casual note, pinned to the fridge, can bear

as much of the writer's humanity as the most carefully scripted e-mail.

That's my list for improvement. Take what appeals, and leave the rest. It's a free country.

Here is a story about how handwriting can still be important, and why we shouldn't let it go. In the university where I teach, one undergraduate creative module contains a specific task, a 'writer's notebook'. The students have to make notes on all sorts of things – observations, passing fancies, plot ideas, scribbled asides, as well as sketches and drafts of poems, short stories, perhaps bits of drama. When I explain this task to the students, invariably someone says, 'Can I type it all on the computer and hand it in because I can't write any other way?' I give in, having been instructed that I have to, but I do encourage students to write as much as they can by hand. It makes you think, I say. It looks less permanent. It has more of you in it. Most students, even now, take this advice and do produce volumes which are full of work written by hand, notes and thoughts and inventions both casual and highly developed. When they have been a student's constant companion over four months or so, they are, I have to say, a total joy.

Last month a student of mine died, quite suddenly. It was a terrible shock to everyone who knew her: she was a grand girl all round. She had done this module, and had produced a fat notebook in which every word was written by hand – you would recognize her handwriting as soon as you knew her. It bulged with invention, and cut-outs, and marginalia, and massive crossings-out, and all

manner of things. After I heard that she had died, I went down to the cellar where these things are stored, and, with a little difficulty from the administration, extracted her writer's notebook from the archive.

It was just full of her. You could see where her pen had moved across the page, only months before; you could see her good creative days and the days where nothing much had come; you could see what she had written quickly, in inspiration, and the bits she had gone over and over. I only taught her, but I was moved by it, and felt a connection with the poor girl, whom I had liked a great deal.

The department in which I work had created great difficulties in letting me see it at all. Administrators who had never met the girl had pretended that it was locked up and could not now be unlocked. Looking at it, I could understand why it had created such nervousness in them. It frightened people who were frightened of literature, and humanity, and the texture of life. Written at length, in hand, it just was my student. It was going to be a precious thing to hand over, and I hoped the administrators would be up to the task in the end. Some part of the writer's spirit had passed into the handwriting, and had stayed there. Her humanity and her hand overlapped, and something remained, indelibly, in these physical traces. I handed it back to the administrator, and she locked it up again, safely, in her cupboard.

Notes

2. INTRODUCTION

1 Tamara Plakins Thornton, *Handwriting in America*, p.90.

3. THERE'S NOTHING WRONG WITH MY HANDWRITING

1 *Times Higher Education Supplement*, 23 February 2012.
2 'Write and wrong', *Guardian*, 14 April 1987.
3 Dominic Sandbrook, *Seasons in the Sun*.
4 PR Newswire, 26 May 1994.
5 'Many believe penmanship is losing out to technology,' *Detroit News*, 3 January 2000.
6 'Poor handwriting led to fatal dose,' *The Times*, 9 December 2005.
7 *Times Higher Education Supplement*, 15 April 2010.
8 Caron Dann, 'From Where I Sit – A sad loss of literacy Down Under', *Times Higher Education Supplement*, 11 September 2008.
9 http://www.education.gov.uk/schools/teachingandlearning/curriculum/secondary/b00199101/english/ks3/attainment/writing, retrieved 1 February 2012.
10 'Pupils' handwriting is not up to scratch', *The Times*, 9 June 2006.
11 Ibid.
12 Ibid.
13 *Letters Written To His Son*, letter LVI.

14 'Indiana schools to teach children to type instead of joined-up handwriting', *Daily Telegraph*, 7 July 2011.

15 'Teachers say good penmanship is a thing of the past', AP State and Local Wire, 23 June 2001.

16 'Pupils get black marks for standard of writing', *Scotland on Sunday*, 17 October 2010.

17 'Whatever became of Palmer?' *New York Times*, 8 January 1984.

18 'P is for penmanship', *Chicago Daily Herald*, 15 November 2006.

19 'Can you read this?' *New York Times*, 25 January 1995.

20 'Teaching the Write Stuff', *Detroit News*, 8 May 2007.

21 'Righting writing wrongs', *Washington Times*, 11 July 2000.

22 'Write and wrong', *Guardian*, 14 April 1987.

23 'The death of handwriting', *Guardian*, 14 February 2006.

24 'Joined up letters, at a stroke', *Independent*, 30 May 1996.

25 'Between the lines', *Guardian*, 8 April 1997.

4. A HISTORY OF HANDWRITING FROM STRING ONWARDS

1 Steven Roger Fischer, *A History of Writing*, p.30.

7. OUT OF THE BILLIARD HALLS

1 Tamara Plakins Thornton, *Handwriting in America*, p.49.

2 Reproduced in Rosemary Sassoon, *Handwriting of the Twentieth Century*, p.23.

3 http://www.spencerian.com

4 Kitty Burns Florey, *Script and Scribble*, p.71.

5 Ibid, p.25.

6 H.C. Spencer, *Spencerian Key To Practical Penmanship*, pp.39–40.

7 Thornton, *Handwriting in America*, p.48.

8 H.C. Spencer, *Spencerian Key To Practical Handwriting*, cited in Thornton, *Handwriting in America*, p.50.

9 Rosemary Sassoon, *Handwriting of the Twentieth Century*, p.20.
10 Henry Gordon, *Handwriting and How To Teach It* (circa 1875), quoted in Rosemary Sassoon, *Handwriting of the Twentieth Century*, p.35.
11 Rosemary Sassoon, *Handwriting of the Twentieth Century*, p.27–9.
12 Kitty Burns Florey, *Script and Scribble*.

8. VERE FOSTER AND A.N. PALMER

1 Thornton, *Handwriting in America*, p.67.
2 Thornton, *Handwriting in America*, p.68.
3 'Many believe penmanship is losing out to technology', *The Detroit News*, 3 January 2000.
4 Alfred Mendel, *Personality in Handwriting*, pp.304–5.

10. PRINT AND MANUSCRIPT AND BALL AND STICK

1 Geoffrey Willans and Ronald Searle, *Molesworth*, Penguin Modern Classics, p. 118.
2 Priscilla Johnston, *Edward Johnston*.
3 Evelyn Waugh, *Decline and Fall*.
4 Rosemary Sassoon, *Handwriting of the Twentieth Century*, p.74.
5 Ibid, p.64.
6 Donald Jackson, *The Story of Writing*.

11. 'UNE QUESTION DE WRITING'

1 To be found on http://www.laserlearning.tv
2 'Can you read this?', *New York Times*, 25 January 1995.
3 Paul R. Pope, *'Deutsche oder Lateinische Schrift?'*, *The German Quarterly*, May 1931.
4 'German teachers campaign to simplify handwriting in schools', *Guardian*, 29 June 2011.

5 Rosemary Sassoon, *Handwriting of the Twentieth Century*, p. 72.

13. HITLER'S HANDWRITING

1 Gerhard L.Weinberg, 'Hitler's Memorandum on the Four Year Plan: A Note', *German Studies Review*, February 1988.
2 Gerhard L.Weinberg, 'Hitler's Private Testament of May 2nd, 1938', *The Journal of Modern History*, December 1955.
3 Robert Harris, *Selling Hitler*, p.180.
4 Ibid, p.193.
5 Ibid, p.353.

14. PREPARING THE BOYS FOR DEATH

1 Alfred Fairbank, *The Story of Handwriting*, p.61.
2 Examples shown in ibid, plates 37 and 38 and fig. 7.
3 *Dictionary of National Biography*.
4 'Duelling handwriting styles', *The Ottawa Citizen*, 15 March 1998.
5 Alfred Fairbank, *The Story of Handwriting*, p.66.
6 Reginald Piggott, *Survey*, p.31.
7 Tom Gourdie, *Italic Handwriting*.
8 Kitty Burns Florey, *Script and Scribble*, p.166.

16. INK

1 Eric Singer, *A Manual of Graphology*.
2 *The British Bellman*, 1648. Charles Hindley, *A History of the Cries of London*, p.41.
3 Joyce Irene Whalley, *Writing Implements and Accessories*, p.80.
4 *The British Bellman*, 1648. Charles Hindley, *A History of the Cries of London*, pp.100–1.

18. PENS

1 Joyce Irene Whalley, *Writing Implements and Accessories*, pp.41–2.
2 Ibid, p.44.
3 Ibid, pp.52–4.
4 Ibid, p.67.
5 Ibid, p.65.
6 Ibid, p.83.

19. MARION RICHARDSON

1 *Dictionary of National Biography*.
2 Marion Richardson, *Writing and Writing Patterns: Teacher's Book*, p.3.
3 Ibid, p.4.
4 Ibid, pp.21–41.

20. READING YOUR MIND

1 Tamara Plakins Thornton, *Handwriting in America*, p. 88.

22. VITATIVENESS

1 Tamara Plakins Thornton, *Handwriting in America*, p.97.
2 Ibid, pp.110–12.
3 'On Autographs', from *Curiosities of Literature: Second Series*.
4 Eric Singer, *A Manual of Graphology*.
5 Singer, p.169.
6 Rosa Baughan, *Character Indicated by Handwriting*.
7 Dorothy Sara, *Handwriting Analysis for the Millions*.
8 Rosa Baughan, *Character Indicated by Handwriting*, p.32.
9 Stephen Kurdsen, *Reading Character from Handwriting*, p.53.
10 Princess Anatole Marie Bariatinsky, *Character As Revealed by Handwriting*, p.26.

11 Nadya Olyanova, *Handwriting Tells*, p.235.

12 Alfred O. Mendel, *Personality in Handwriting*, p.33.

13 Irene Marcuse, *Guide to the Disturbed Personality Through Handwriting*.

14 Stephen Kurdsen, *Reading Character from Handwriting*, p.17.

15 Translated in Singer, p.30.

16 Ben-Shakhar, 'Can Graphology predict occupational success?'

17 Raj Persaud, 'Writing wrongs', *Guardian*, 10 February 2005.

18 Irene Marcuse, p.67.

19 Dorothy Sara, *Handwriting Analysis for the Millions*.

23. NOT BEING ABLE TO READ: PROUST

1 Proust, *In the Shade of Young Girls in Bloom*.

2 Proust, *Selected Letters*, vol IV, ed. Philip Kolb, p.96.

3 Ibid, p.392.

4 Céleste Albaret, *Monsieur Proust*, p.188.

5 Proust, *Sodom and Gomorrah*.

6 Proust, *Letters*, vol. 4, pp.77–8.

7 Proust, *In the Shade of Young Girls in Bloom*.

8 Proust, *The Fugitive*.

9 Proust, *In the Shade of Young Girls in Bloom*.

10 Ibid.

11 Ibid.

12 Proust, *The Fugitive*.

13 Proust, *Sodom and Gomorrah*.

14 Proust, *The Prisoner*.

15 Proust, *Sodom and Gomorrah*.

16 Proust, *The Walk by Swann's House*.

17 Ibid.

18 Proust, *The Fugitive*.

19 Proust, *The Guermantes Walk*.

20 Proust, *Time Found Again*.

21 Proust, *The Fugitive*.

22 Céleste Albaret, *Monsieur Proust*, p.199

23 Proust, *The Walk by Swann's House*.

24 Proust, *The Fugitive*.

25 Ibid.

26 Proust, *The Walk by Swann's House*.

27 Proust, *The Fugitive*.

28 Ibid.

29 Proust, *The Walk by Swann's House*.

30 Ibid.

31 Proust, *Sodom and Gomorrah*.

32 Proust, *Time Found Again*.

33 Céleste Albaret, *Monsieur Proust*, pp.270–1.

24. GISSA JOB, SIEGMUND

1 Niall Ferguson, *High Financier*, p.421.

2 'For More Employers, the Scrawl is All'; *Washington Post*, 14 July 1989.

3 Raj Persaud, 'Writing wrongs', *Guardian*, 10 February 2005.

4 By Levy, cited in Ben-Shakhar.

5 Adrian Bangerter, Cornelius J. Konig, Sandrine Blatti and Alexander Salvisberg, 'How Widespread is Graphology in Personnel Selection Practice? A Case Study of a Job Market Myth' *International Jounral of Selection and Assessment*, 17, 2 June 2009.

6 *Private Eye*, July 1970, quoted in Niall Ferguson, *High Financier*.

7 Ferguson, *High Financier*. p.419.

8 Ibid, pp.306–7.

26. BIROS AND NOT-BIROS

1 E.g. http://www.mendoza.edu.ar/efemerid/l_biro.htm, retrieved 10 November 2011.

2 Stephen Bayley, 'Marcel Bich', obituary, *The Independent*, 2 June 1994.

3 Ibid.

4 From Bic's corporate website, http://www.bicworld.com

5 '*La Très Véritable Histoire du stylo Bic*', images by Christian Rossi, scenario by Xavier Seguin, *Okapi* number 307, 1984.

6 Letter from Marcel Bich to shareholders, 1978.

7 Alfred Fairbank, *The Story of Handwriting*, p.85.

8 Reginald Piggott, *Handwriting: A National Survey*, p.147.

9 Nicolete Gray, 'Away from the signs of the times, and back to a fair script', *The Times*, 2 December 1977.

Bibliography

Céleste Albaret. *Monsieur Proust.* London 1976.

Adrian Bangerter, Cornelius J. Konig, Sandrine Blatti and Alexander Salvisber. 'How Widespread is Graphology in Personnel Selection Practice? A Case Study of a Job Market Myth'. *International Journal of Selection and Assessment* 17, 2009.

Princess Anatole Marie Bariatinsky. *Character as Revealed by Handwriting.* London, 1924.

Rosa Baughan. *Character Indicated by Handwriting.* London, 1919.

George Bickham. *The Universal Penman.* London, 1743.

Wilfrid Blunt. *Sweet Roman Hand.* London, 1952.

Lord Chesterfield. *Letters Written to his Son.* Oxford, 1890.

Edward Cocker. *The Pen's Triumph.* London, 1658.

Charles Dickens. *Bleak House.* Oxford, 1979.

———— *David Copperfield.* Oxford, 1981.

———— *Great Expectations.* Oxford, 1993.

———— *Little Dorrit.* Oxford, 1979.

———— *Nicholas Nickleby.* Oxford, 2008.

———— *The Old Curiosity Shop.* Oxford, 1997.

———— *Our Mutual Friend.* Oxford, 2008.

———— *The Pickwick Papers.* Oxford, 1986.

Mark Dunn. *Ella Minnow Pea.* London, 2001.

Alfred Fairbank. *The Story of Handwriting*. London, 1970.

Niall Ferguson. *High Financier*. London, 2010.

Steven Roger Fischer. *A History of Writing*. London, 2010.

Kitty Burns Florey. *Script and Scribble*. New York, 2009.

Sigmund Freud. *The Psychopathology of Everyday Life*. London, 1948.

Henry Gordon. *Handwriting and How To Teach It*. London, ca.1875.

Tom Gourdie. *Italic Handwriting*. London, 1955.

Robert Harris. *Selling Hitler*. London, 1986.

Charles Hindley. *A History of the Cries of London*. London, 1881.

Donald Jackson. *The Story of Writing*. New York, 1981.

Edward Johnston. *Writing, Illuminating and Lettering*. London, 1918.

Priscilla Johnston. *Edward Johnston*. London, 1959.

Stephen Kurdsen. *Reading Character from Handwriting*. Newton Abbott, 1971.

Zachary Leader. *The Life of Kingsley Amis*. London, 2006.

Irene Marcuse. *Guide to the Disturbed Personality Through Handwriting*. New York, 1969.

Alfred O. Mendel. *Personality in Handwriting*. New York, 1947.

Nadya Olyanova. *Handwriting Tells*. London, 1969.

A. N. Palmer. *Palmer's Guide to Business Writing*. Cedar Rapids, 1894.

Reginald Piggott. *Handwriting: a National Survey*. London, 1955.

Paul R. Pope. 'Deutsche oder Lateinische Schrift?'. *The German Quarterly*, May 1931.

Marcel Proust. *In Search of Lost Time*. London, 2002.

———— Selected Letters (London, 1983–2000)

Max Pulver. *Symbolik der Handschrift*. Zurich, 1930.

Marion Richardson. *Writing and Writing Patterns: Teacher's Book*. London, 1933.

Billie Pesin Rosen. *The Science of Handwriting Analysis*. New York, 1965.

Dominic Sandbrook. *Seasons in the Sun*. London, 2012.

Dorothy Sara. *Handwriting Analysis for the Millions*. New York, 1967.

Eric Singer. *A Manual of Graphology*. London, 1969.

J. T. Smith. *Nollekens and His Times*. London 1829.

H. C. Spencer. *Spencerian Key to Practical Penmanship*. New York, 1869.

Anthony Summers and Robbyn Swan. *The Eleventh Day*. London, 2011.

Elizabeth Taylor. *Blaming*. London, 1976.

Tamara Plakins Thornton. *Handwriting in America*. New Haven, 1976.

Evelyn Waugh. *Decline and Fall*. London, 2011.

Gerhard Weinberg. 'Hitler's Memorandum on the Four Year Plan: A Note'. *German Studies Review*, February 1988.

—— 'Hitler's Private Testament of May 2nd, 1938'. *The Journal of Modern History*, December 1955.

Joyce Irene Whalley. *Writing Impements and Accessories*. Newton Abbott, 1975.

Geoffrey Willans and Ronald Searle. *Molesworth*. London, 2000.

Picture and Text Acknowledgements

The author and publisher would like to thank the following for permission to reproduce the images and text used in this book:

Page 25 Gordon Brown's handwriting © Rex Features; Page 35 Elizabeth I's handwriting and signature © Private collection / The Bridgeman Art Library; Page 45 Bill of Lading reprinted courtesy of The Granger Collection / Topfoto; Page 46 Handwriting by G. Brooks 'Musick' from *The Universal Penman*, George Bickham, 1743, reprinted courtesy of Mary Evans Picture Library / Interfoto Agentur; Page 53 Spencerian handwriting chart reprinted courtesy of Just Write Studios; Page 56 Carstairs' System, taken from *Handwriting of the Twentieth Century* by Rosemary Sassoon, reprinted courtesy of Intellect; Page 59 sample from Henry Gordon's *Handwriting and How To Teach It*, taken from *Handwriting of the Twentieth Century* by Rosemary Sassoon, reprinted courtesy of Intellect; Page 63 Uncial hand from Preface to the Gospel of St. Mark, from the Lindisfarne Gospels, © British Library Board / The Bridgeman Art Library; Page 67 Sample from *Vere Foster Copy Books: Two*, reprinted courtesy of the British Library; Page 69 Civil Service hand from *The Theory and Practice of Handwriting* by John Jackson, reprinted courtesy of the British Library; Page 71 Extract from the notebook of Sergeant Con Keeler (LAPD), © Don and Kathy

extracts reading groups
books competitions new events
discounts extracts extracts discounts
competitions reading groups
books new reading groups events
events books extracts discounts
extracts new titles reading groups
interviews events new
events extracts extracts books
discounts interviews
new books events new books
events new events extracts
discounts extracts discounts
www.panmacmillan.com
extracts events reading groups
competitions books extracts new books